GELLÉRT
THERMAL
BATH

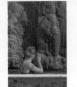

MYSTIC
HOT SPRINGS

STANLEY, IDAHO

YELLOWSTONE

CALDEIRA
VELHA

EDUARDO
AVAROA NATIONAL
RESERVE

BURGDORF
SOAKING
TUB

MAIN POOL
AND LODGE

HVERAVELLIR'S
GEOTHERMAL
POT

STEAMED
GLASSES

PÉTUR
BLÖNDAL
GÍSLASON

T0352624

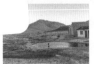

HVERAVELLIR'S
SOAKING POOL

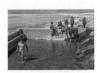

LAGUNA
HEDIONDA

TERMAS DE
POLQUES

COMMUNITY
CLEANING EFFORT

INCOMING WAVE

WRINGING
OUT HAIR

STABILITY
ROPES

HOT SPRING
SEDIMENTS

WARM SPRING
RIVER

WHEELER
PEAK

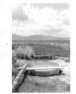

DESERT SOIL

CATTLE
TROUGH HOT
SPRING

MINERAL
COATED
STAIRS

SWIMMING
ABOVE BOX
CANYON

SUNDHÖLLIN

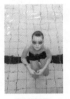

GABRIEL
LEARNING TO
SWIM

TILE WITH
SPLASHES

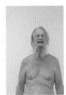

STEFAN AT
SUNDHÖLLIN

BATHING
COWORKERS

TERU NO YU

UME NO YU

HINODE YU

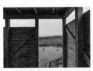

UUNARTOQ HOT
SPRINGS

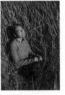

NUUNU ELI
OLSEN

UUNARTOQ
WATER

ICEBERGS

AIR GREENLAND
HELICOPTER

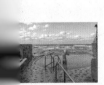

JRÕFUSHI ONSEN

PAMUKKALE

"COTTON PALACE"

TRAVERTINE
POOLS

HIERAPOLIS

ANTIQUE POOL

TRAVERTINE
POOLS

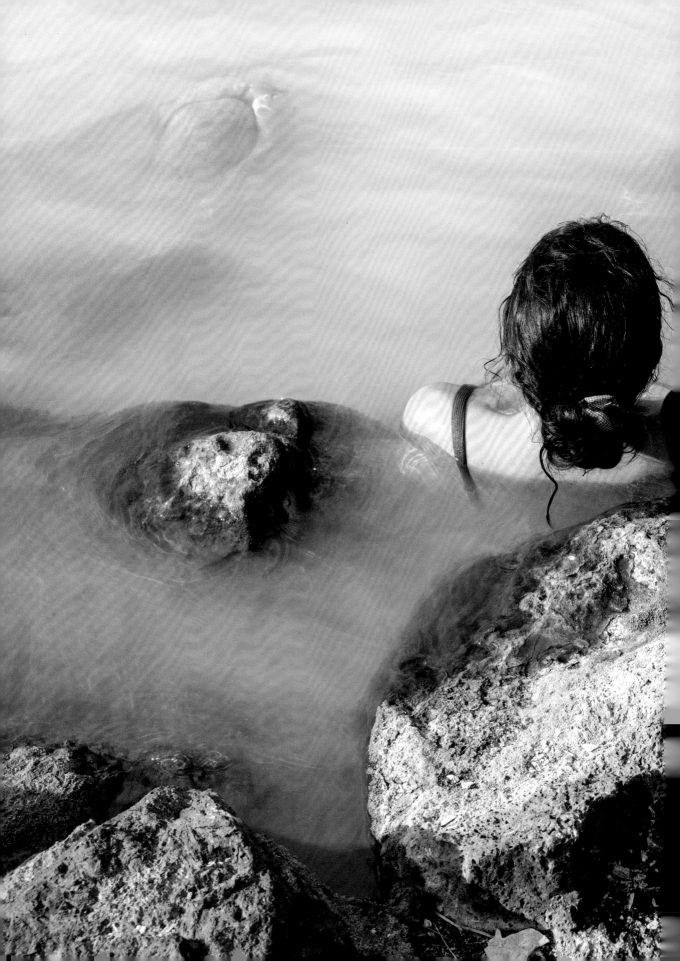

Hot Springs

PHOTOS AND STORIES OF
HOW THE WORLD SOAKS,
SWIMS, AND SLOWS DOWN

Greta Rybus

TEN SPEED PRESS
California | New York

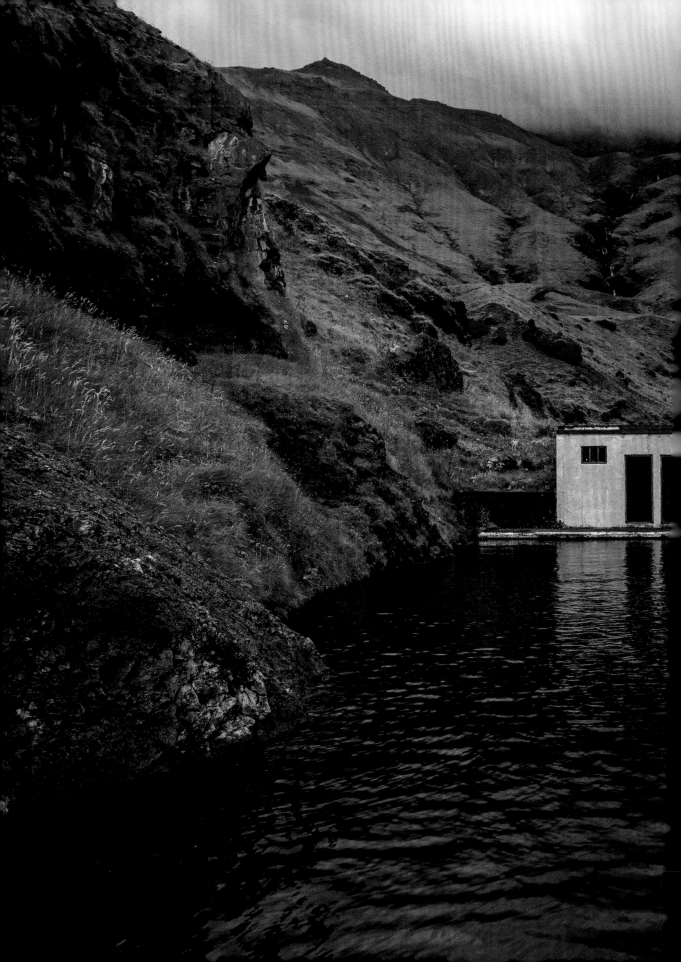

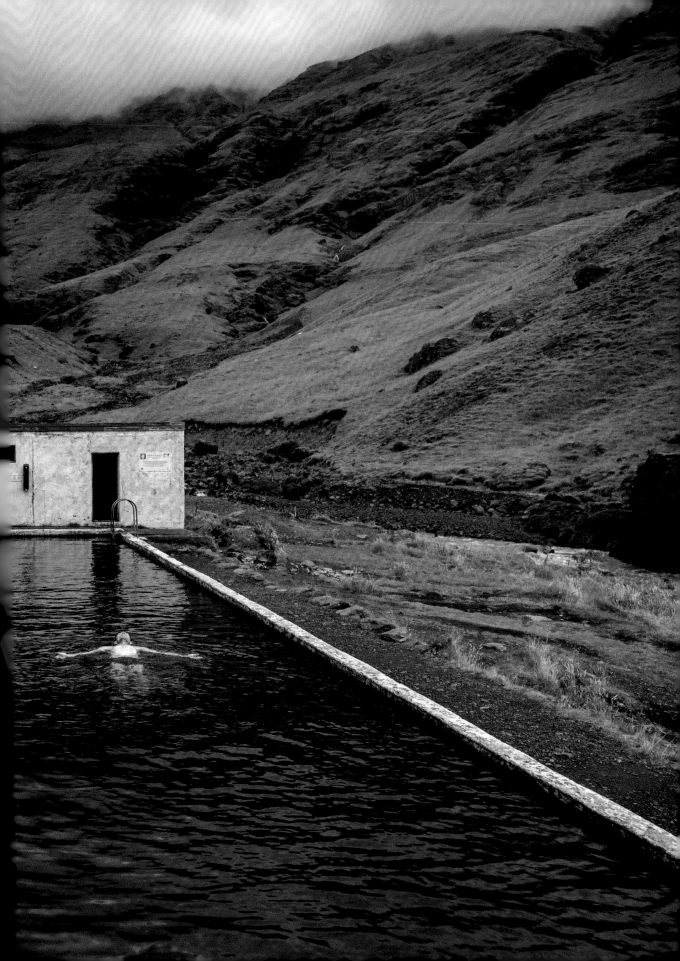

Contents

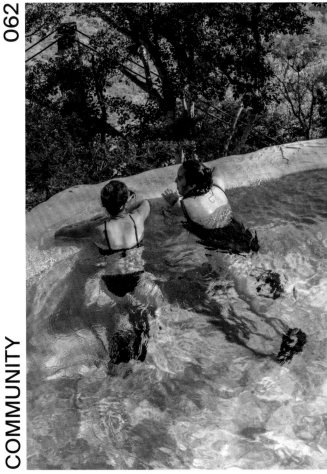

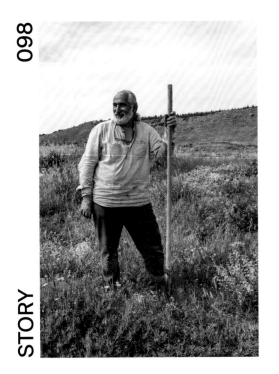
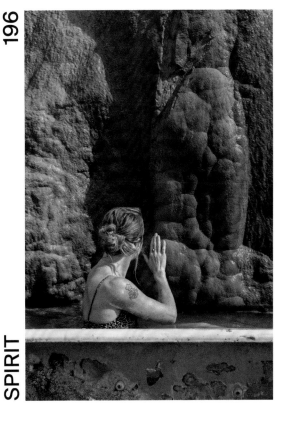
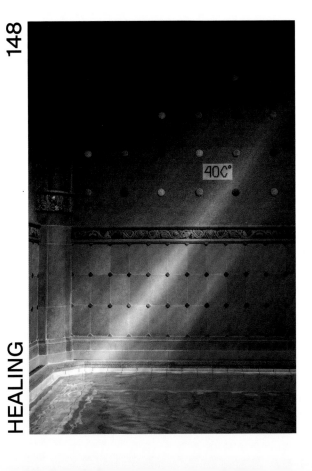

LOCATIONS

● 14

● 12
● ●17
● 7 ● 2

● 9

● 1

● 22
● ●15
● 20

● 5 ● 21

● ●13
4

● 11

● 6

● 16
● 3

● 19

● 10

18 ●
● 8

● 23

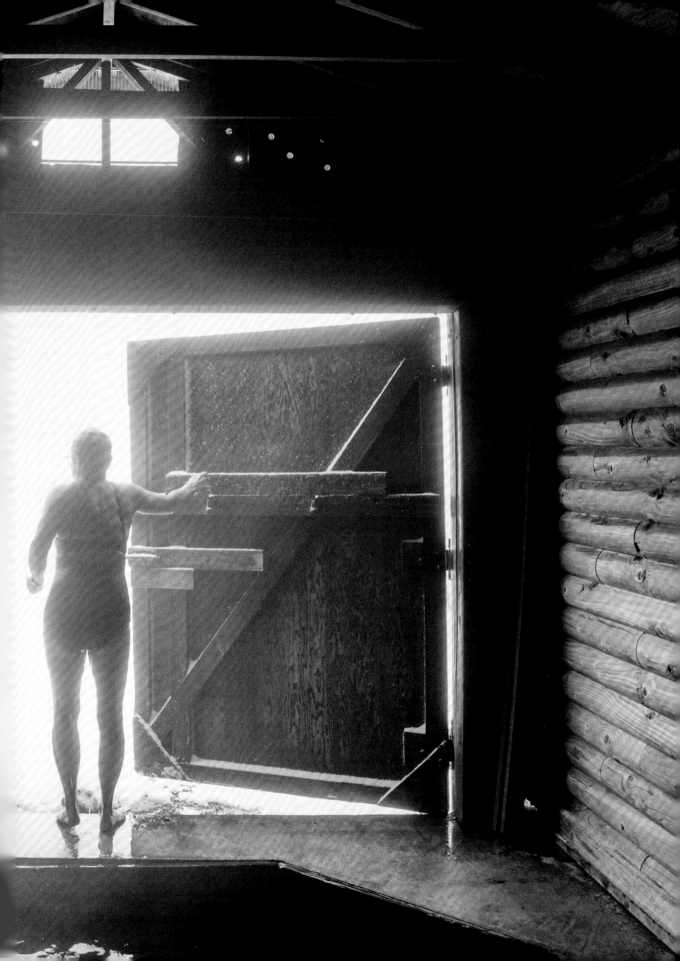

Introduction

FOR THE LOVE OF HOT WATER

The world's first official national park was made because of hot water. Awestruck by the wonder of natural springs and geysers, President Ulysses S. Grant signed an act to establish Yellowstone National Park in 1872. It was the first major action by the US government to protect and recognize the importance of nature and its connection to people. My ancestors, who settled in Montana's Madison Valley in the 1860s, visited the park as a family in 1873, first by wagon and then on horseback. We have journals from their visit, testimonies of wonder and fearsome awe: "It holds one spellbound . . . it is so busy and spiteful that it is much admired. . . . Wonderful in the full sense of the term. I do not consider myself competent to describe any of the views we find. Anyone who knows how grand and beautiful they are, must see for themselves."

A reverence for the outdoors and a sense of adventure have continued to shape our family's pastimes. Hot springs were usually a part of our family trips when I was growing up.

We'd hike into wild springs or take a soak after backcountry skiing. I learned to swim in a hot springs pool, my arms stuffed into water wings. One time, on a road trip across Utah, my hair turned copper red from the iron content in a hot spring. I grew up in a culture of outdoorsiness: we spent school breaks on long trips bicycle touring, kayaking, backpacking, or skiing. The hot springs were my first experiences in nature where we did nothing but rest. At home, I found comfort in a hot bath. When I had a headache or heartache, I'd spend hours in our claw-foot tub.

My parents, both schoolteachers, moved our family of three overseas when they accepted jobs in international education systems. When I was fourteen, we moved to rural northern Japan, where the hot bath culture became a part of our weekly routine. We'd walk past farmland into our neighboring community, with a little pail for our towels and soaps. We'd scrub and shampoo ourselves next to elders, teens, and mothers with their children, our voices hushed in the steam. Then we would enter the pools and soak. As a college student working in food service at a mountain lodge in Idaho, I'd visit a riverside hot spring before or after my longest shifts.

Each hot springs story starts deep underground, where groundwater or rainwater trickles through subterranean faults and fissures, mingling with magma and heated rocks. Pressure forces the heated vapors and liquids upward, back toward the surface. It can take the

form of geysers, fumaroles, and mud pots. Sometimes, miraculously, it creates hot, mineral-rich water of various temperatures and temperaments, some perfect for humans to soak in.

To soak in a hot spring is to be cradled and cared for by the dynamic forces of the planet. It is its own meditation. I love how my body becomes reacquainted with itself in hot water. I love the contrast between hot water and cold air, the way steam and sweat become indistinguishable. My cheeks and skin soften; my muscles no longer tense from thoughts. I can see it in other people, too. Their eyes are less quick, their brows slack. No one ever seems to be in a rush at a hot spring.

Soaking is a singular human experience: it promotes presence, relaxation, and reflection. It removes pretenses and distractions. It gives us the opportunity to be a citizen of nature, ritual, and community. I've learned in my travels that each soaking experience is unique, tied to culture, traditions, and geography.

I'm now a photojournalist living in Maine, where there are no natural hot springs. Most of my projects are magazine and newspaper stories about the ways we humans connect to the natural world. I spend a lot of time with small-scale farmers, fishers, ranchers, foragers, and artists—people who have maintained a strong connection to the land, who understand how much we rely on it for our survival and well-being. They've shown me not only how to live gently with nature but also how rare it is to live that way. I've seen how humans set themselves apart from wilderness, seeing it as something to exploit, dominate, or fear. We've taken for granted the consistent providence of nature, forgotten the everyday natural phenomena that shape our lives with grace and bounty.

I believe that one of the solutions to environmental degradation is to restore our own relationship with land, water, plants, animals, the cosmos, and each other. As more populations urbanize and as technology dictates and commands more of our lives, we need reminders that we exist alongside and within nature. There are many ways to do this but few as immediate and clear as taking a soak in a hot bath, no matter where you are in the world.

This book is an exploration of hot springs and the various, spectacular ways this geological marvel can express itself with the collaboration of humans. Some look like palaces, others like a hole in the ground. Some feel like a party, others like a prayer. But every hot spring has the solace of heat, warm water that holds you and forces you to be present. Every hot spring is said to have healing properties, to be filled with elements dragged from inside the planet. These gathering places form odd communities, giving us a sense of belonging to each other and the earth.

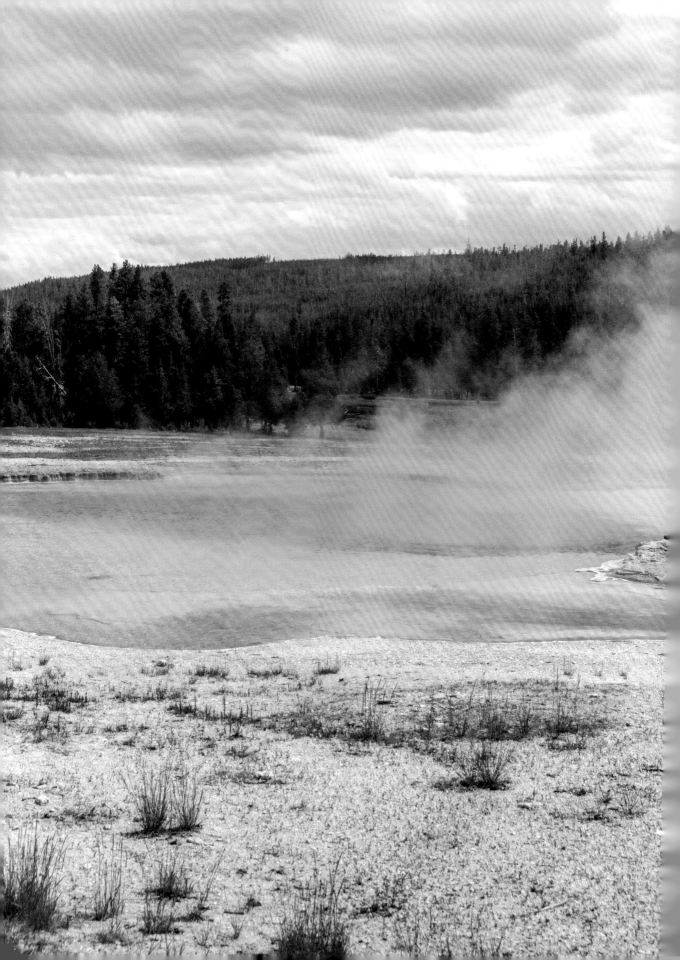

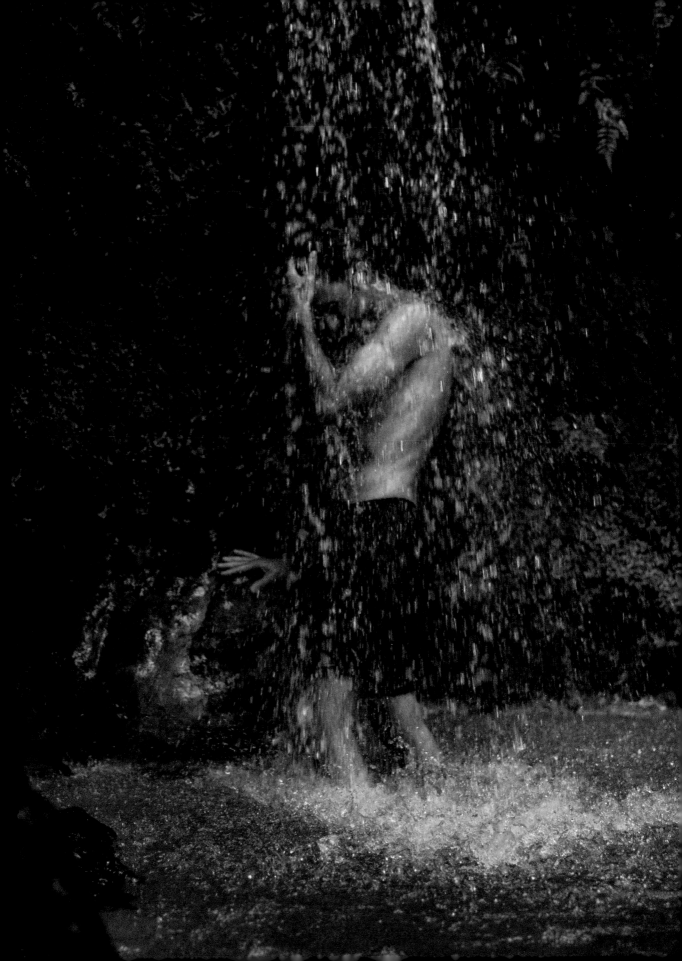

Etiquette and Ethics

As a photojournalist, I focus on telling stories about things I hope to protect: those who harvest our food, humanity's resilience and reliance on nature, those with knowledge of the wilderness in and around us. As we enjoy the beauty of the earth's hot springs, it's easy to forget how fragile these sacred places are. Geothermal ecosystems are home to plants, insects, and microorganisms that have evolved to survive in extreme conditions. They're so precisely adapted to the chemical and physical compositions of their home that they may exist there and only there. Each wild hot spring is part of a geothermal food web, a network of fungi, algae, bacteria, insects, and animals. Humans are not apart from that ecosystem; we are members of the great natural network that includes hot springs. But like the rest of the natural world, hot springs are threatened by human-caused climate change, deforestation, erosion, and overdevelopment.

We have the will and ability to preserve them, as hot springs are worth protecting. They belong to nature first, and to us second. We can use our time at hot springs to remind ourselves of our duty to care for ourselves, each other, and the world around us. The rules of hot springs can be summed up as one little phrase: take care.

TAKE CARE OF YOURSELF.

Hot water is healing. But, like anything else, use caution and moderation.

Before soaking, notice the places where water flows in, and where it flows out. Spigots, hoses, or inflow or outflow openings may need to be adjusted to bring the temperature to a safe level for soaking.

Always test the water with your hand before submerging.

Pay attention to your body, so you can decide when the water is too hot or you've spent too much time in it.

Drink plenty of water, while soaking and after. You may also need to eat before soaking to regulate your energy.

Take a break if you feel light-headed, dizzy, a thumping heartbeat, or nausea.

Don't soak if you are having gastrointestinal issues, have an open wound, or have a contagious illness. Consult with a doctor before soaking if you have cardiovascular disease or if you are currently pregnant.

The areas around hot springs can be slippery. Use hand railings, move slowly, and bring waterproof sandals to navigate them safely.

Everyone is different; you may need to exit before others.

Commercial hot springs are often required to meet water quality standards, but many of the wild hot springs found in nature aren't managed or regulated. Proceed with caution, and shower as soon as possible after soaking in wild springs.

TAKE CARE OF ONE ANOTHER.

Know that your presence at a hot spring impacts others. Some hot springs are places for fun, others are for respite.

Visit in groups that are appropriate for the size and capacity of the hot springs. Leave room for others, and in smaller hot springs, mind your soak time. Others may be waiting for their time in the water.

Match your noise level and behavior to suit the tone of the hot springs. Generally, it's okay to talk with your companions, but keep a quiet, mindful volume.

Always ask before taking photographs.

Hot springs are typically public spaces, naturally welcoming and open to all. When you soak, you will see people of all ages and body sizes. Remain respectful.

There is a platonic intimacy to the experience of soaking, but hot springs are not an appropriate location for sexual expression. As a placard at a hot pool complex in Wyoming says, "Leave your lovin' at home."

Some may bathe nude and others in a swimsuit, and the state of dress while soaking may be a reflection of cultural customs. Follow local norms and respect the personal boundaries of other bathers.

TAKE CARE OF NATURE.

Most of the hot springs in this book are operated by a caretaker. This is intentional, as too many visitors will cause harm if not closely monitored. If you plan to visit a wild bathing space, remember that you are the caretaker for that moment.

Assess the hot springs. If they look poorly cared for or overused, it's not the time for a soak.

Our time at a hot spring includes both the approach and the soak. Be careful to stay on marked trails. Do not trample or harm plants or the soil. Do not remove plants, rocks, or other elements of nature.

While some hot springs are meant to cleanse the body, never use soaps or detergents when soaking in wild hot springs. Avoid using strong lotions or fragrances on a day when you plan to soak. This includes even "eco" or biodegradable products.

Don't urinate in the hot springs. It sounds gross, but it must be said!

Pick up after yourself and remove any trash, including litter left behind by previous visitors.

Hot springs rely on stability and protection, and are threatened by climate change, deforestation, erosion, flooding, fire, and development. This book shares examples of different ways to manage resources, including collective and Indigenous practices that need broader public support. Consider supporting policy and conservation efforts that protect wildlands and hot springs areas.

Be good to yourself and to others. And have fun! Take time to appreciate the unique offerings of each hot spring: its healing properties and landscapes, its history and sense of place, and its sense of solace or camaraderie. Enjoy the journey there and whatever you find when you arrive. Happy soaking!

Adventure

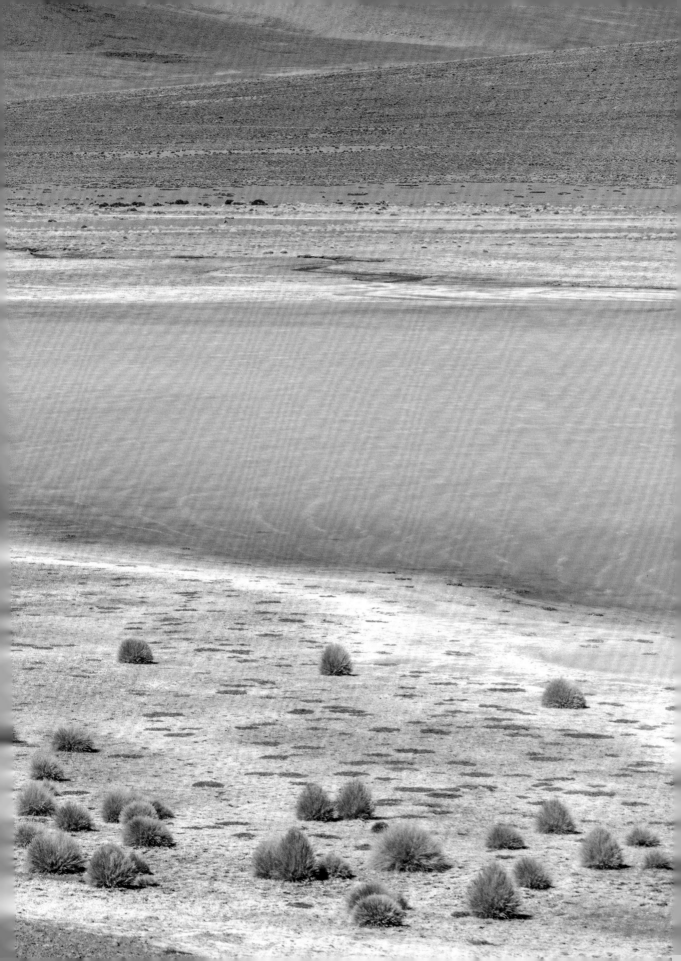

Burgdorf Hot Springs

IDAHO, UNITED STATES

My mother and father got married at a public garden on Warren Wagon Road in McCall, one of the last stops on the western edge of Payette Lake as you leave town toward Burgdorf Hot Springs. My mother wore a cotton summer dress and flowers in her short hair. The wedding was simple, just their closest friends; they'd both been married, then divorced, before finding each other. She was five months pregnant with me, their only child. When I was little, they'd tell me how happy they were that I got to be at the wedding.

They spent their honeymoon at Burgdorf, staying in the littlest cabin, called Busby, at the end of the road. Thus, Burgdorf is the first hot spring I ever went to. We visited throughout my childhood, but only in the summers when the road was passable. Idaho summers are hot—these days, there may be nearly a month of temperatures above 100°F—but the air is cooler at the higher altitudes, close to the mountains. Sometimes, we walked up through the grasses and peeked in through a window of the Busby cabin. Back then, my mother's flower wedding tiara was still hanging in the rafters.

When I think of Burgdorf then, it feels quieter and wilder. Logs used to float on the pool's surface, slick and waterlogged. When someone felt rowdy or competitive, they'd attempt to balance on a log, letting it roll under their feet to test their balance and agility. The game had been passed down from loggers and foresters. Burgdorf has since had a bit of a cleanup and a revamp. But mostly it remains the same: the log-lined pool and its gravel bottom, the smaller pool so hot it's like a test of strength. The main lodge is still there with its woodstove, as is the cluster of cabins at the edge of the forest and the meadow. Frayed AstroTurf still helps make the steps into the hot springs a little less slippery. And it still feels a bit like the Wild West; it's held on to its history.

Fred Burgdorf, a German dairy farmer, followed trade winds around Cape Horn to

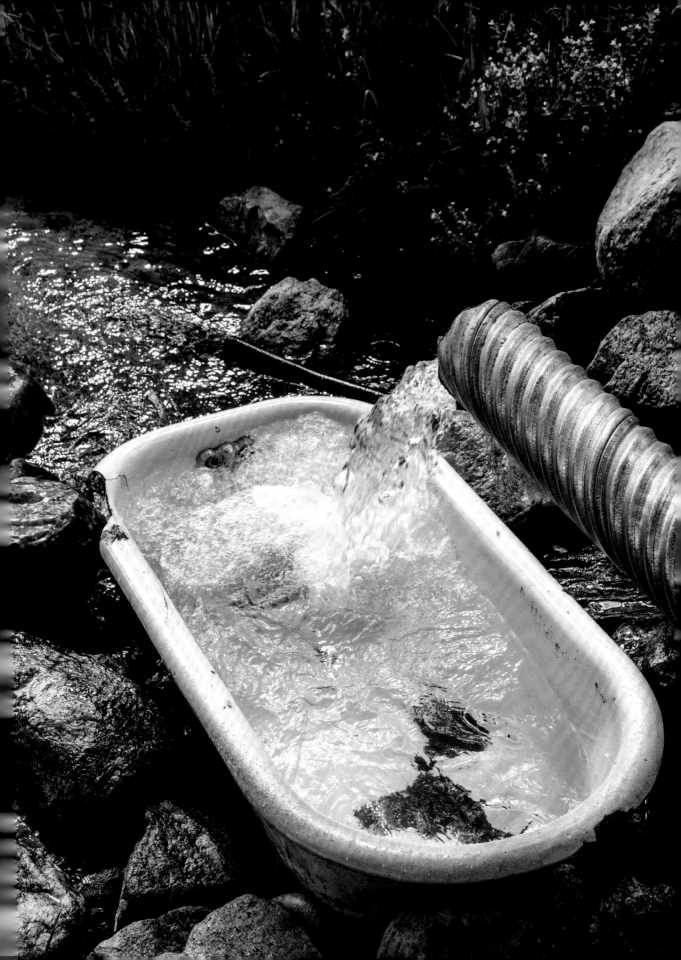

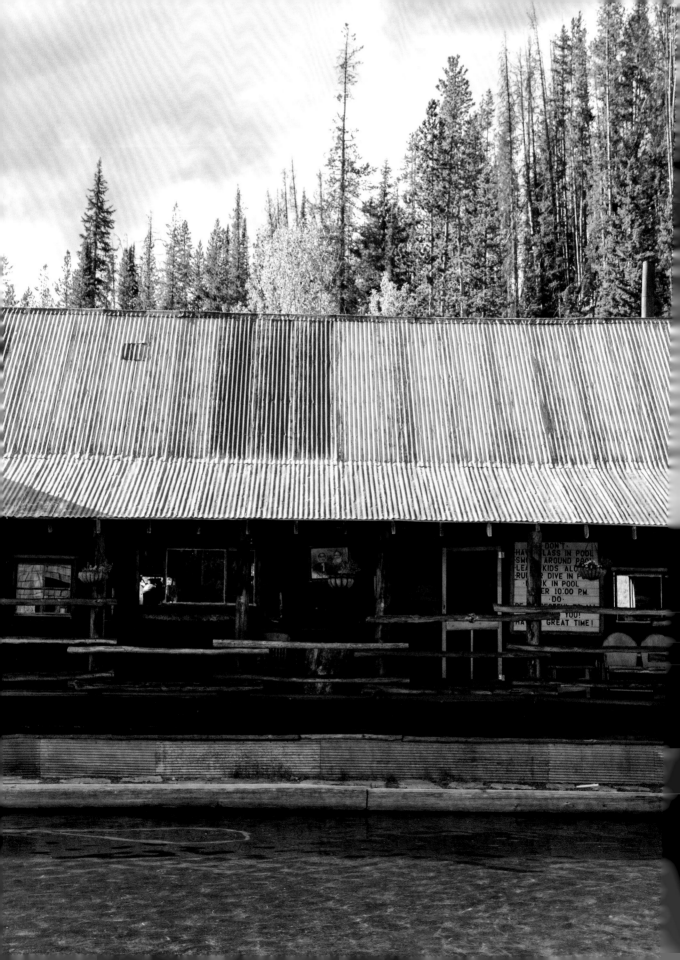

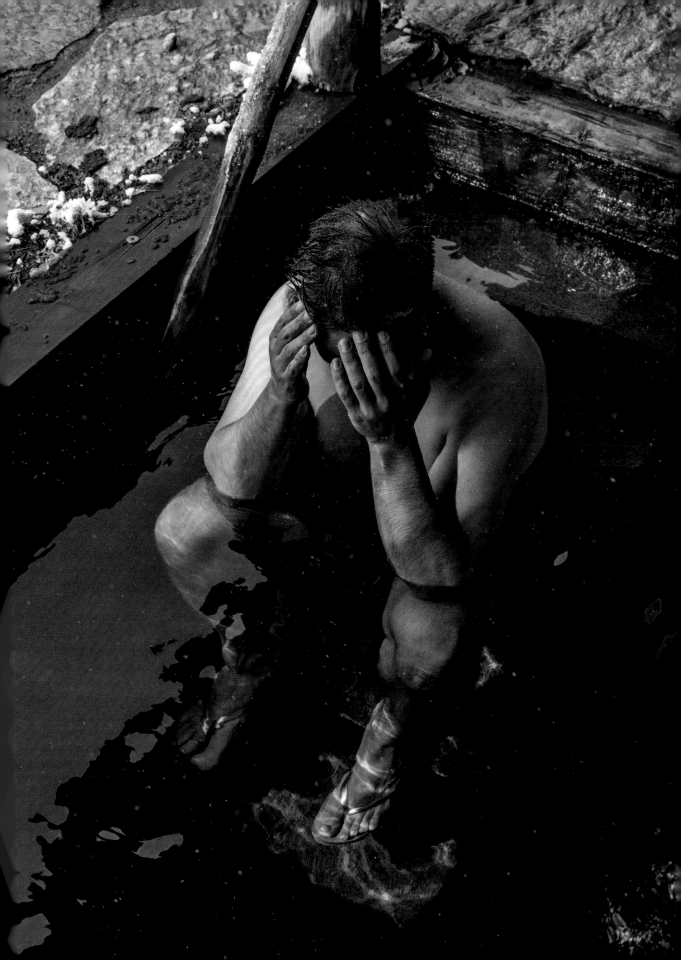

the Pacific (becoming shipwrecked along the way) and found work in San Francisco and Portland hotels before making his way to Warren, Idaho, following the trail toward gold. Instead, he founded a cattle ranch and dairy, and heard of the hot springs from Chinese miners. In the late 1860s, Fred set up accommodations at the site of the springs, situated along a main thoroughfare for wagons, stagecoaches, and horse-drawn sleds. He built a hotel, cabins, and the pool from the forest's logs. He met and married a touring entertainer, a woman named Jeanette. Together, they dressed fancily: she in bustles and he in a suit and white goatee. They were known for their hospitality, seeing to it that there was strong drink, fine food, music, and merriment. At the time, a reporter for a regional

paper wrote about the hotel, "There is not a house on the coast that has a more deserving reputation for good living." The article described bear steaks cooked over an open fire, salmon fresh from the nearby creeks, and confections that rivaled San Francisco's. The reporter went on: "The curative properties of the springs . . . are of the sulfur variety and are remarkable for the almost miraculous cures of rheumatism, inflammatory and otherwise, that have been effected by a course of bathing. . . . Every miner and packer that travel this route can testify to the virtues of these springs."

Over time, Fred's eyesight began to fail and Jeanette passed away. James "Jim" Harris purchased the hot springs in 1923, and Fred could stay there as long as he liked. Today, the hot springs are still managed by the Harris

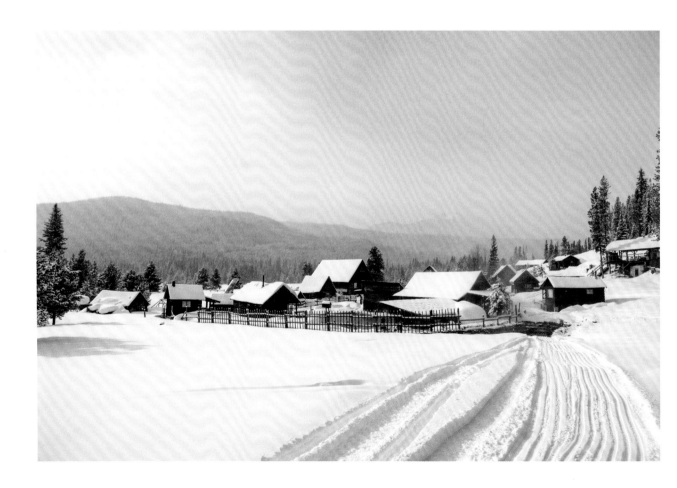

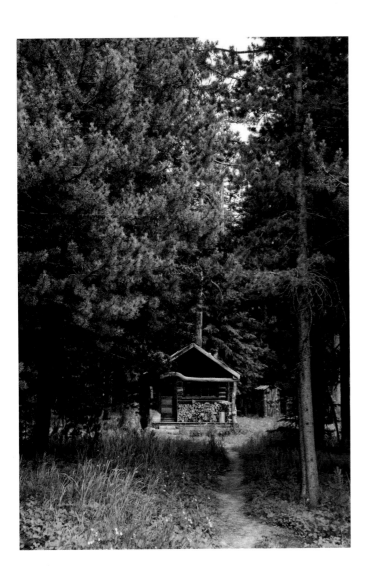

family, surviving personal and historical changes like the end of local industries, the pressures of war, and economic struggle. At times, Burgdorf languished. And then there were times of revival.

In 1967, Jim's grandchildren Scott Harris and his sister took the helm of the management of the hot springs after they fell into disrepair. Scott, along with his wife, Connie, and his young son Nicholas, saw Burgdorf as a dream. They decided to open it up to friends who wanted to stay there in exchange for restoring the cabins. It became a hub for hippies, workers, and musicians. "We followed the golden rule, we offered swims by donation," said Scott. It was a time of dreaming and idealism.

Later, reality struck. The Harris family moved to nearby McCall to pursue careers and the business of raising children. Scott and Connie expanded their family to include Tyler, Andrew, and Lindsey. They worked to put the land in easement to conserve the meadow and forests, and they hired caretakers to manage the complicated day-to-day operations of the hot springs. Caretaking is no easy task, given the remoteness and the demands of guests and old buildings. There is little electricity or plumbing. The nearest store is hours away and for seven months each winter, deep snow makes the road impassable to cars, accessible only by ski or snowmobile. Three times in recent years, the springs were threatened by nearby forest fires, the blazes worsened by climate change.

But for visitors, Burgdorf remains a place of respite, just like in the old times. The cabins are simple: you bring your own bedding and food, a headlamp for the nights. You get used to not using your cell phone and to building fires for warmth. You venture out on the rutted dirt roads or the snowbound path. In the summer, you can pick wild huckleberries, the way my parents did as honeymooners. In the winter, you can watch the frost and snow make sculptures, freezing wet hair in place. You can feel a little wild again.

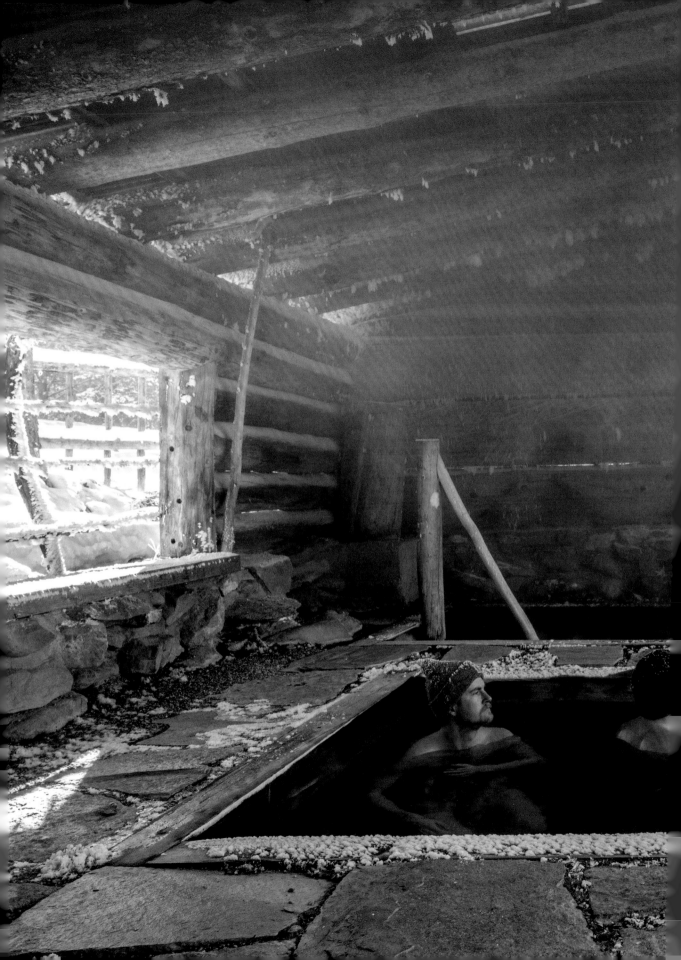

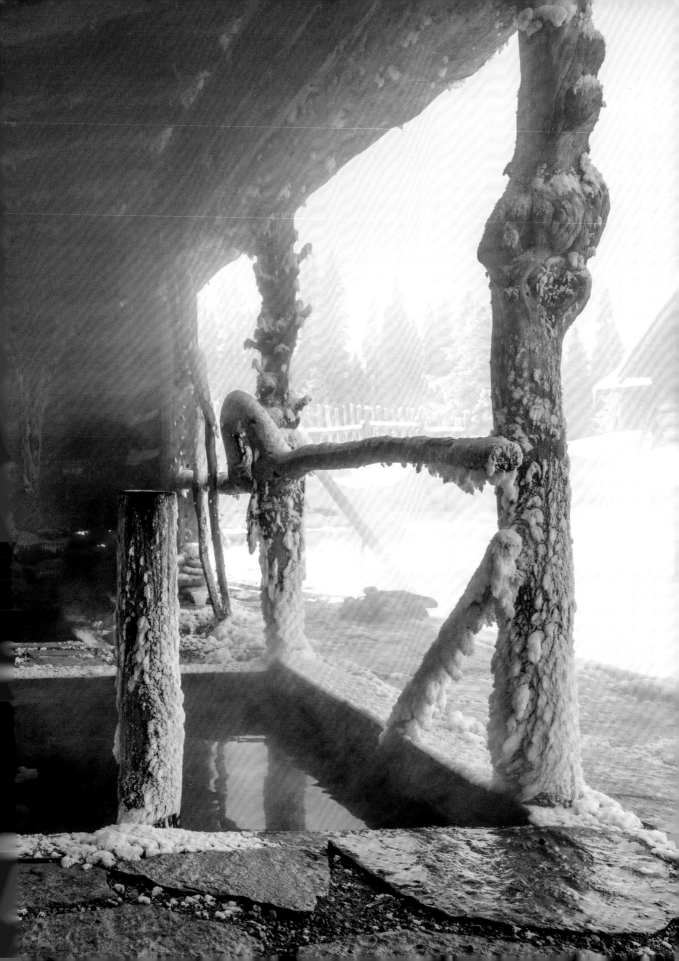

The Highlands Geothermal Sites

ICELAND

Pétur Blöndal Gíslason was cooking a lamb pie when he told me about picking wild thyme in the mountains and hunting for ptarmigan. He's the manager of Hveravellir, an outpost in the Icelandic highlands, a little haven in one of the most desolate landscapes I've ever seen. "Yeah, it is wild here. It's my love for the wilderness that brought me here," he said while chopping vegetables. "This has been a place for travelers for a long time, because the road from the north to the south and back went through here, through the decades. The hot pool is the main reason people come."

He was cooking for the hungry hikers, bicyclists, and travelers who braved the legendary F-roads to make it here. Iceland's inland road systems are unpaved gravel roads with entrances marked with bright warnings: you must have a car with high clearance, four-wheel drive, and a full gas tank. There are no filling stations or facilities, only hours of vigilant driving across desolate roads; you must watch for ruts, creeks, rocks, and boulders. You won't miss your turn, though; you'll see it across the flatness from miles away.

In this area of the western highlands, there are only two signs of civilization: Pétur's huts at Hveravellir and the base at Kerlingarfjöll, separated by an hour or so of moonscape. Set between glaciers, Kerlingarfjöll is a geothermal mountain range that seethes with steam. It was named for a female troll who was turned to stone.

Páll Gíslason, a guide and the now-retired manager of the tourism operation in Kerlingarfjöll, first came to the area as

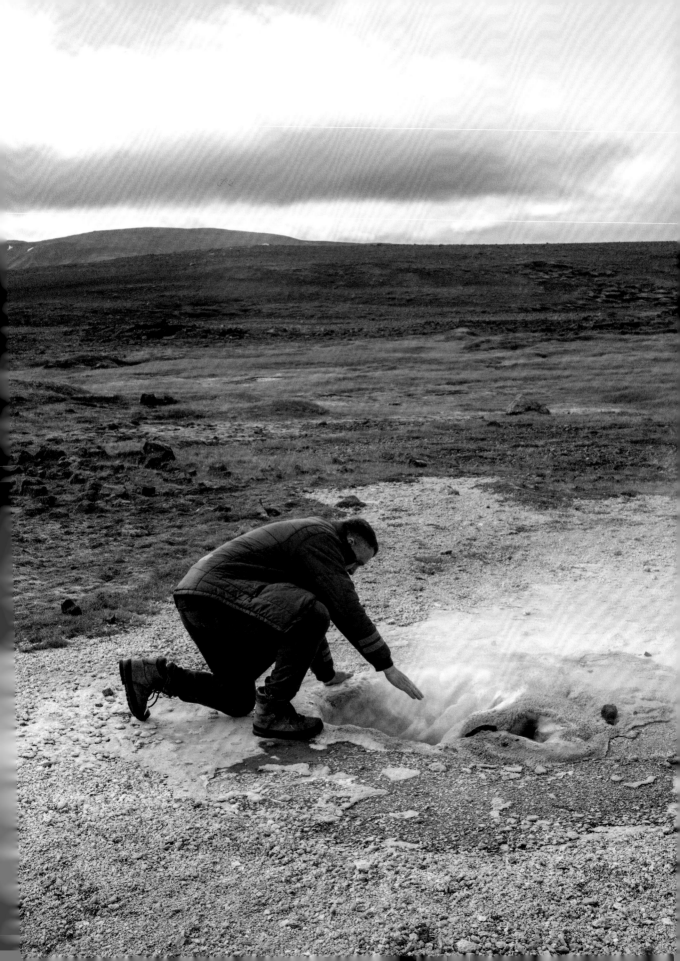

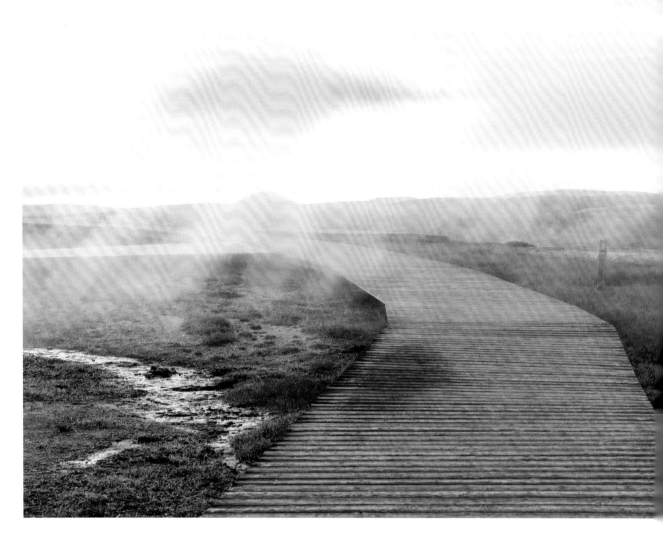

a university student wanting to ski. "Back then ... we had no way of going abroad that wasn't really expensive," said Páll. "But in the late '70s, early '80s, people began to value vacations even here within Iceland." In the early days at Kerlingarfjöll, there was only a simple hut for those who brought their own sleeping bags and wanted to stay the night. Over the years, the operation has expanded to include a little café in an A-frame hut, a hotel, a communal kitchen, and recently, a small hot spring along the river valley.

Hveravellir is settled into a stretch of flatness, mountains rising in the distance. Beyond the main lodge's parking area is the original hut, built in 1938. It still has cozy wooden bunk beds for weary outdoorsy folks and a little kitchen to cook provisions. From the main sleeping quarters, a window looks out on the soaking pool, just below the hut. People strip down, maneuver carefully across the slippery rocks, and settle into the water while their glasses steam up or swim trunks billow.

Up the hill is a colorful array of fumaroles and geysers, boiling and bursting on either side of a boardwalk. Pétur glides his hand through a vent of steam; he has a comfort with the heat that comes from his many years here, first as a traveler and later as a manager and owner. He tells me about NASA scientists who

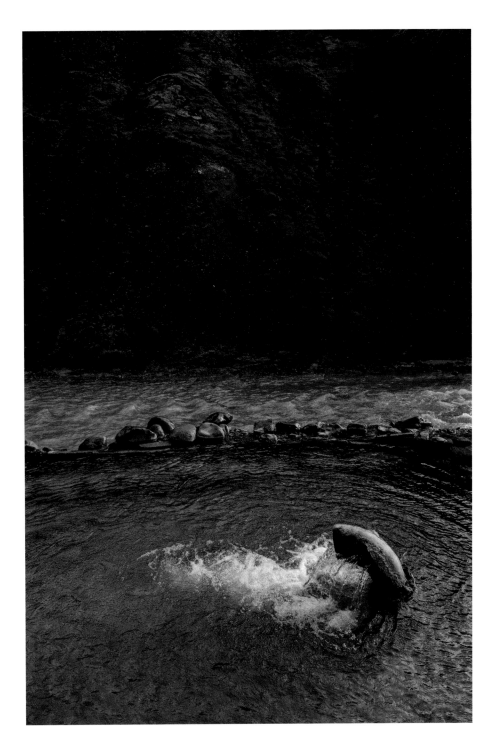

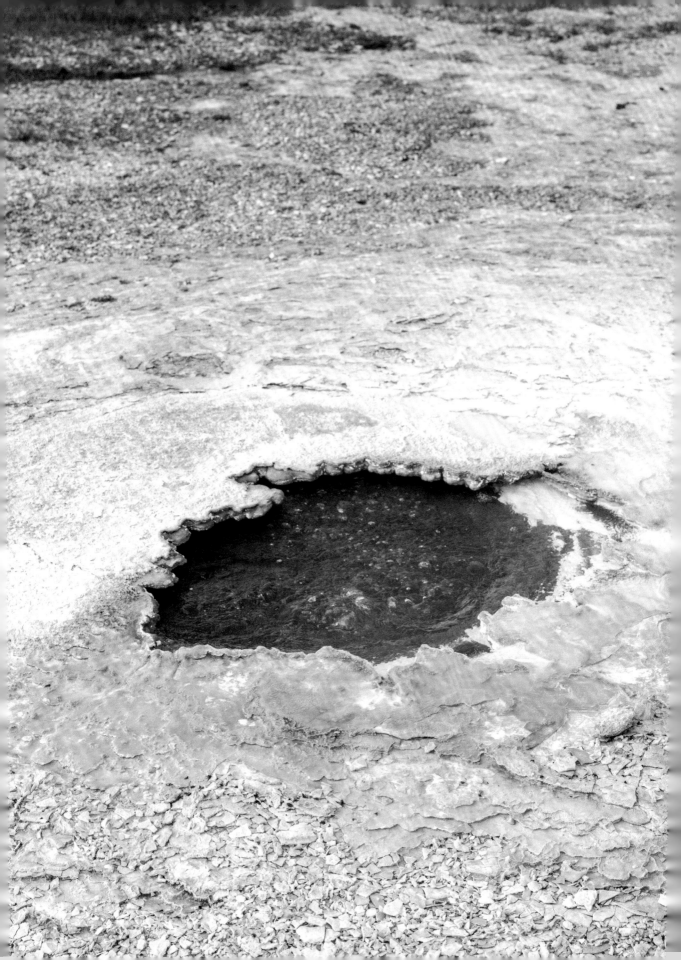

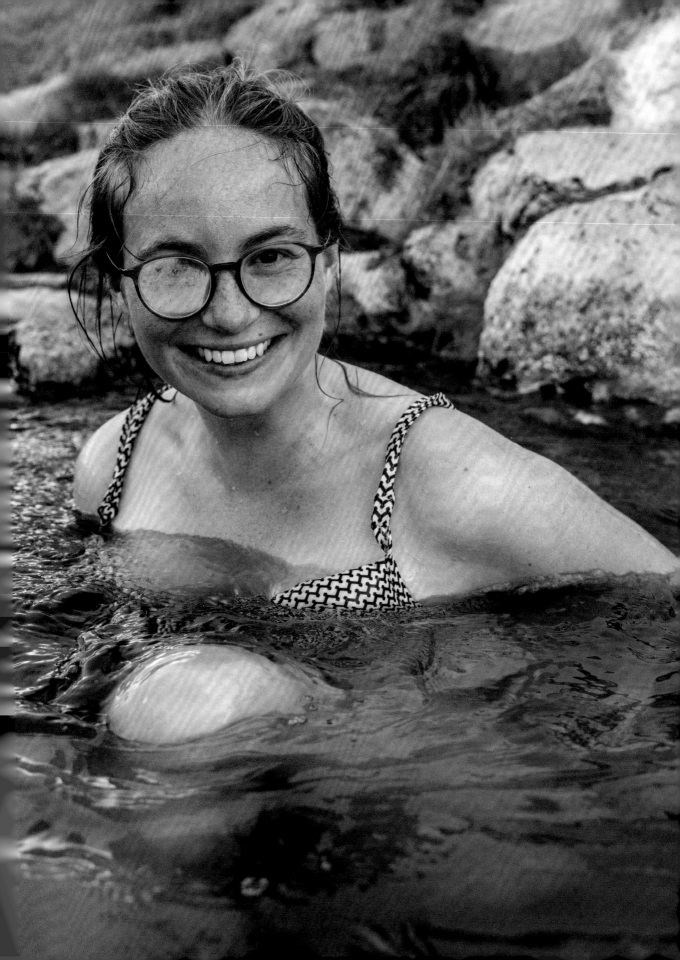

came to study the nearby landscape to learn about Mars. And then he tells me the story of the first people who came to Hveravellir, considered Iceland's Bonnie and Clyde:

The first settlers were Fjalla-Eyvindur (Eyvindur of the Mountains) and his wife, Halla, who came in the seventeen-somethings. They were outlaws, they lived off the land. They harvested the hot water and used the formation of the hot lava and small caves for shelter. They lived life on their own terms. He was a handyman with everything, he would create things with nothing. Here, there is so little of what you need for living.

But he caught sheep and preserved their meat, he made baskets with just the materials in the landscape, and he made them waterproof. No one knows how he made them that way. Later, they were captured. Halla, Eyvindur's wife, was being held prisoner and she was getting old. One morning she came out of the house and it was a beautiful day and she was scanning the area, and she said, "Today, it must be so beautiful in the mountains." And they never saw her again. She is believed to have gone to the mountains one last time, to die.

To love such a landscape requires an intimacy with discomfort; to remain acquainted with the elements, hunger, and fear. I saw bicyclists riding along the F-roads, spattered in mud. I met hikers taping their blisters before their first bite of lamb pie at Hveravellir. For them, like Halla, it was worth it to feel their bodies come alive on the uphills, to see the celestial drama of the northern lights, to feel the coolness of the wind off the ice and the warmth of the hot pool. Every day, it is beautiful in the mountains.

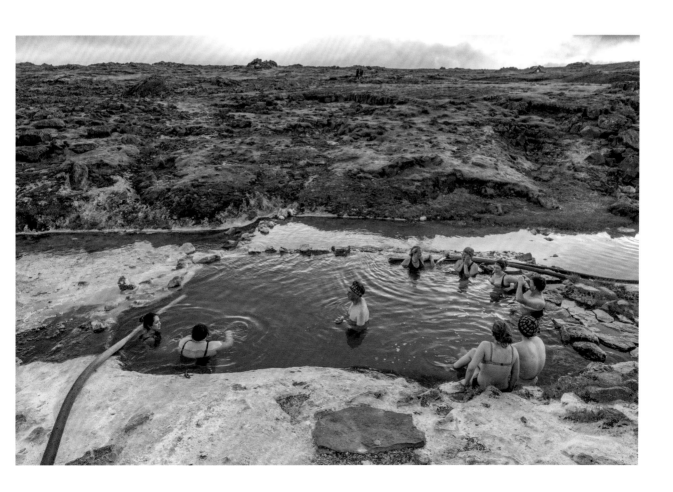

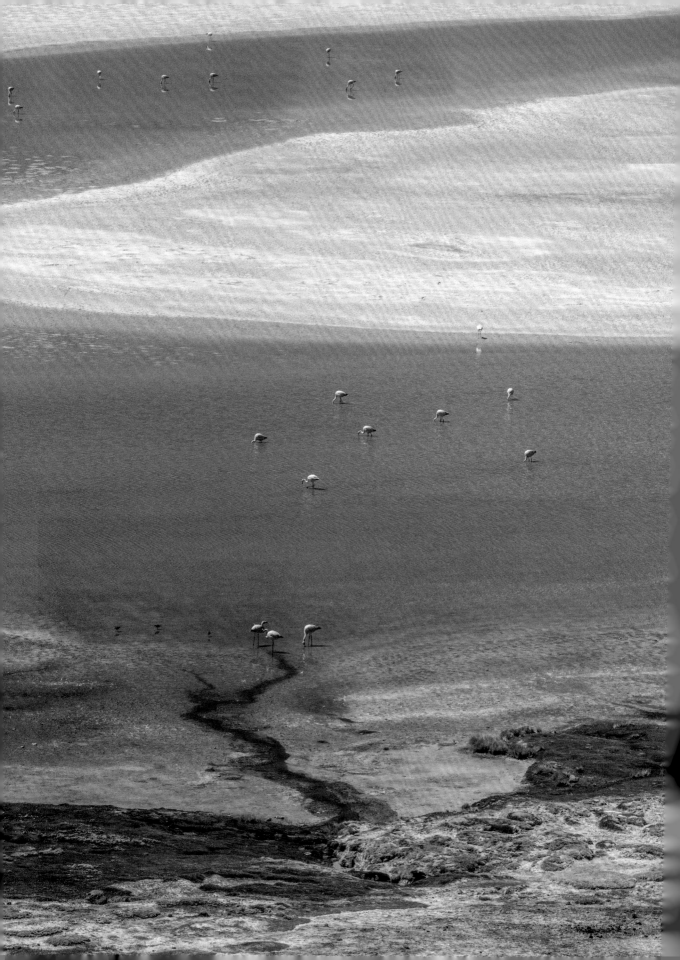

Potosí Region Hot Pools

BOLIVIA

I traveled to Bolivia with my friend Tess, a Californian who moved to Maine and who taught me to surf in the cold North Atlantic. We always said we'd go on a surf trip together, but instead we ended up in Bolivia, entirely landlocked, in search of hot springs. We visited the Potosí region in the southwestern part of the country, an area known for Salar de Uyuni, the world's largest salt flat: a glittering four thousand square miles of blinding, crystallized white. It's the mineral remnants of a prehistoric lake, visible from space; a favorite of tourists like us who hire guides to drive across the nothingness.

Our guide instructed us on all the ways to pose for photos in a place with such strange perspectives, ways that made me seem huge and Tess tiny, and vice versa. He showed us the places where a few inches of water over the salt made the flats look like a mirror, and where it sparkled like a disco ball.

Before venturing to the wild and remote hot baths of Eduardo Avaroa Andean Fauna National Reserve, we spent a day exploring the small, municipal hot springs in nearby communities around Uyuni. In the hillsides to the east of the salt flats, there are bathing places for community members to wash both their bodies and their laundry. At Aguas Termales Sayarani, a short walking distance from a rural neighborhood, there are two washtubs and some clotheslines near cement pools. At Aguas Termales de Calerias, the larger pool was packed with children on a school field trip, laughing and splashing. And at Aguas Termales de Tomave, a spade-shaped pool overlooks an ancient but functional grain mill powered by a small stream. As we drove through the area, the wind whipped up dust devils. We watched out the windows for condors.

Eduardo Avaroa Andean Fauna National Reserve is in Bolivia's southwest corner, an all-day drive from Uyuni with a stop in the mining town of San Cristóbal for snacks. In the reserve, the established road disappears,

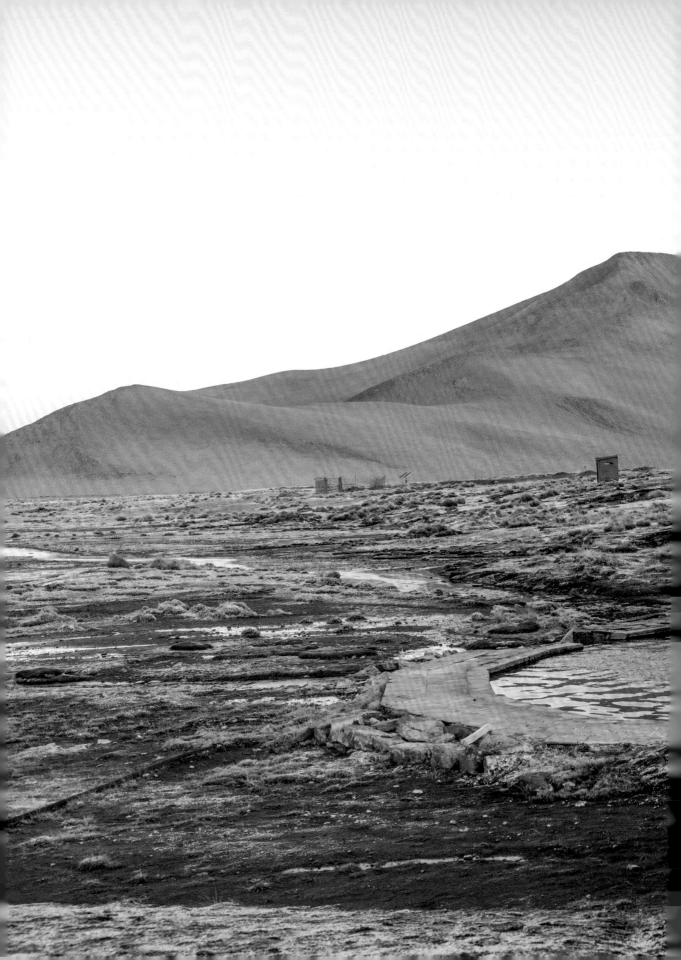

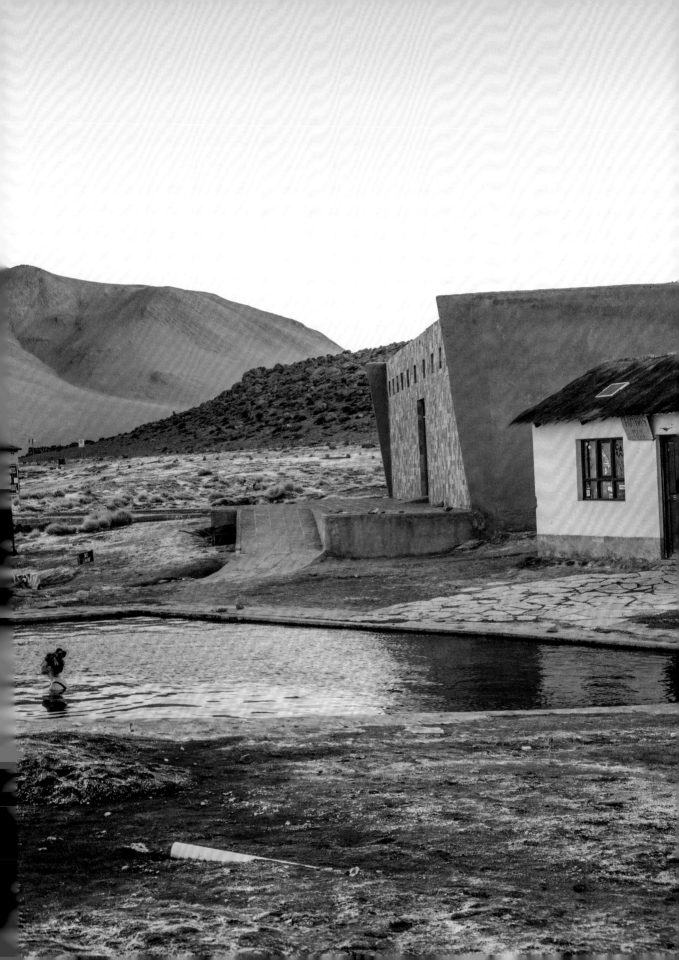

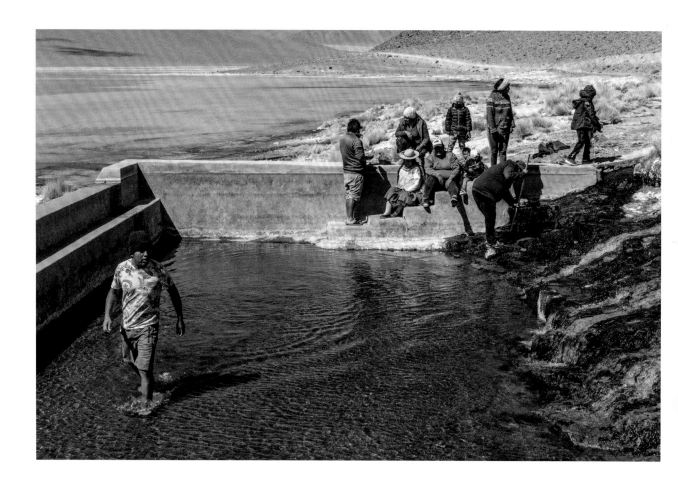

replaced by faint, wind-whipped tire tracks across red sand. Visitors are admitted only with approved Bolivian guides, and tour groups leapfrog along in 4×4 Toyotas, making the same stops: the rock formations for picnic lunches, the four lagoons, a tree-shaped stone, and finally, the entrance to the reserve, where credentials and passports are logged. The way there feels mysterious, each turn feels arbitrary and surprising. There are no signs to point the way. Our driver, Victor, makes turns by memory; he has spent the past twelve years driving variations of this route.

The reserve looks like the surface of the moon or Mars. It's surreal and disorienting. Being in such a place feels irrational; the

distances are so long, the nights so cold. The water doesn't run in rivers or pool in potable lakes. Instead, the landscape is a palette of lagoons in pink, red, white, and green—crusted in salt, borax, arsenic, or algae. Flamingos congregate in certain lagoons; the shores are lined with their fallen feathers. The rest of the world—its cities, oceans, and forests—feels like an alternate reality, one that couldn't possibly exist on the same planet as a place like this.

Within the park, Termas de Polques is often the last destination for visitors: a small hotel and a shallow thermal pool are situated between a parking lot and Salar de Chalviri, a desolate salt flat. We arrived at sunset, and

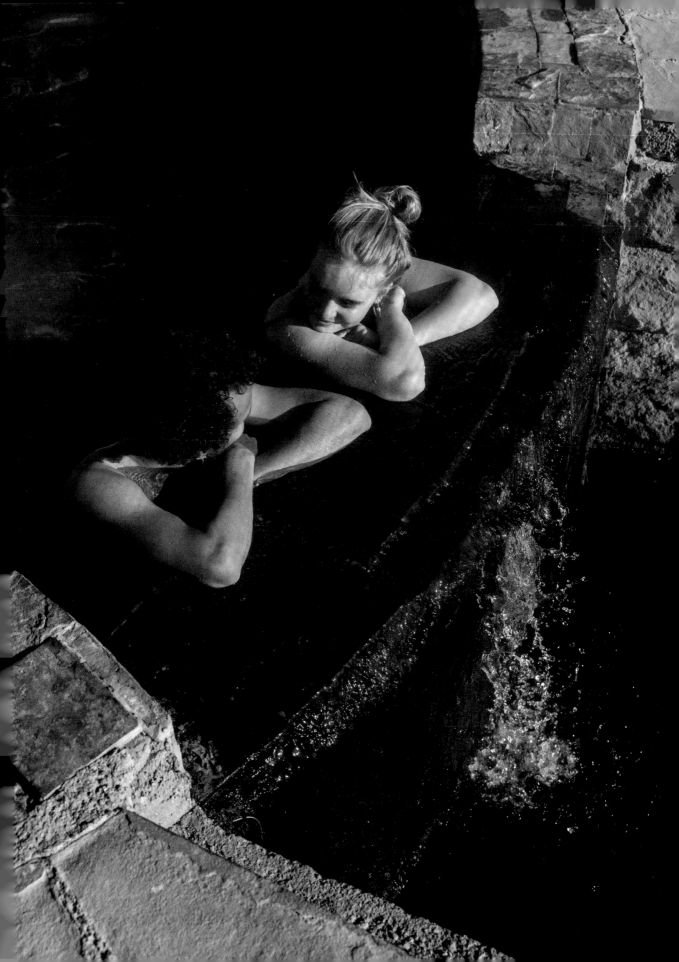

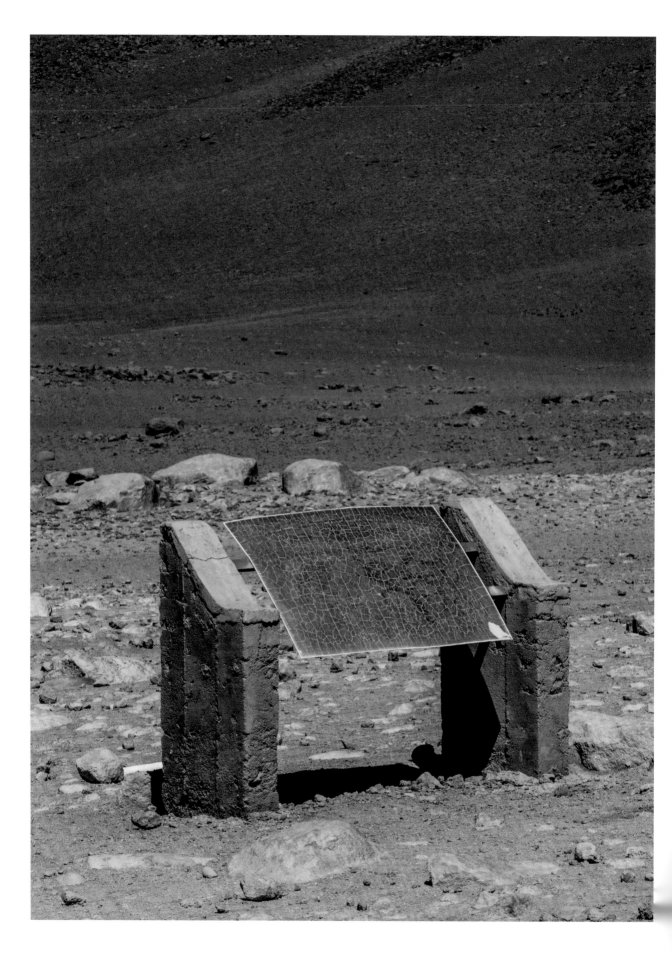

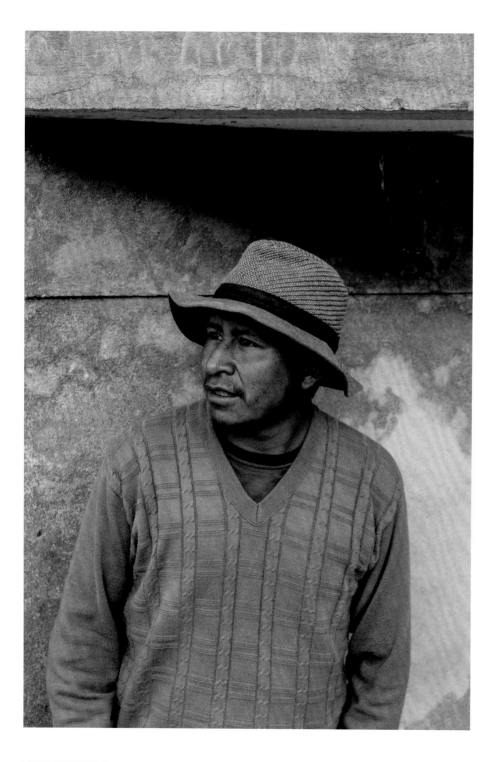

Tess and I rushed to the pool to watch the sun settle and the stars emerge.

In the morning, we sought out one more hot spring, one that had gone viral on social media with a single photo that showed someone floating languidly on the surface of a rectangular pool, the candy-colored landscape beyond it. We found it on the side of the main road, drained of water but bustling with people with tools and shovels. The local community had shown up to work on the pool together, folks of all ages taking turns scrubbing the cement walls and floor of the springs, pausing every so often for slices of watermelon. We chatted a bit before embarking back across the painterly, unearthly landscape.

It took another full day to get back to town; for hours we watched the desert and rock formations and strange water bodies from the vehicle. Driving across such rough terrain is loud: the 4×4 rattles and jostles. Noise drowned out our voices and eventually we fell silent. It was not unlike surfing, where we regularly pause to pursue a wave, our friendship formed by the rhythms of nature.

Ponta da Ferraria Ocean Hot Springs

AZORES, PORTUGAL

People strip into swimsuits, their rumpled piles of clothes and towels dotting the black rocks. Thermal water eases into a rough notch in the rocky coastline, a hot spring within the ocean. Waves rush in, bringing cool water toward the land, sucking the thermal water toward the sea. Salt water in, mineral-rich volcanic water out. The small thermal cove can only be accessed at low tide, when the waves aren't too wild and the hot water isn't too diluted by the rising sea.

A simple metal ladder leads to the little cove of warm water. Gulls and other seabirds wheel and whirl above. Heat ebbs and flows with each set of waves. Ropes hover above the water's surface, and people hold tight. The ropes provide bathers stability as the waves move bodies like strands of kelp. Swimmers audibly gasp and cheer as each wave approaches. It feels daunting, being at the edge of nature like this. The waves move your buoyant body and reacquaint you with the push and pull of the sea.

The Azores are an archipelago 1,130 miles off the coast of Portugal. In addition to the naturally occurring hot baths, the locals have created "piscinas naturais," or natural seawater swimming pools, in the rocky shorelines. Built up with stones and cement, the pools are filled by the waves and tides. There are over a dozen of such human-built seawater pools around the islands. But Ponta da Ferraria's unique shape was created by the earth's forces.

There are 1,766 volcanoes in the Azores, each of the nine islands formed by their eruptions. Ponta da Ferraria is set on the westernmost point of São Miguel island, where green-capped volcanic hills slope sharply toward the ocean. A series of eruptions has left behind a pseudocrater, a lava dome, and basalt columns. Volcanic land-slides or lava flows created a "fajã," a flat

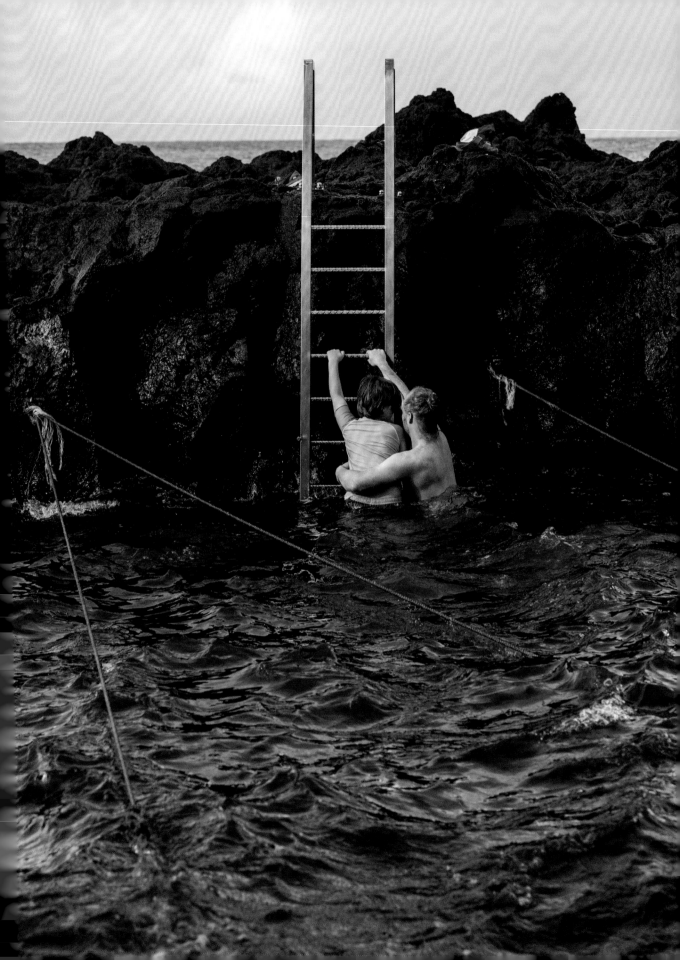

volcanic debris field that reaches seaward. There are few fajãs outside the Azores.

The hot spring itself is a volcanic fissure, a remnant of geologic upheaval and chaos. "Ponta da Ferraria was formed by this recent geological event," said Professor Isabel Soares de Albergaria, who studies the history of landscapes. "It's a very recent place. . . . The road has only been there for maybe thirty years. Before that, people went there on foot or on donkeys."

All along the coastline, the sea is wild and hostile, the waves too volatile to be approachable. The natural pool is a haven, protected and warmed just enough for safety, twice each day. As the tide shifts and warm water becomes too inundated by cold seawater, people climb the little ladder up and over the ledge of black rock, with the sea still surging below them, shivering in the wind, wrapping themselves up in towels and wringing water from their hair.

They are animated by adrenaline. They look a little wild-eyed and addled by wonder. Some hot springs are a reprieve from life, a way to pause and rest. Others are a way to feel more alive, to engage and interact with a wild world. Ponta da Ferraria is the latter. This is a place for the part of us that seeks out the thrilling, the tumultuous, the electrifying.

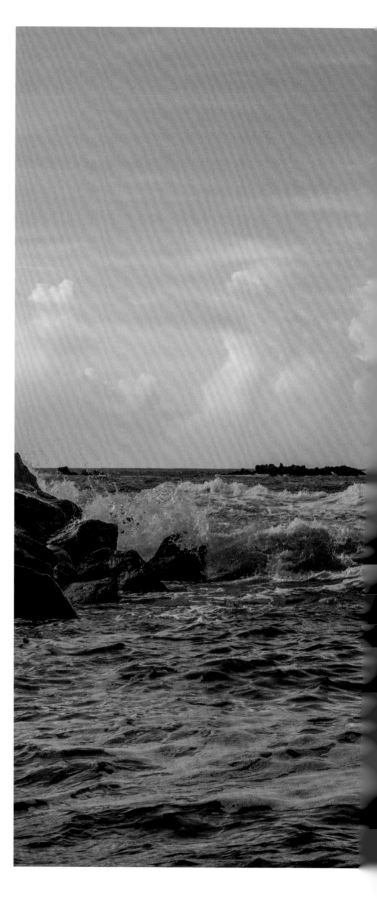

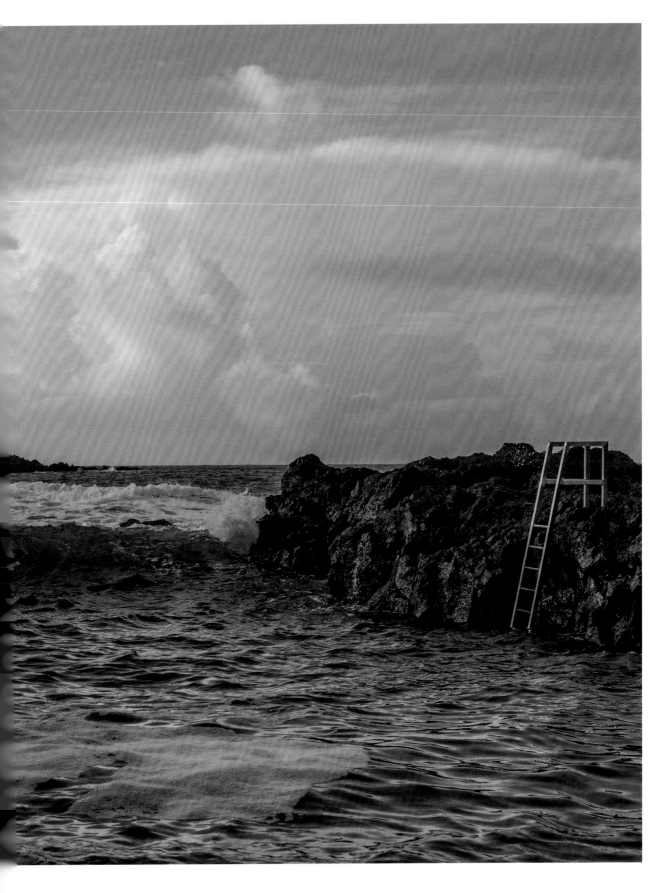

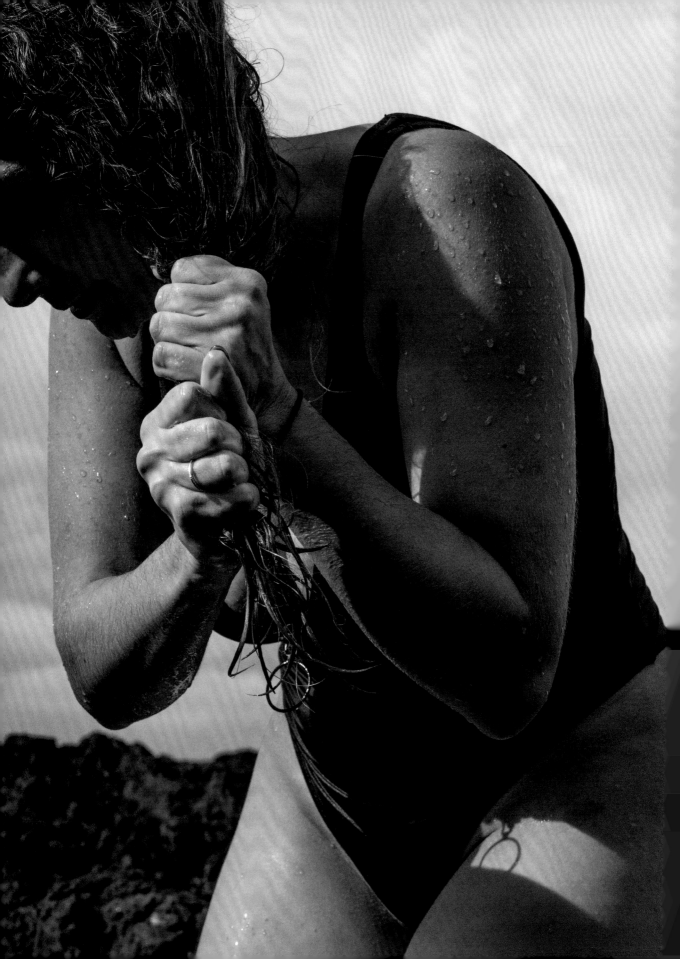

The Great Basin's Wild Hot Springs

NEVADA, UNITED STATES

In Nevada, the mountains seem endless. With 314 named ranges separated by deep valleys, the spines of the mountains scrape upward, with tilted, layered strata that present and clarify the geologic timescale. They've withstood a million years like it was a blink, a blip. Clouds throw wide shadows across the valley floor, creating the dark illusion of lakes.

Water here is scarce, with only ten inches of rain expected each year. The Great Basin—which encompasses Nevada and stretches beyond to parts of Utah, California, Oregon, and Idaho—is a place where water flows in, but not out. Within the basin, water moves, pools, or evaporates but never travels to the sea. Despite the aridity, life has adapted to this landscape.

Most mountain ranges in this region sit above an active fault that pushed them above the surrounding flatness. At the feet of the jagged ranges unfurls an endless sagebrush sea. The sage expanse turns to juniper, then piñon and aspen, and eventually, clusters of unfathomably ancient pines at the highest altitudes, where the air is thin and cool. At nearly five thousand years old, bristlecone pines have survived storms, earthquakes, and the harshest of environments. In another part of the state are the nation's oldest petroglyphs, their origins estimated to date back ten to fourteen thousand years. This land is home to the Washoe, Numu (Northern Paiute), Newe (Western Shoshone), and Nuwu (Southern Paiute) people.

In the summers, it can get so hot it dries the spit from your mouth; in the winters, so cold it cracks open the skin. This state contains the chaos of Las Vegas, the mystery

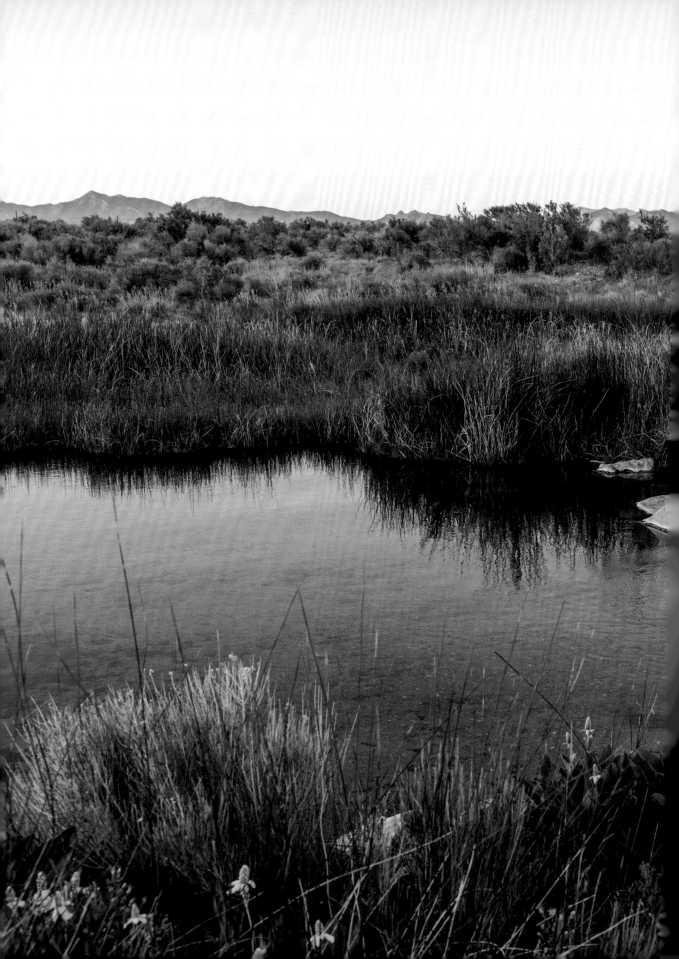

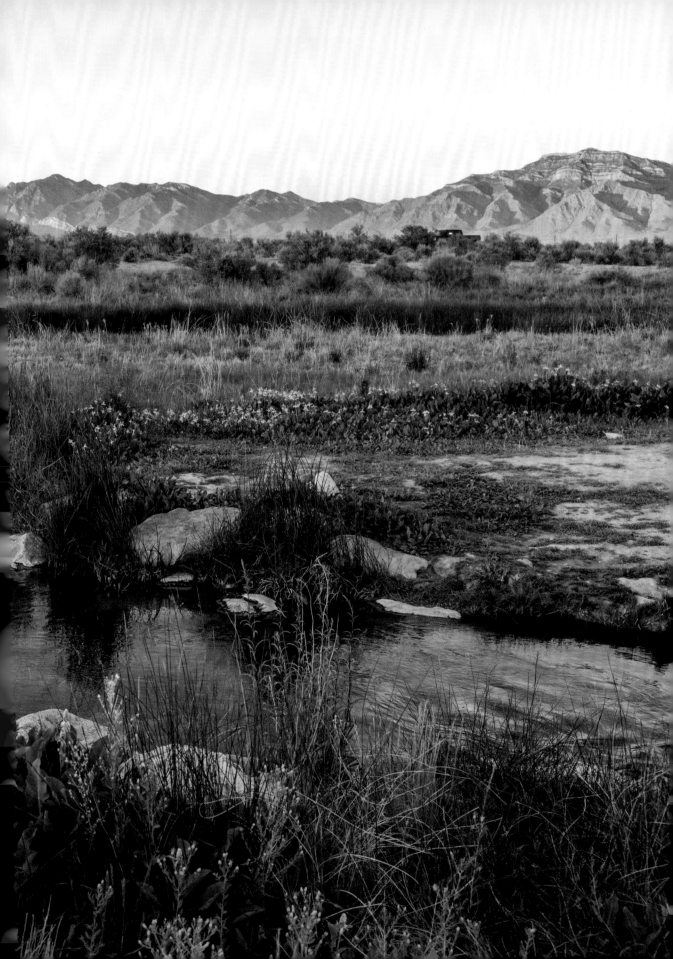

of Area 51, and the placidity of the high desert. Here, you can use an iPhone to navigate to the oldest human etchings and the most ancient living beings.

Nevada is the country's most geologically active state, home to the most hot springs in the United States. While there are over three hundred natural geothermal springs here, only about forty of them are safe and accessible for soaking. Most of the hot springs are wild, simultaneously in danger of overuse and somewhat of a secret. Especially so in Nevada, where getting to many hot springs requires a four-wheel-drive vehicle and detailed directions from a local. At one location, a visitor scrawled "Use common sense! Don't be a jerk!" on a water pipe. Following that directive, the names of the specific hot springs won't be mentioned here.

There is one hot spring that is more like a hot creek, a turquoise river of lukewarm water. Another is a deep tub that looks out over Joshua trees and jackrabbits. There's a hot spring shaped like a heart, a hot spring in a repurposed cattle trough, a hot spring in the desert made famous by Burning Man. Each requires a spirit of adventure, some research, and a bit of chance. They can be well maintained or recently trashed by careless visitors or roving livestock; the roads can be too rough for passage, the climate too hot in summer or too frigid in winter. But when you time it right, the air is scented by wild sage, the silence so pure you can hear your ears drumming. At sunset, wild burros come to drink, the descendants of donkeys brought by prospectors during the days of boom and bust. At night, the stars emerge bright and unhindered from light pollution.

A pamphlet in a Nevada motel suggested going out for a "wonder-wander," an excursion to just see what you see, go where you want to go. Much of Nevada is Bureau of Land Management land, open to the public for camping and hiking. No need to follow a trail or use an established campsite; just look out for snakes and clean up after yourself. If you head out to wonder-wander by car, tune in to Radio Goldfield, run by volunteers in a town of just a few hundred who put together shows

like *All New Tumble B Weed Show*, *The Desert Rat Show*, and my favorite, *Madam Edie's Early Country Western Show*. The station calls itself "The Voice of the Old West," and when Edie spins Kitty Wells, Marty Robbins, and Ernest Tubb, that seems true. This place feels ancient and vast, like time itself has skewed or cracked open. The landscape provides a proximity to days bygone, a rapport with the primordial, a portal to the past.

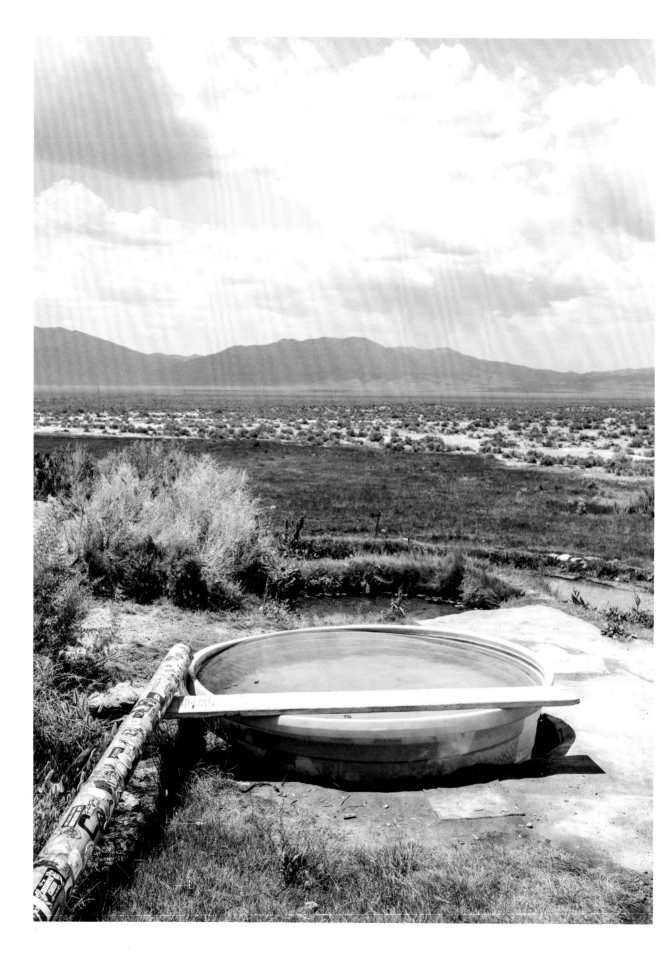

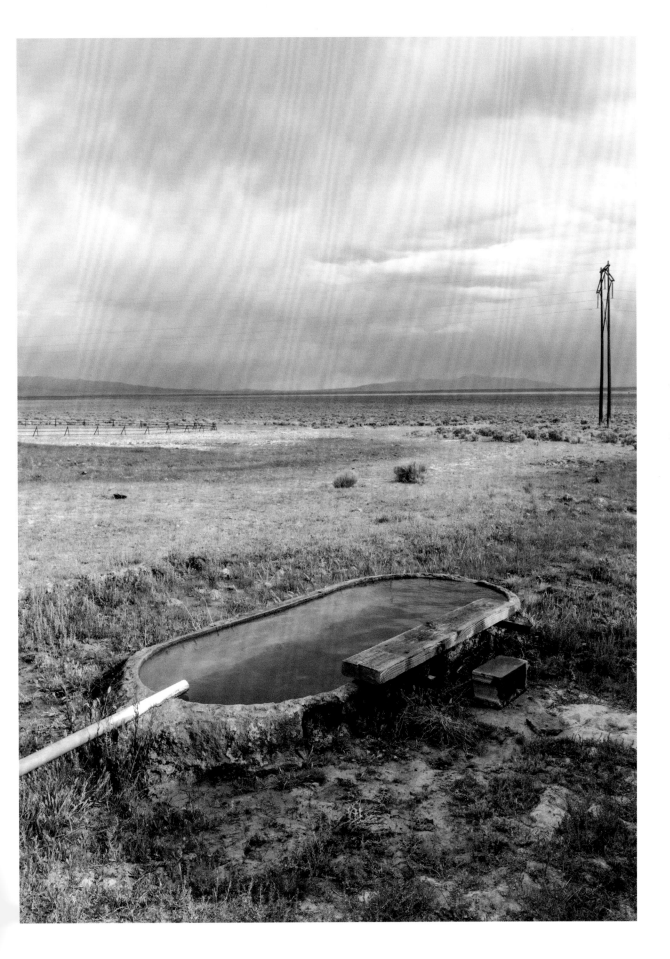

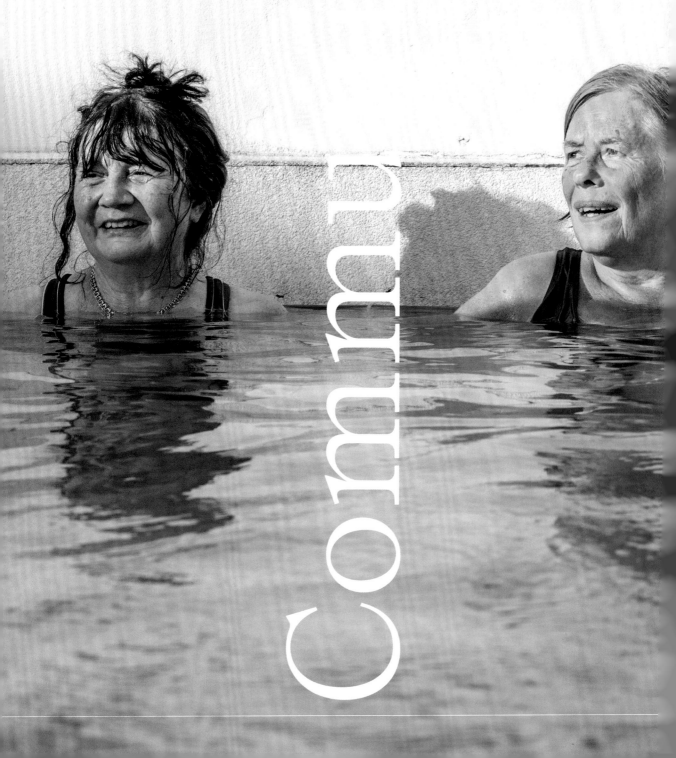

Commu

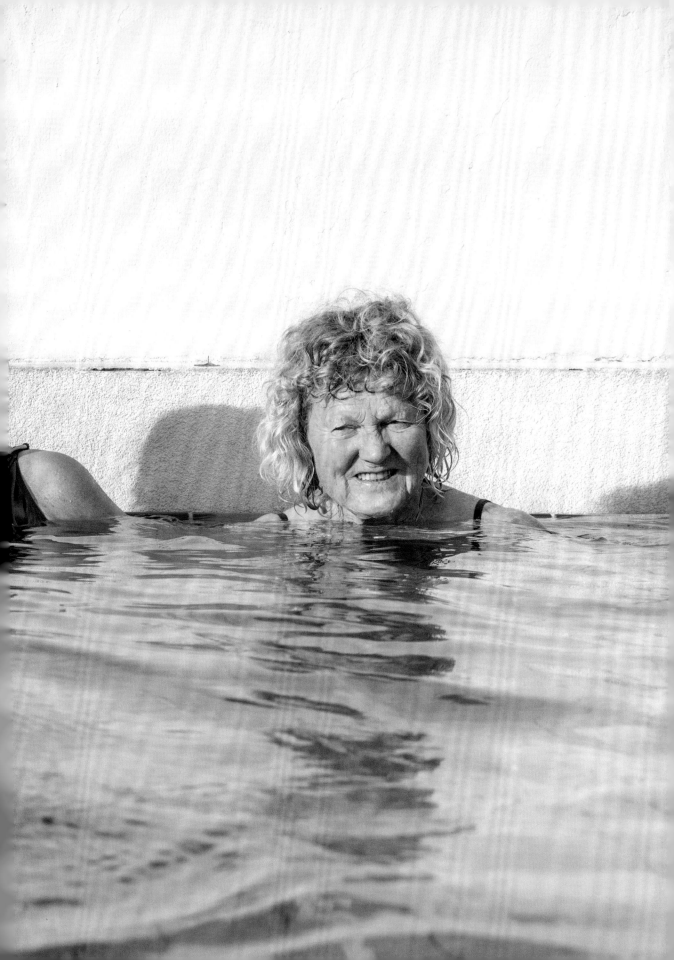

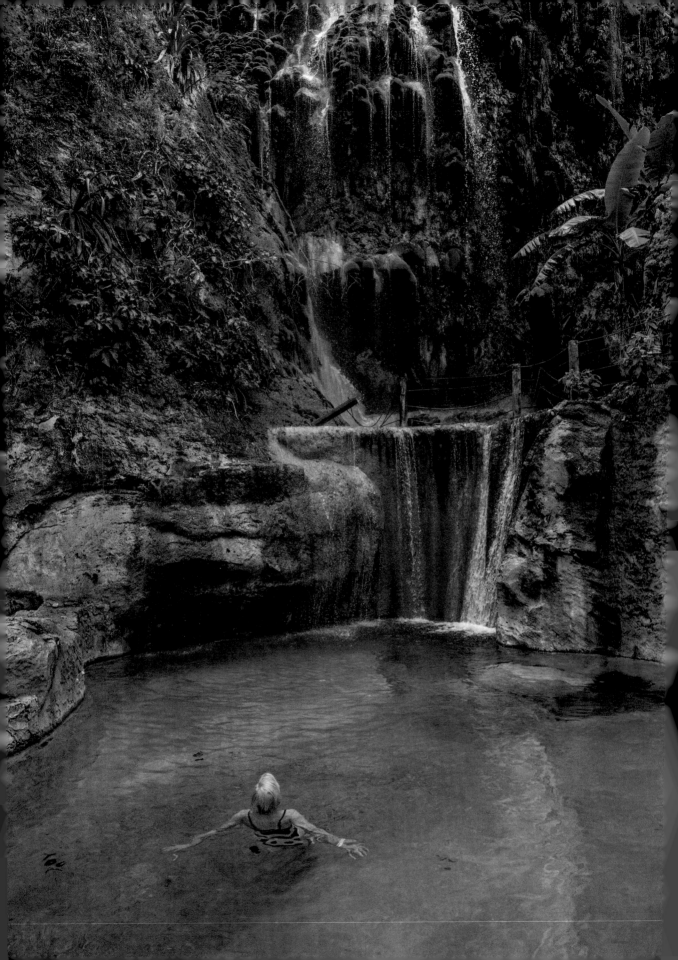

Grutas Tolantongo

MEXICO

Grutas Tolantongo is an intricately designed network of pools, pipes, and paths that nestled into a steep hillside. Warm blue water fills the highest pool, then spills over into a lower pool, cooling slightly as it descends. The curving structure is sophisticated, looping like lace. It's a marvel of design. In total, there are over eighty pools here, depending on who you ask, with more being built. I lost count at fifty.

The main water source is a large cave at the end of the canyon, set behind a lattice of waterfalls; the cavern drips with water like rain in a thunderstorm. At the bottom of the valley winds a warm, milky-blue river.

The hot springs, and the area beyond it—which contains acres and acres of farmland and the nearby town of San Cristóbal—are all part of an "ejido," a form of collective land-ownership. The ejido system was established during the reform measures of the Mexican Revolution in the early twentieth century, restoring land rights to farmers and dissolving private estates held by the powerful and wealthy. The right of Mexico's Indigenous communities to own their own land was at the heart of the revolution, whose slogan was "Tierra y libertad": Land and Freedom. With landownership came the ability to grow food, to have self-determination and self-sufficiency. The land was returned to the descendants of the original inhabitants, with decisions, obstacles, and resources shared among them.

The Ejido of San Cristóbal is the cooperative that includes Grutas Tolantongo. It started like most ejidos: with land and agriculture. Working as a team, the members grew a small orchard with avocados, lemons, oranges, and bananas, that thrived in the warmth of the

It takes four hours to get from Mexico City to Grutas Tolantongo, a drive that takes you past circus-style tents selling barbacoa, sprawling suburbs, fields of cabbage, and busy public markets. As Grutas Tolantongo nears, roadside stores appear, selling inflatable pool floaties and water shoes. The road pitches up toward the mountains, then down eighteen steep switchbacks into a box canyon. At the entrance gate, a man hands out a map depicting pool structures, hotel complexes, restaurants, offices, the river, waterfalls, and grottoes.

springs. In the 1970s, they began constructing a road so that others might be able to experience the waterfall, the river, and the grottoes.

In the cooperative, there are roughly 130 "ejidatarios," or decision-making members. The ejido provides employment to them, their families, and others in the community. The work is shared, too: everyone pitches in, and everyone takes on a role. But every year, that role changes. During an annual event, names and positions are selected at random using a tombola game, like in bingo. One year, someone could be cleaning bathrooms and the next, managing the souvenir shop or tending the fields. This way of working allows for a more educated and diverse life and better informs community members to make decisions for the whole. "In some Indigenous communities, people need to learn different aspects of the whole community," said researcher Jozelin María Soto Alarcón, who studies feminist political ecology and community economy. "If they do not have experience, they cannot become a leader; they need to learn and practice."

The ejido system is connected to "buen vivir," or good living, a concept and practice based on a Latin American Indigenous philosophy that emphasizes communal well-being and harmony. Instead of centering on the individual, it values the whole. Instead of promoting only profit, it considers ecosystems, families, and the long-term future.

Not every ejido is as successful or efficient. Their ability to thrive can depend on available resources and the philosophies of the community members. At the time of

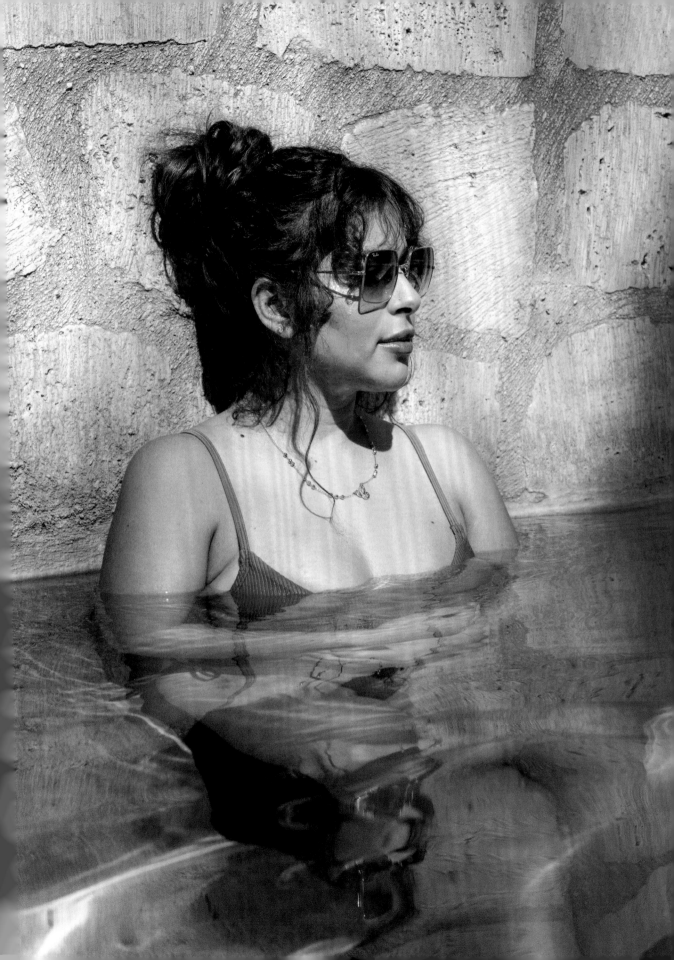

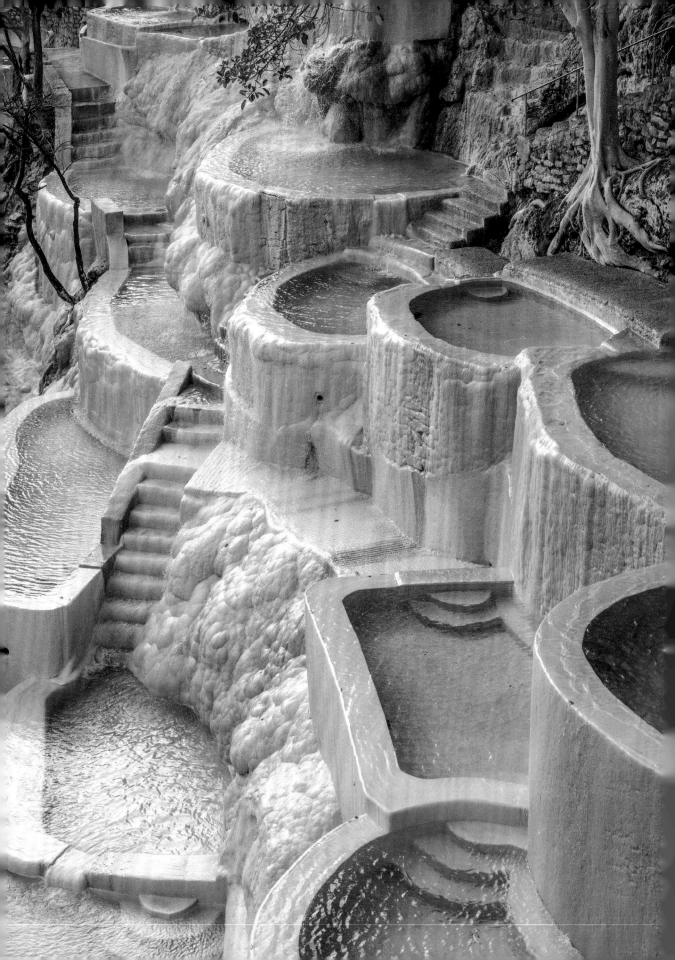

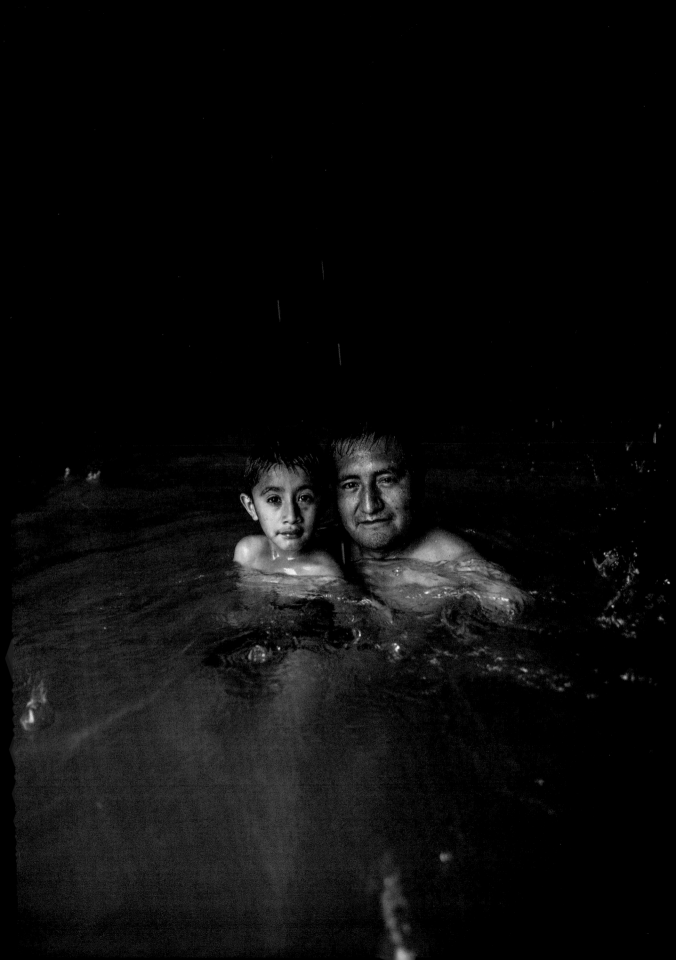

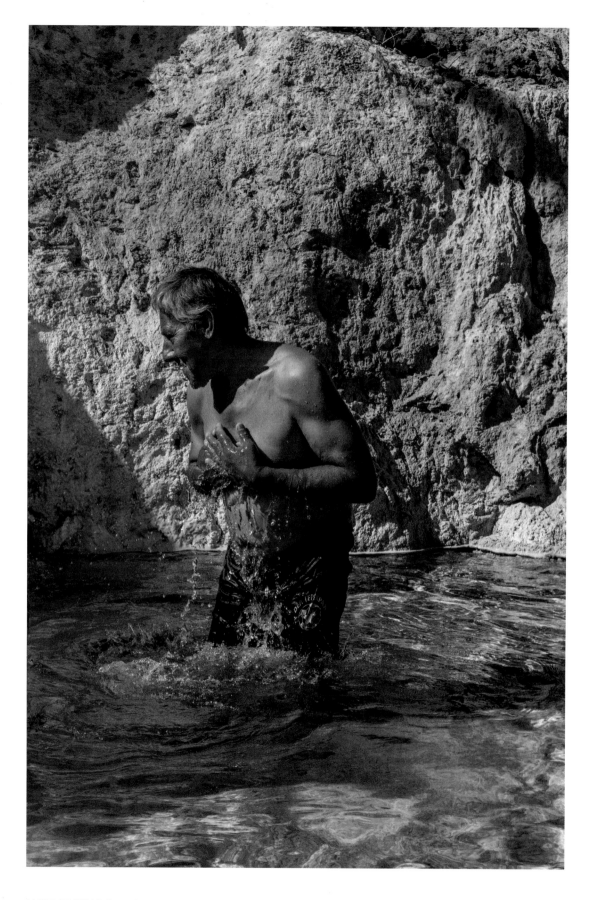

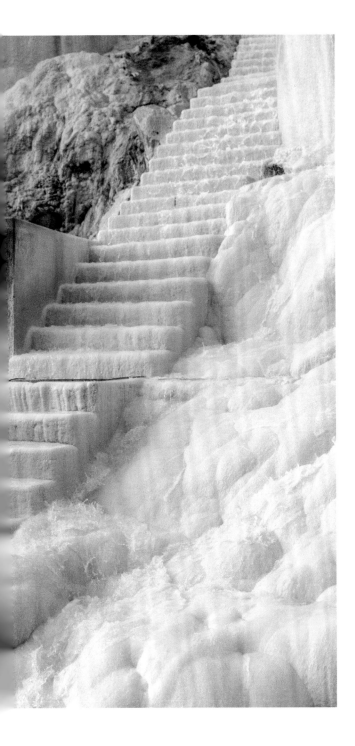

agrarian redistribution in 1917, ejido land was protected and forbidden to be sold. But as Mexico prepared to enter the North American Free Trade Agreement (NAFTA) in 1991, the land was permitted to be rented, sold, or privatized. Thus, the ejido system became vulnerable to outside investors, threatening the unity of existing collectives and eroding local employment systems, leading to an increase in emigration from Mexico. But the ejido remains an important method of land use and tenure in Mexico, and a reflection of local values. Today, about half of all land in Mexico is part of an ejido.

In the mornings, the Instagrammers show up first, when the pools are empty and the photo ops are at their best. They take turns posing on the edges of pools or looking over their shoulder as they walk. Eventually, light slants in through the mountains and finally touches the pools. It seeps into the valley in golden beams.

Later in the day, cars and buses come from the city and around Mexico, carrying groups of friends, sweethearts, and families. There are children with squirt guns, a man listening to meditative music on a small speaker, a couple holding hands, a family of four generations on vacation. In the evenings, travelers and soakers cook meals of tortillas, meat, and roasted cactus over open fires, just feet from the water. The smell of woodsmoke settles in with dusk, and the lights of the settlement across the canyon flicker.

Every other day, a cleaning crew drains and scrubs one section of the pool network. Brigido Rebolledo Cruz even cleans the cliffs, walking nimbly onto its sheer sides in rubber boots. He's been working here for thirty-five years. While we chatted at the entrance of the pools, a coati—an animal like a raccoon—ate a stack of leftover tortillas on top of a shrine of the Virgin Mary. In the evening, when the work was done, Brigido and the other workers reclined in the uppermost pool with a little boom box. He waved at me from the water.

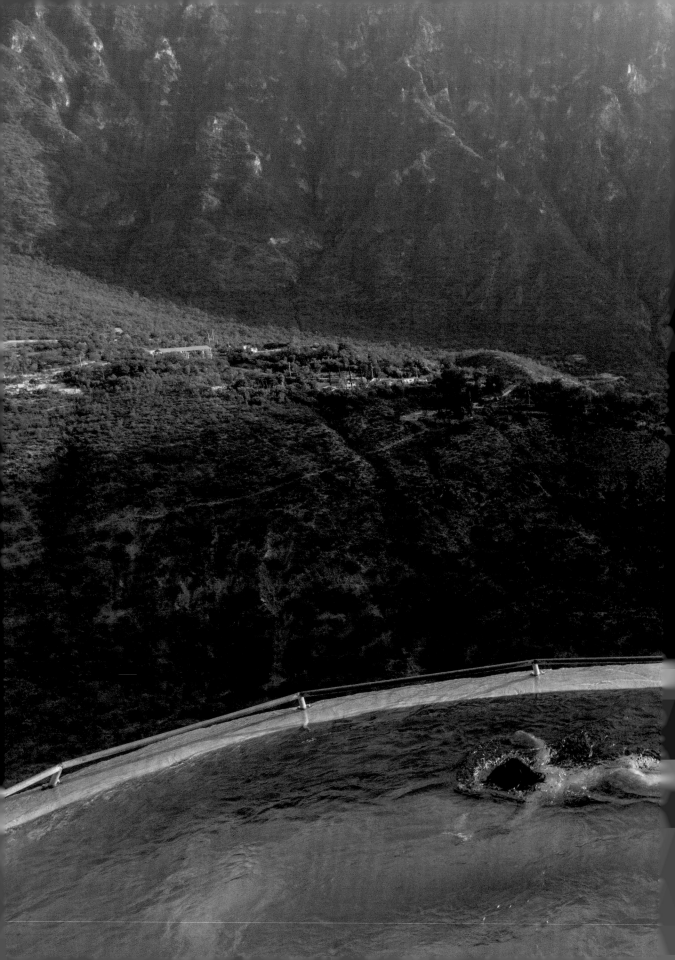

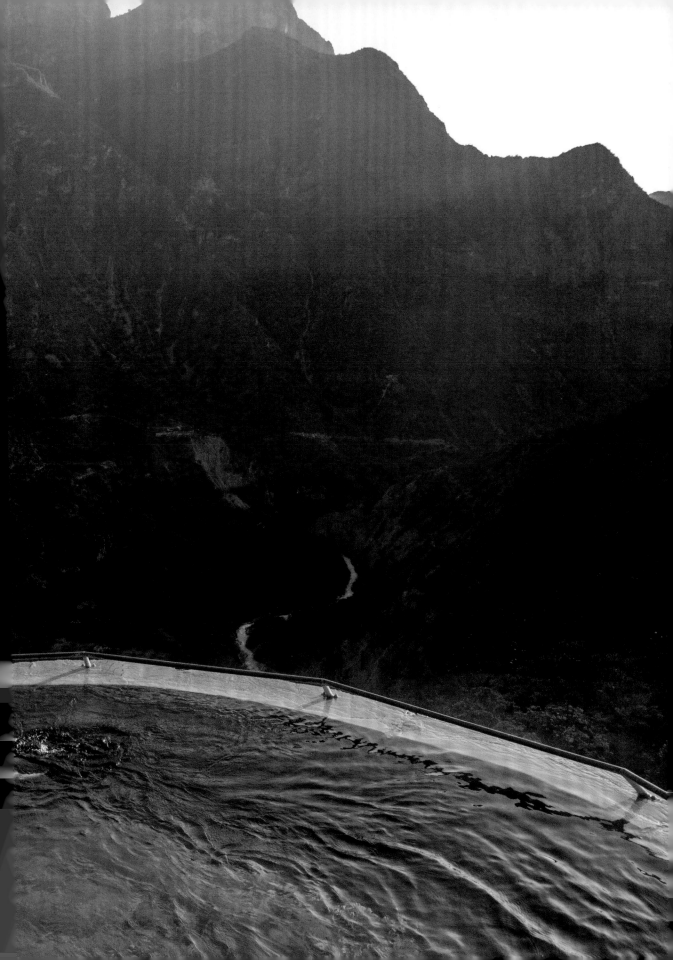

Sundhöllin Public Baths

ICELAND

Stefan is a regular. Lawrence is, too, but he comes mostly to work out. Gabriel comes with his schoolmates to learn to swim, but he also comes with his mother, Emilia, to practice jumping into the pool. Sundhöllin, the oldest public bath in Reykjavík, serves as the city's most iconic neighborhood pool.

Sociologist Ray Oldenburg coined the term "third place" in 1989 to describe the spaces outside home and work that are not created for monetary transaction or acquisition. "The development of an informal public life depends on people finding and enjoying one another outside the cash nexus," he wrote. He advocated for the creation and protection of casual gathering spaces for the public.

In Iceland, the thermal pool serves that purpose; it's an important part of daily or weekly routines. Most neighborhoods and towns have a municipal thermal pool, thanks to Iceland's good fortune of having geothermal water. A source of energy and warmth, it is tapped to power homes and provide community.

Some start their day at a thermal pool for a soak; others stop by on their lunch break. Some of the newer community pools have features like waterslides, but Sundhöllin is compact, simple, and urban. In the summertime, people who live in apartments come to sun themselves on the chairs on the upper deck. In the wintertime, people show up to experience the cold weather in warm water.

Hot pools are essential to Iceland's recent history. "They were part of the project of becoming a modern, independent nation," said professor and anthropologist Helga Ögmundardóttir. "Iceland became independent

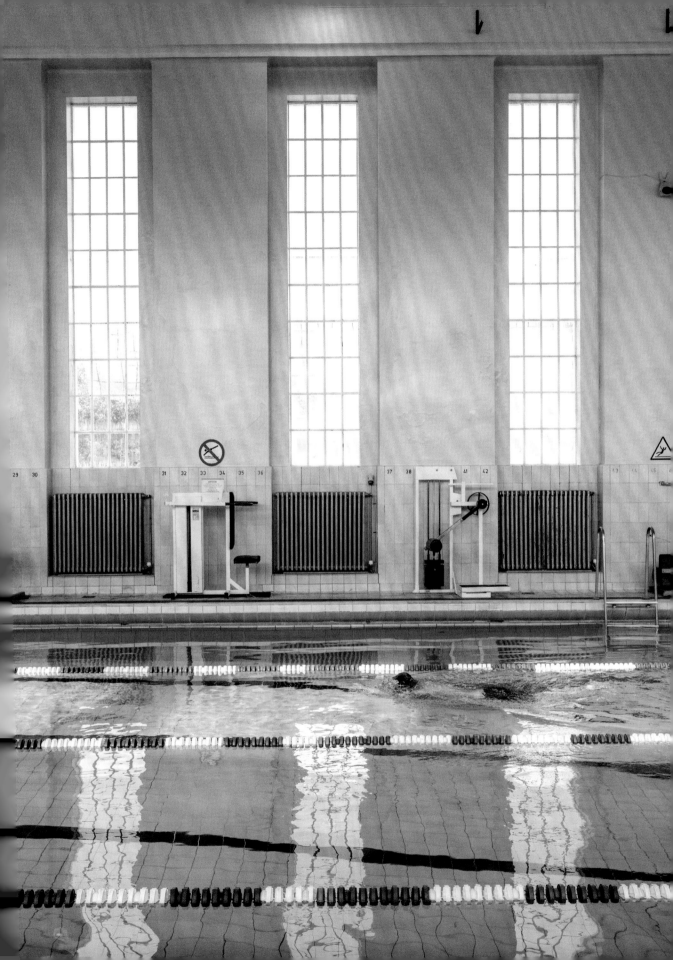

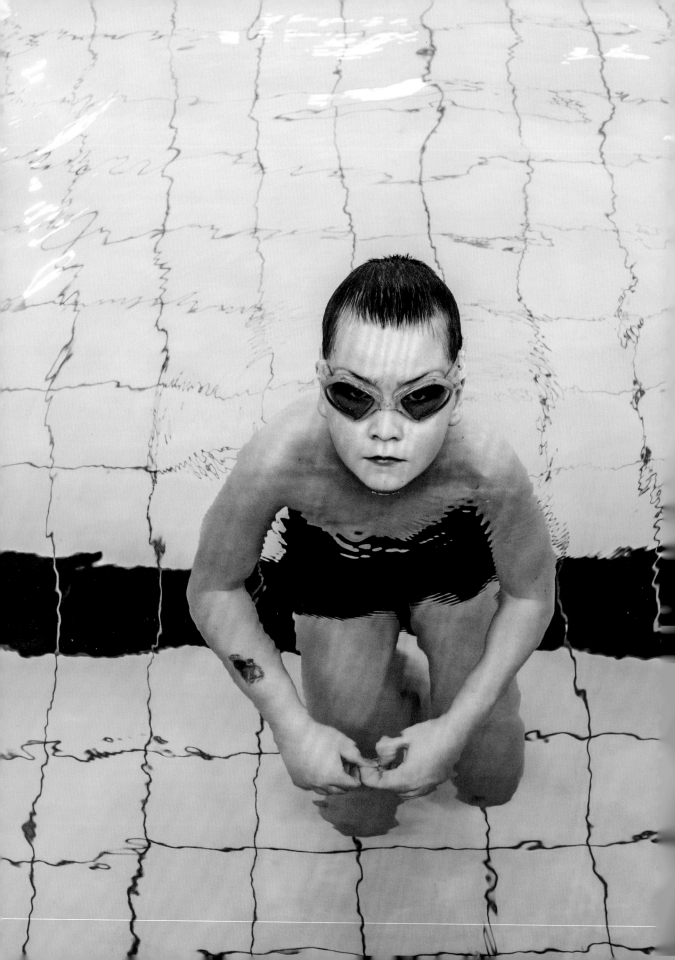

in 1944. It was a young country asking, 'What does an independent nation have to show to be recognized and respected by other independent countries?' Each town was to have a school and a store. And of course, each town needed a swimming pool, something to offer its inhabitants and its guests."

These pools have been woven into Icelandic identity. "The hot-tub culture of Iceland has been equated to the French café," said Brjánn Baldursson, who works at Sundhöllin. "This is a place where people can chew the fat together. Even the president of Iceland comes here. And people all have to shower before the tubs. Even the president has to do that. And then he goes and chills with everyone else."

Sundhöllin was built in 1937, designed by Guðjón Samúelsson, Iceland's most notable architect. Its name translates to "the swimming palace." Large-paned windows let light filter into the pool. There is a diving board and frequently used exercise machines and hand weights. The tile is warm and worn. In 2017, the complex underwent an expansion. The original building was kept intact, but a series of outdoor pools, tubs, and new features were added, including a sleek new entrance and meeting area.

When I was there, a group of boisterous boys did stunts off the diving board into the historic pool, and the lifeguard admonished them with a bit of a smile. He seemed to know them. An elder used an exercise bench to do sit-ups. Outside, in the hottest pool, a cluster of colleagues talked intently among themselves. Later, one of them caught my eye and told me about their frustration with a coworker. A group of women reclined in the shallowest pool and laughed. I thought about all the scandal, strategizing, and secrets shared here over the years.

Brjánn told me that the best stories are shared in the changing room, a casual place of comfort and rapport. "You're all naked in the locker room," he said. "You think they'd rush to put on a towel but they don't, they stand there and chat. There you are, naked as nature made you, and for those few moments you are all the same."

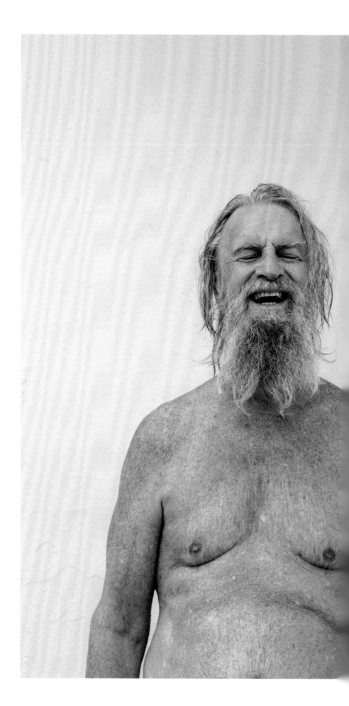

Several locals mentioned seeing President Guðni Th. Jóhannesson at Sundhöllin and described chitchatting with him in the locker rooms or in the pools. It sounded so casual, so regular and routine. I emailed the president's team, and within a day or two, I received a response from the president on official letterhead topped with a crest:

I am tempted to argue that public pools count among my nation's contributions to civilization. I know that is hyperbole, but I am sure that on any given morning in Iceland, you could find someone sitting in a hot tub in one of the country's plentiful pools willing to defend that case, if only to maintain the conversation. All year round, many inhabitants begin their daily routine by having a swim and then a chat in the "hot pot" with friends or newcomers, domestic and foreign alike. It is there that the problems of this world are discussed and sometimes solved, at least in the minds of the most diligent "potterverji" (hot tub inhabitant).

He continued:

I personally always enjoy the chance to meet friends and strangers, either at my local swimming pool or elsewhere in the capital region and the country at large. The basic formula is simple. We have hot water from our abundant geothermal sources, pleasurable solitude or plentiful company. And in the pool and the tub, we are all equal.

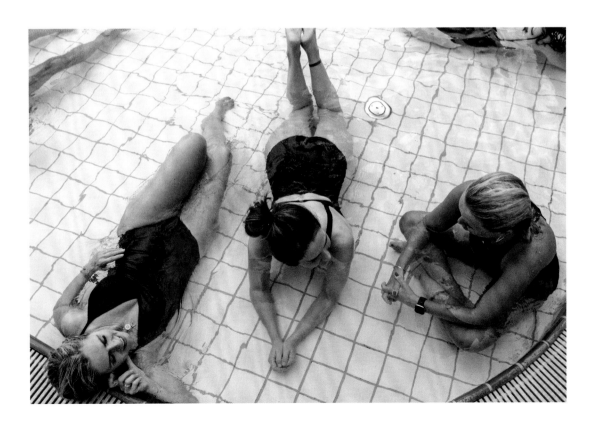

Tokyo Sentō

JAPAN

Amid the rooftops of most Tokyo neighborhoods are tall, solitary smokestacks reaching upward like sentinels. They are the chimneys for the local hot baths, or "sentō." There are two types of bathing spaces in Japan, the traditional "onsen" and the more neighborly sentō. While the onsen uses available geothermal water, the sentō uses artificially heated municipal water, allowing them to be built wherever they are needed to serve the local needs for communion and cleanliness.

Most public sentō follow a common, classic design. A tiled entrance has lockers for shoes and umbrellas, with a door leading to a women's side and another door leading to a men's side. The interior is symmetrical and spacious with a low partition that divides a changing room and bathing space for these genders. Voices carry easily across each side. Inside the bath are stacks of small stools and pails, rows of spigots and low showers, and several tubs of varying temperatures. Colorful murals or mosaics portray classic Japanese motifs; in Tokyo, Mount Fuji is the most popular design. Vending machines sell cold drinks, and posters advertise community events or provide instructions for self breast exams. Most sentō have a laundry facility.

Akebono yu is managed by Atsushi Moriyama, a third-generation sentō owner. He arrives in the morning to stoke the stoves that heat the water. When he can, he uses wood from houses that have been torn down to make way for new development. In many ways, the sentō itself is a relic of an earlier era. They were first built to provide essential services in urban areas, where for many decades most homes had no plumbing or baths.

"During my childhood, most of the houses didn't have a bath, so many people went to a sentō," said Atsushi. "But gradually, the number of customers has decreased because everybody has a bath in their houses now. But more young people are coming. Some customers come every day."

Not all sentō have seen this surge in popularity. I visited Teru no yu on its closing day, after seventy years of operation. The entrance was filled with flowers and gifts for the retiring

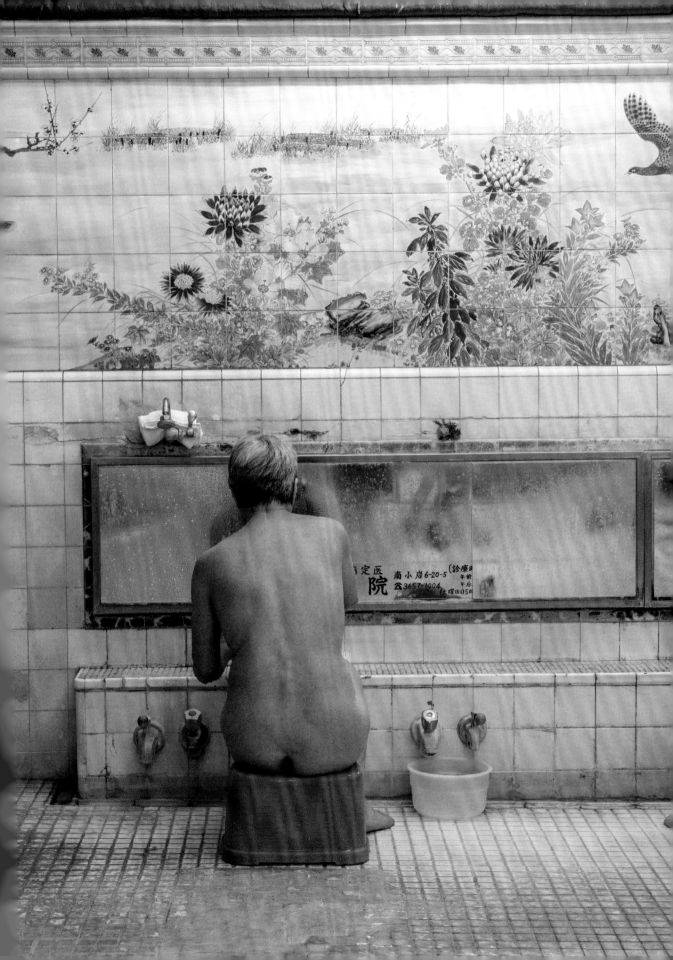

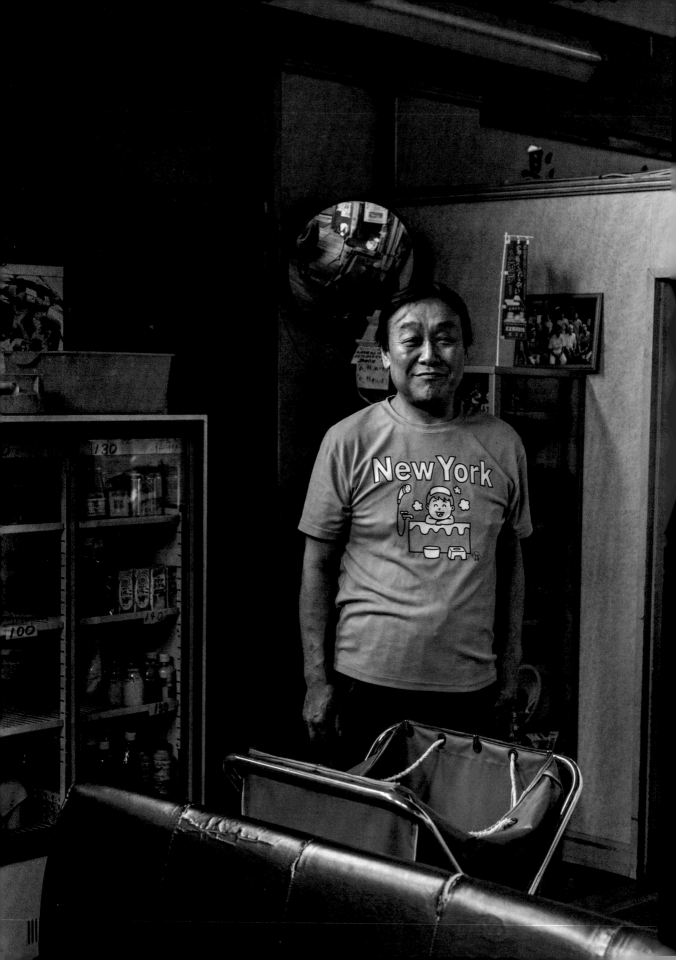

owners, with notes thanking and congratulating them for a job well done. It was the last day of routines that have repeated for decades. Regulars arrived on foot, wheelchair, or bicycle for opening time, and they shared memories of Teru no yu. "I'm so glad we met here," said two women to each other. Many of the regulars worried about the closure of their sentō and their beloved routine. The closest public bath is now a train ride away. One elder told me she had bathed here with her son when he was just a baby, over thirty years ago. She pointed to where there once was a mural of Mount Fuji and where there had been a fish statue that spurted water from its mouth. "Today, I enjoyed my last time here and savored my moments in the bath with all the memories around me," she said. Women exited the baths, some of them with hunched bodies and tender joints, accepting help to get dressed. The women here had likely seen each other naked as they aged, neighbors becoming friends. United by routine.

Tokyo has about 480 sentō at the time of writing this book. In 2006, there were nearly a thousand; about thirty sentō close each year. At Kosugi yu, Miho Latham and her team are part of a growing effort to preserve and revive sentō culture. She had come to the baths as a customer and now manages a team of young people who work together to operate the facilities. In addition to the more mundane tasks of running the stoves, cleaning the tubs, and folding towels, she likes to support her staff by integrating their interests and skills: one employee draws a zine and another manages a running club associated with the sentō. They've made affiliations with local companies and businesses and have special programming at the baths. Because of these new ideas, Kosugi yu is increasingly popular. She said that many sentō see fifty customers a day. Some see up to four hundred. Their sentō welcomes between eight hundred and two thousand bathers, depending on the day, and they have extended their opening times to be one of the few sentō that offer morning bathing times, to allow for more visitors.

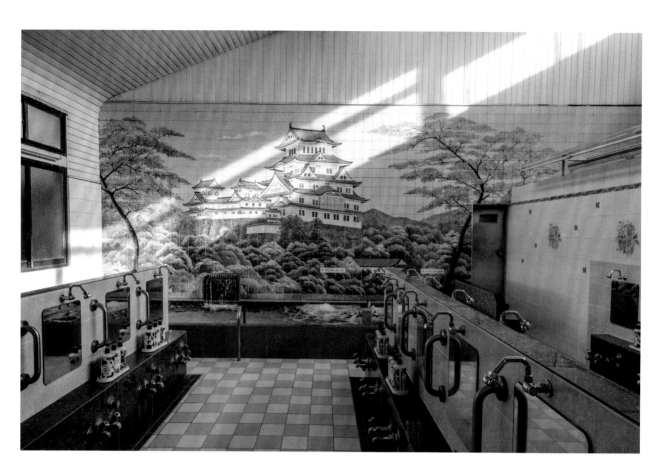

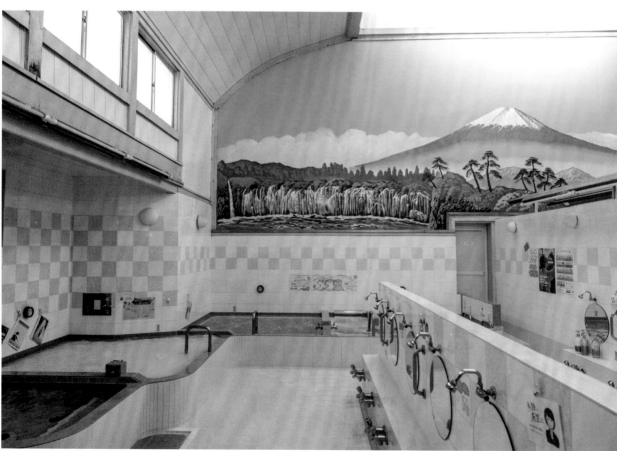

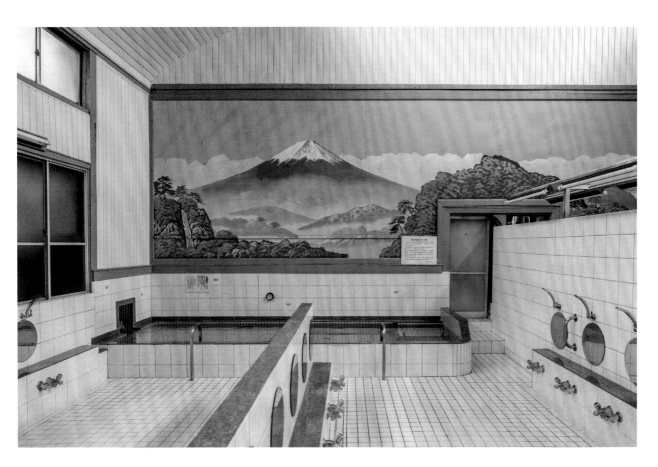

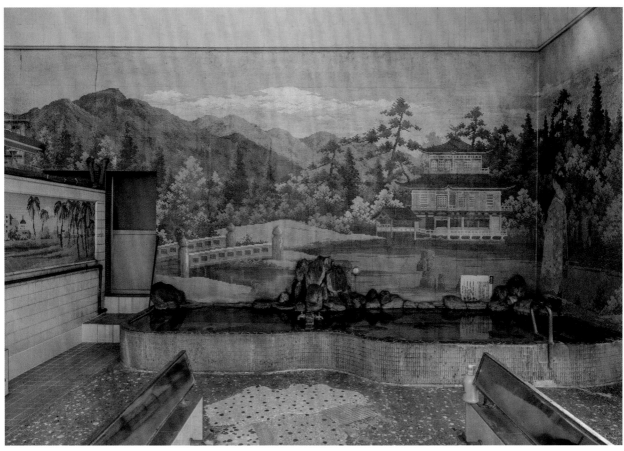

"Yes, this is quite a tough job, but I can work hard by seeing their happy faces," said Miho. "It keeps me going and makes me happy. So, I work here for my happiness." Still, many older sentō owners feel the strain of running such a demanding business—especially on prime real estate in one of the world's most crowded cities. Selling the land for development is a popular option for some owners as they age and the customer base dwindles.

Daini Kotobuki yu is managed by third-generation owner Taeko Shigihara and her husband, Kazuyuki. It opened in 1964, and they have worked hard to preserve the sentō for the neighborhood. They both agreed that it would be easy to close down a sentō after a lucrative offer from a real estate agent, but they have dedicated their lives to this work and know that people depend on them. Kazuyuki speaks like a sociologist; he has spent years noticing the intricacies and intimacies of the bath. "Sentō is a great place to understand how people live," he said. "There is a pattern to the day: the women who come by themselves at opening time are the women who live alone. The men who come at opening time are those whose wives are at home cooking for them. Their wives will come later in the day. I listen to the people and can hear what they worry about and discuss with each other."

The sentō provides a space for many things at once. It allows people to clean their bodies, a most fundamental human need. But the murals, the special tubs with salt and minerals, the way the space is set up for conversation—they reveal needs as important as any. The need for beauty. The need to get out of the house for a while. The need to be with our neighbors. The need to tell someone else the story we just heard. The need to sit quietly with our eyes closed, even for just a few minutes.

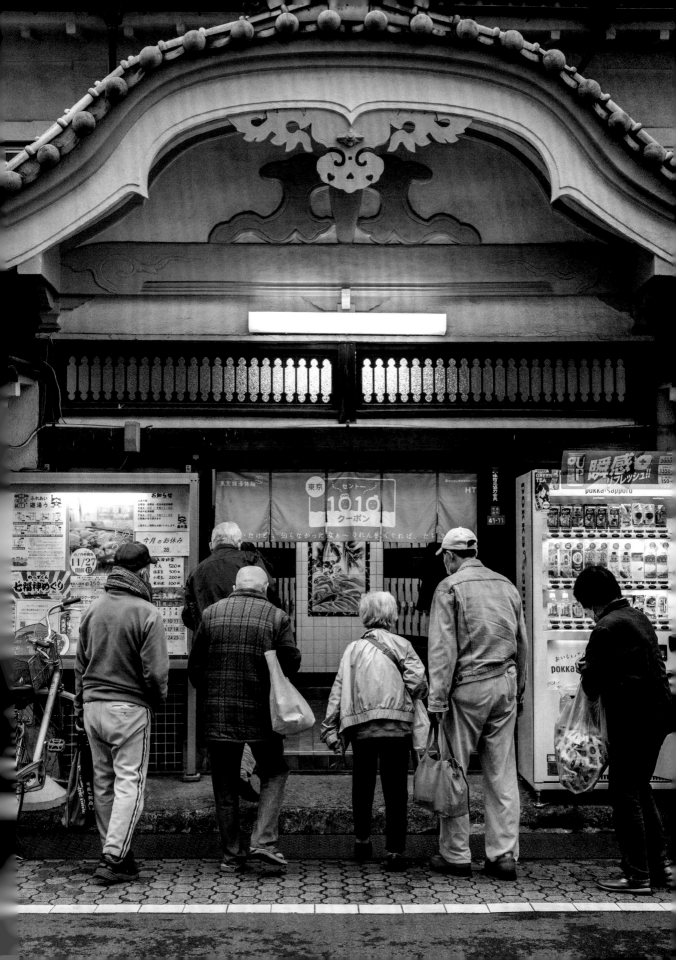

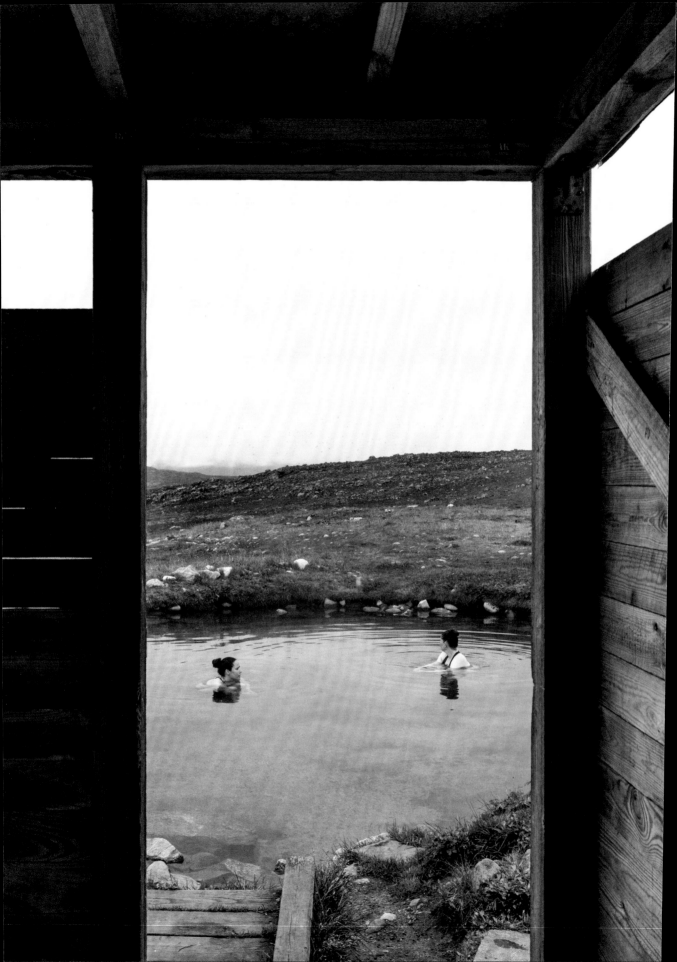

Uunartoq Hot Spring

GREENLAND

The polar cap has its own weather patterns. Swirls of wind and snow whip off the ice, forming ridges and patterns that look massive even from the vantage point of an airplane window seat. Planes arrive in Greenland from Denmark and Iceland only a few times a week. There are no roads connecting towns, and in-country travel is weather dependent and irregular. I waited two days for my flight from Nuuk to South Greenland, and as the plane headed southward, the geography started to change. The shape of the ice sheet is shrinking and shifting with climate change. After the plane, I caught one of two cherry-red helicopters, and sat shoulder to shoulder with locals for whom this ride is part of their regular commute. Pilots distributed ear coverings, and we nestled our smaller bags between our knees. Icebergs and their fragments dotted the brilliant blue ocean below, while in the helicopter a woman napped and a young mother nursed her baby.

The landscape is enchanting in its beauty, but it's hostile. There are no trees, and very little soil for crops. It's cold. I wore a heavy down jacket when I visited in early September. To the eye of someone like me, who knows little of this place, there are only two seasons: frozen and just thawed. To someone who has been raised here, there are many seasons. Times for different types of ice, for different sea animals, for different storm patterns, for different ways of living weather-dependent lives. Greenland's history is a story of many people trying to make do in an inhospitable place, populations shifting with changes in climate and resources. Oral and archaeological records give us a timeline of the island's citizens: Various populations settled and at times abandoned the country starting as early as 2500 BCE, including Dorset Paleo-Eskimo, Icelandic-Norwegian Norse, and Thule Inuit, the ancestors of most of the island's current population. The Danish settled and claimed Greenland in the 1700s and 1800s with a continued complex political relationship. Today, around fifty-six thousand people live in Greenland, 89 percent of those identifying as Greenlandic Inuit. The island nation is called Kalaallit Nunaat in Greenlandic.

The Uunartoq Hot Spring is on Uunartoq Island in the Uunartoq Fjord. It's geographically and socially consequential, centrally located between two fjords and equidistant from a few of South Greenland's main towns and settlements. The hot spring itself is a ruin, likely built by the Norse a thousand years ago. It may have been the only place to submerge in warm water for generations of Greenlanders. For a millennia, people have rested their bodies in the same place, finding warmth in the cold just like people do today.

Archaeologist Dr. Christian Koch Madsen has spent time on the island examining its

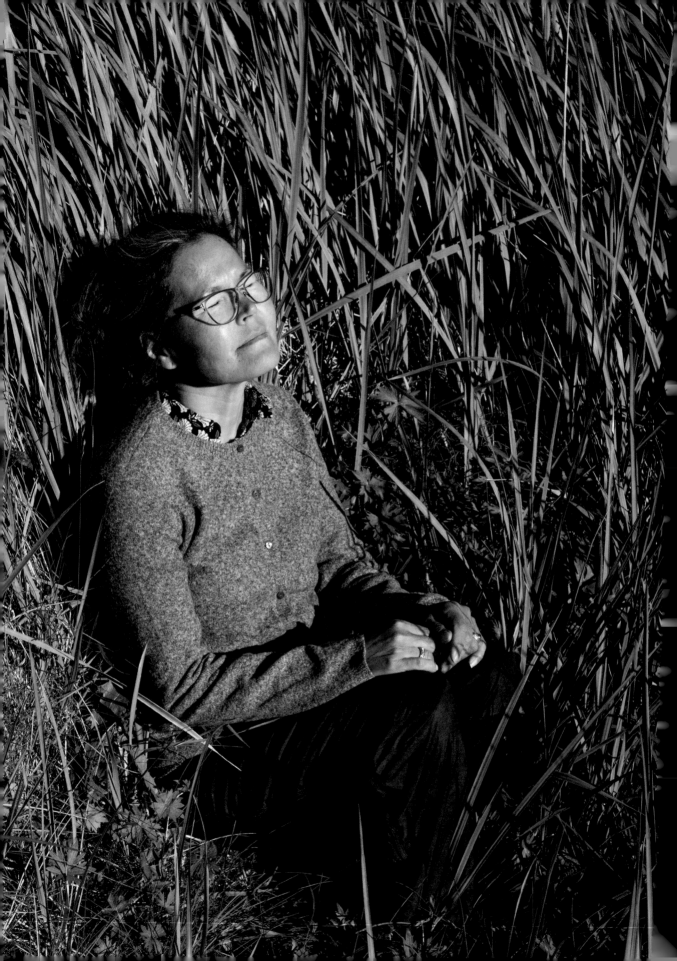

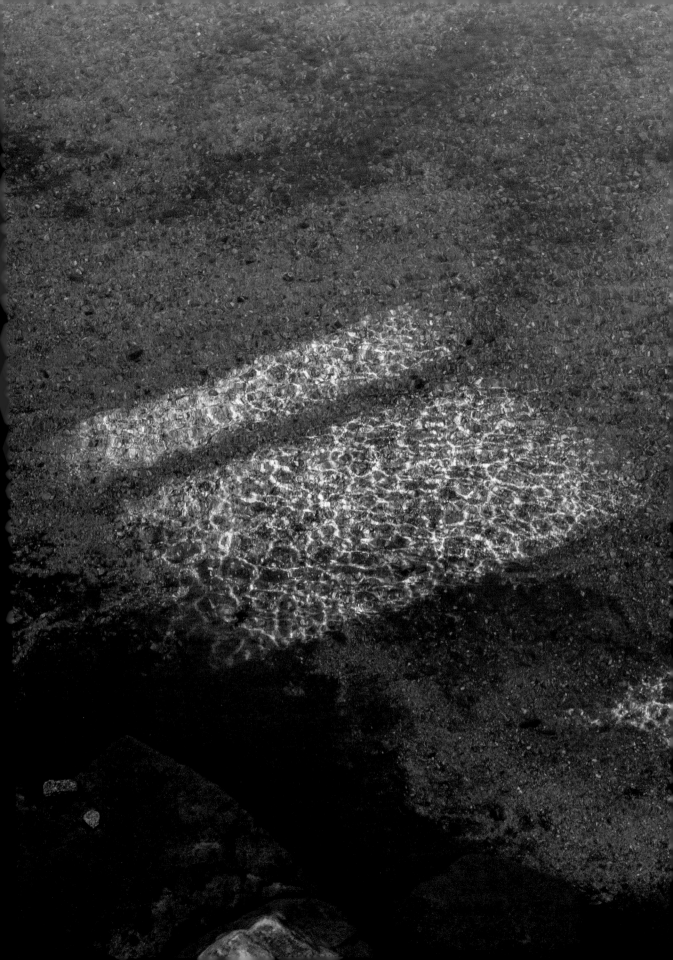

features to determine its past. After a hard day of excavation and research, he and his archaeological team would soak, often with locals or visitors who arrived by boat. "You are in a certain situation where you're not wearing a lot of clothes and you are sitting quite close to strangers," he said. "It makes us want to talk to each other. It makes it a safe space. So there's always a bit of communication, and I'm guessing this would have always been the case. It was probably the same for the Norse and for the Inuit. Everybody."

Walking around the island, you will find the markings of different eras if you know where to look. There are the grassy, concave remnants of Inuit dwellings and the evidence of graves. With too little soil to bury the dead—the landscape was too frozen—they simply piled stones over the bodies. "There are a lot of Greenlandic stories and myths that take place in the neighborhood of Uunartoq. We can see that even in the archaeological record, this was a gathering place," said Dr. Koch Madsen. His archaeological team worked across the entire island, discovering summer dwellings, hunting features, and food caches that weave together a continuous cultural landscape across centuries. They've met with local people who still know old stories about how the island was used.

Uunartoq is registered as a historically preserved place, with both natural and cultural heritage protection. But the entire country is uniquely managed: no one can own land in Greenland. All land can only be borrowed, with the terms of its use agreed upon cooperatively.

As an American, from a nation where a majority of land is privatized, it took me a while to understand how a place could have no landowners, how an entire country could be

shared. I spoke with arctic social scientist Dr. Naja Carina Steenholdt, who explained, "It's rooted in our vision of nature. It's rooted in the perspective that we cannot own nature, that it can only be borrowed while we live. It's rooted in very traditional, very Indigenous views of our nature. We still have that view." Dr. Steenholdt emphasized that Greenland's approach to land usage, while being connected to enduring philosophies, has a role in modernized life and can accommodate advancement, leading to a functioning society without landownership. Their society, she said, operates on principles of sharing everything: land, food, time, care.

Earlier that day, I ate mussel soup in Nuunu Eli Olsen's home in the nearest settlement, Alluitsup Paa. "If someone has a problem with a motorboat or something, we will always help," said Nuunu. "It's not like the scene in *Dumb and Dumber* when he said,

'Watch my things,' and the lady steals his things when he goes into a store."

I saw a unique type of kindness everywhere in Greenland. When taxis were in short supply at the airport, a passenger paid for everyone to ride together. Without a word, another guest at the hotel in Nanortalik filled my teacup, remembering the type of tea I liked. A woman in town let me carry her heavy shopping bags to her home, without fuss or refusal. I realized I was witnessing a certain grace in both the offering and acceptance of kindness. "It's actually not really customary to say thank you in Greenland," said Dr. Steenholdt. "It's just expected that we help each other. It's just how we have to be; we have to help each other because we have such harsh surroundings. It's always a give-and-take situation. Everybody contributes."

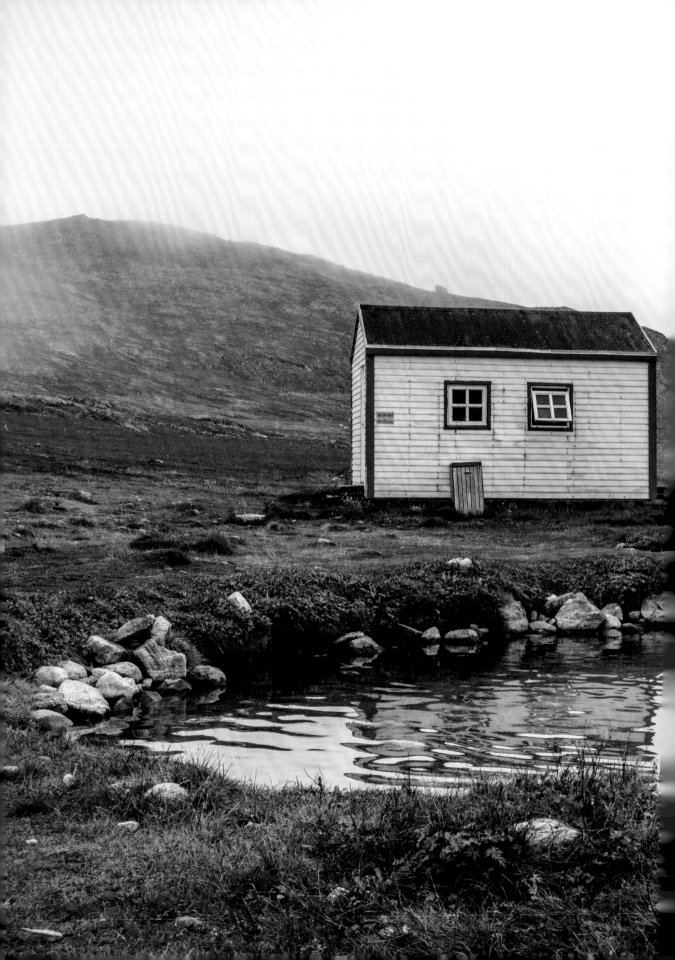

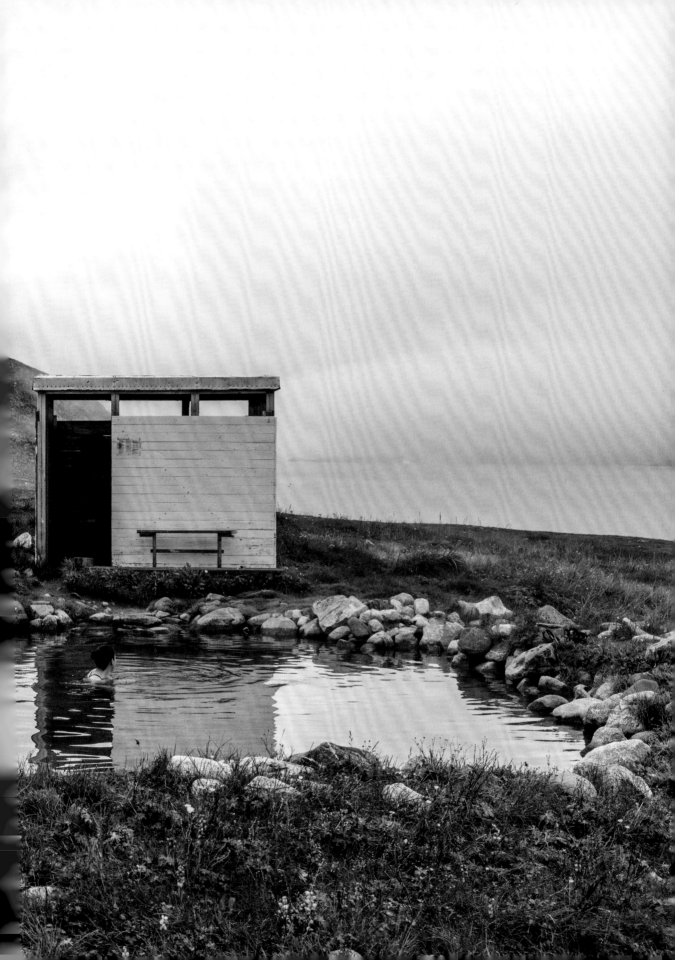

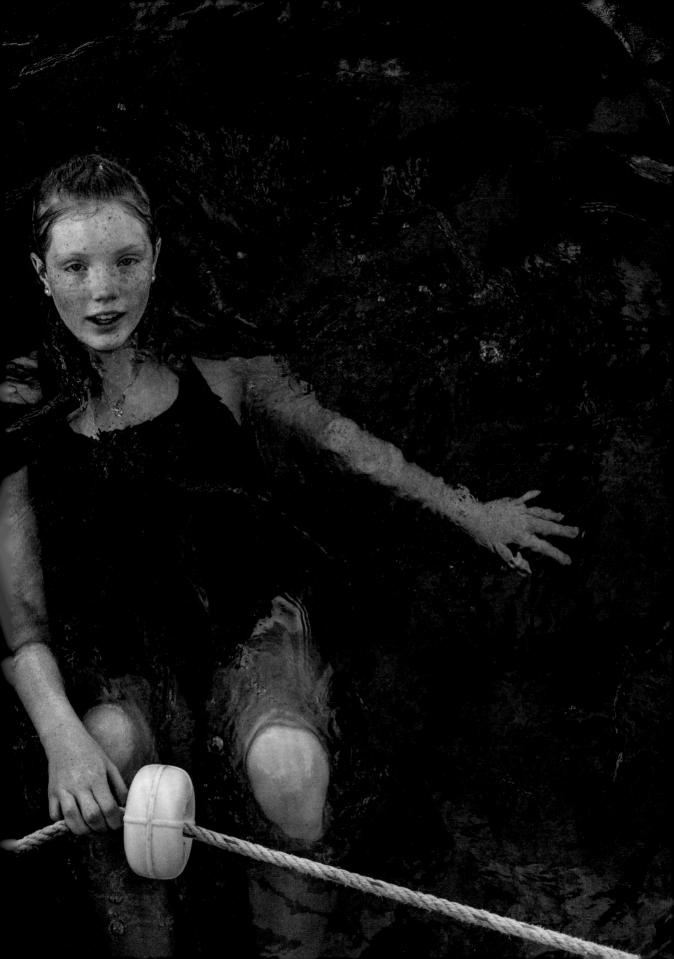

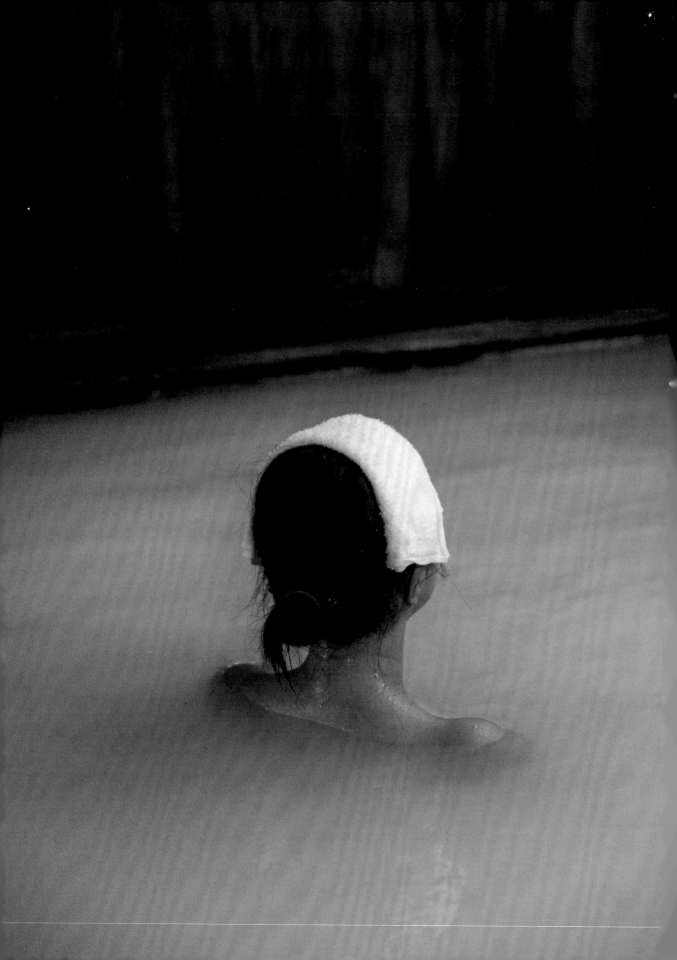

Aomori Prefecture Onsens

JAPAN

When I was fourteen, my parents, both schoolteachers, found jobs teaching on a US Air Force base in Misawa, Japan. I went to ninth and tenth grade at the on-base high school, where fighter planes thundered over campus and every so often earthquakes would disrupt class. We lived in a little house in town, between a potato field and a rice paddy. There were a few local onsen, or public hot baths, around town.

The onsen were so different from the hot springs I'd been to back home in Idaho, places that were outdoorsy and sometimes a little rowdy. In Japan, the hot springs are ritualized and structured. In an onsen, there is a palpable sense of reverence for your own body, for others, and for the water. I learned to use the onsen properly: To pull up a small stool and bowl to the shower area. To scrub every inch of the body, shampoo and condition hair, clean between toes and under fingernails. To fill the bowl from the spigot to rinse the body and, when finished, to splash water over your shower area and the stool. Then, once clean, you soak. You soak until your body is red with warmth, and inside you feel purified, too.

We left Aomori the summer after I turned sixteen, and I didn't return until I worked on this book. It had been twenty years. In that time, Japan had established a new bullet train route from Tokyo to Aomori City, the capital of Aomori prefecture, about an hour away from where we once lived. I took the train, which moved quickly and quietly across the distance, and rented a car at the station so I could explore the local onsens.

My first stop was Sukayu Onsen, a ryokan (traditional inn) famous for its enormous onsen that is said to fit a thousand people. With its windows closed against the late autumn air, the onsen was so steamy it immediately fogged up my camera lens. I noticed how silent the space was despite the crowd of bathers. It smelled like cedar and sulfur.

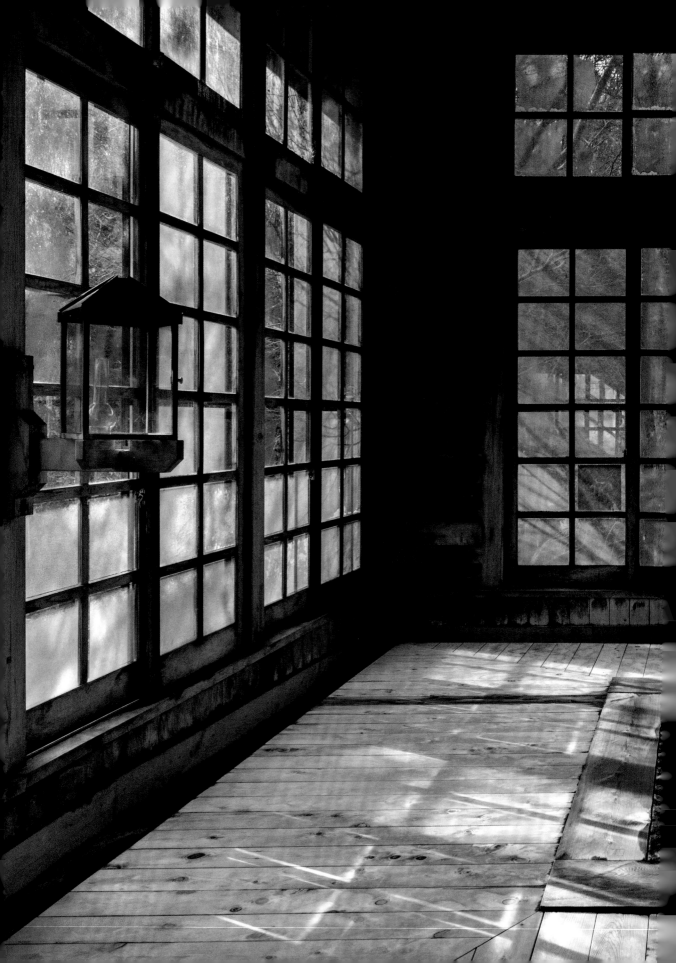

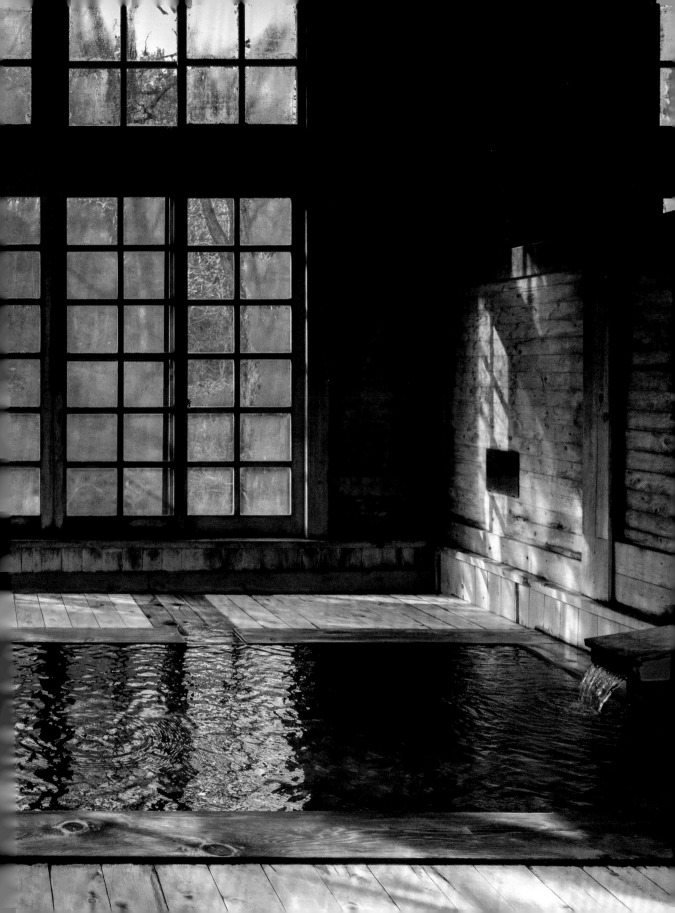

I then traveled to another side of the Hakkōda Mountains to the Michinoku Fukazawa Onsen operated by Mikami-san, who is known locally only by her family name. The lobby space doubled as her living room, where she watched TV with a blanket spread across her lap. Persimmons dried over a woodstove and taxidermy animals stood frozen in various poses around the room. The entire place, the bathing spaces included, felt like visiting someone's home. It's cozy and personal and imperfect.

Tucked in a mountain valley, Lamp no Yado Aoni Onsen is lit by kerosene lamps. Each day at the little ryokan, Fumiyaki Sasamura tends to the lamps in a small hut behind the main building. He carefully cleans, fixes, and fills each fixture. As the sun begins to slant beyond the valley, he lights six lamps at a time, carrying them on a long pole and distributing them in the inn's guest rooms, public spaces, and onsens. Each evening, the ryokan's cooks serve a set dinner of duck stew, mountain vegetables, squid fritters, skewered fish, miso soup, and rice presented on a lacquered tray in tiny plates and bowls like little treasures. Guests sit cross-legged on the floor, each low table an island below the beacon of a lamp. The onsens are in wood-paneled rooms: during the day the sunlight beams through the windows, and at night the kerosene lights flicker across the water.

From there I drove out toward the coast to Furōfushi Onsen with my travel companion, my friend Kaia, an artist living in Kyoto. At Furōfushi, we showered inside a tiled room with an orange pool, then wore our cotton yukata robes outside and across a boardwalk to two ocher-colored baths next to the roiling ocean. The scene was all blue and orange; the

sky and the ocean, the pools and the iron-colored stones. To get there, we drove through apple orchards and fishing villages that reminded me of my current home in Maine. Ironically, Maine and Aomori are closely linked, not only because of their similar climates and fishing and agricultural economies but also because of a Maine ship that wrecked off the coast of Aomori in 1889. The crew and passengers were rescued and cared for by locals, forging a sense of kinship and an official "sister state" relationship fostered by delegations, exchanges, and an annual memorial swim.

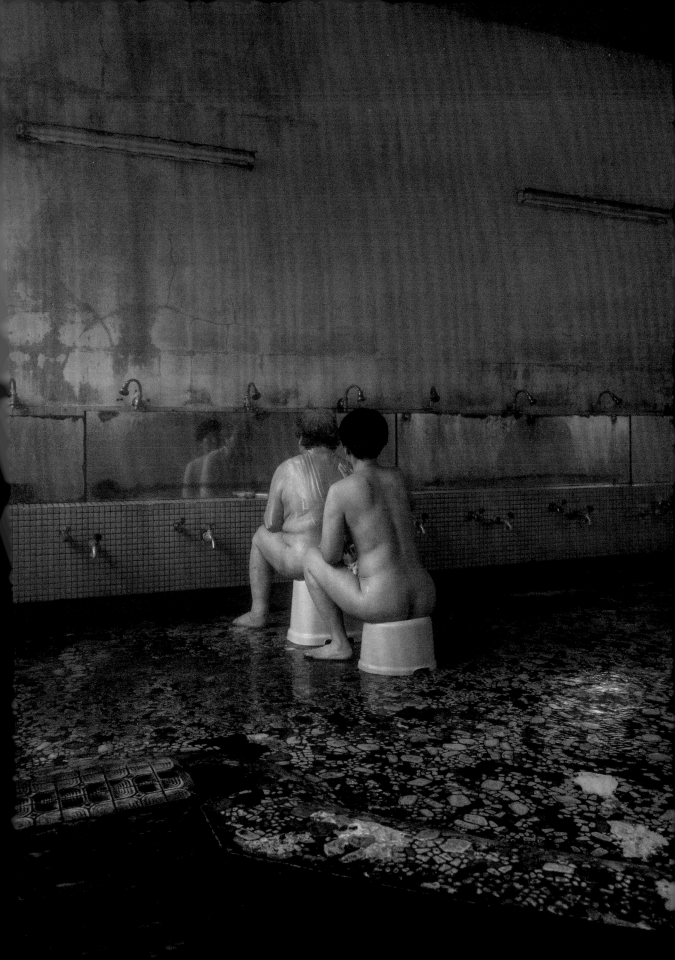

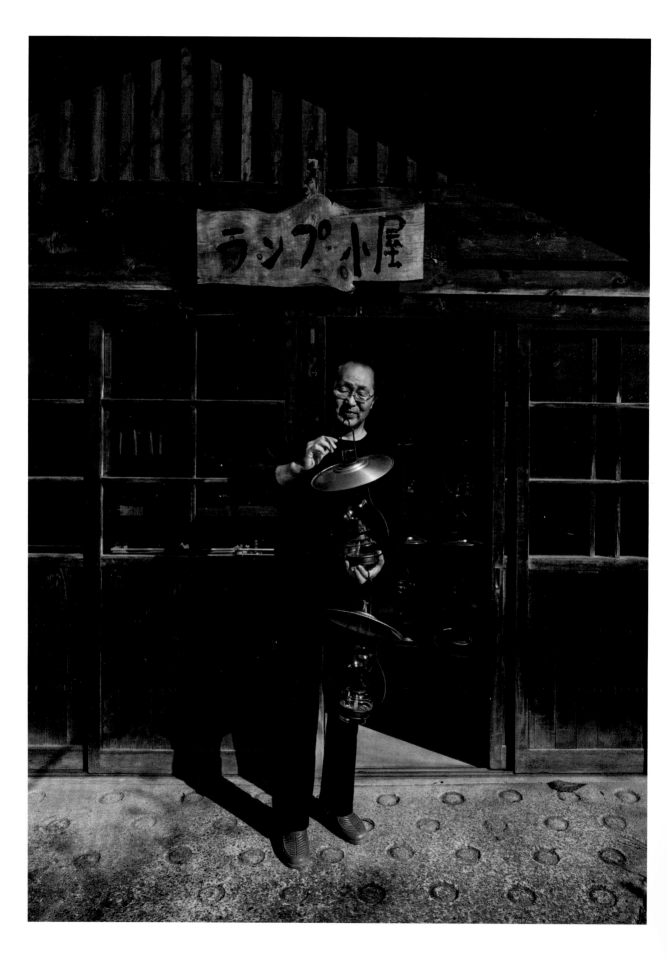

On my last day, I drove toward Misawa to visit my former home. I felt disoriented. The shopping boulevard with old stores and restaurants was gone, replaced by a mall. I found the entrances to the military base and tried to situate myself, but quickly felt lost. Nothing seemed familiar. Resigned and seeking comfort, I went to the onsen. It, too, felt different from how I remembered. There was the pink tile on the ladies' side, the hair dryer that cost ten yen for a few minutes of hot air. In the changing room, I met a mother and daughter from Misawa. We chatted about the ways the town had changed and stayed the same. While she scrubbed the places her mother could no longer reach, the daughter invited me to photograph their onsen routine. This was what I remembered from all those years ago: a clear memory of women helping each other in the bath. This was what felt familiar: the steam, the quiet, the closeness, the care.

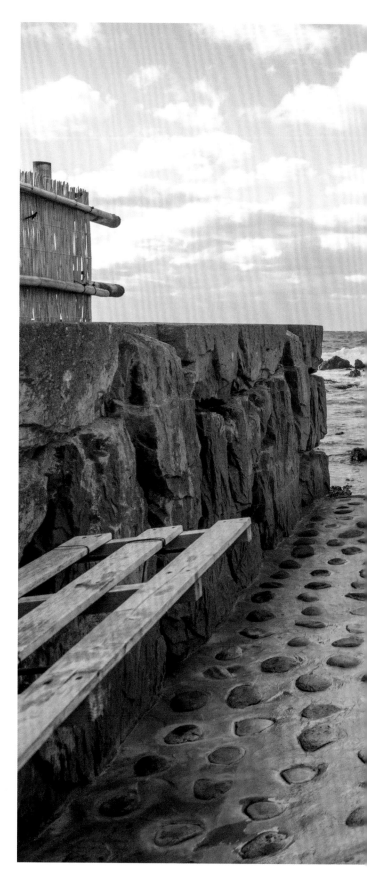

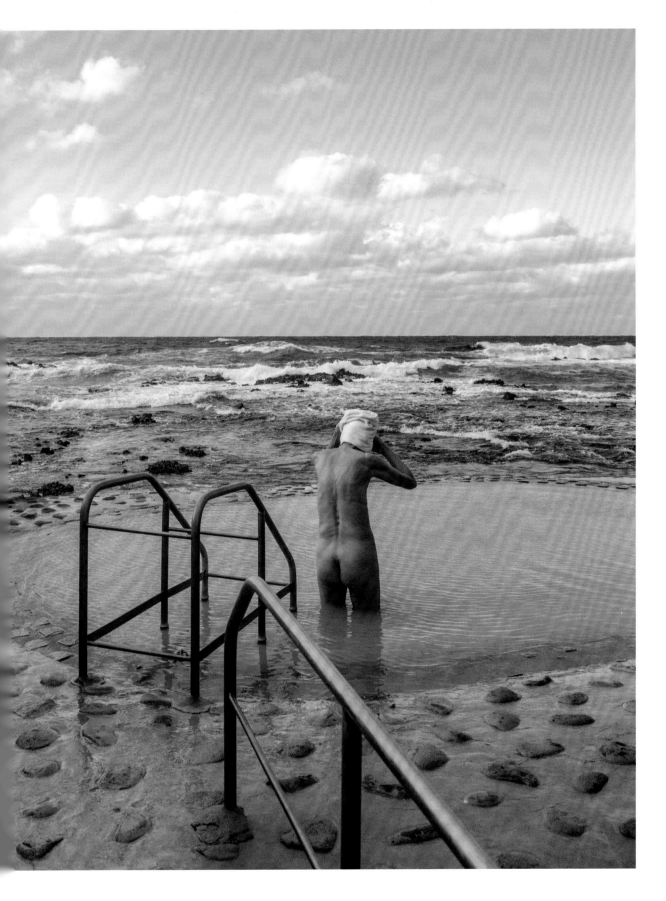

The Travertine Terraces of Pamukkale and the Antique Pool of Hierapolis

TURKEY

In 41 BCE, Cleopatra arrived on the shores of Tarsus, in the southern region of what we now call Turkey, in a gilded boat with silver oars. Her ship was adorned with flowers, the air perfumed with incense. She was dressed as the Greek goddess of love, Aphrodite. Her visit was a tactical one, arranged to solidify an allyship between Egypt and Rome. But it was also where she met Marc Antony, and they became accomplices and lovers. In the span of their great love, Antony gave Cleopatra many gifts. Rumored to be among them was a pool, warmed by the earth's thermal waters and covered with an ornate roof supported by marble columns.

In the seventh century, an earthquake tipped the structure into the pool, and the heavy Doric columns now lie scattered and submerged. While the historic record can't confirm that Cleopatra bathed here, the thermal pool is alternately called "Cleopatra's Pool" or, more officially, the "Antique Pool." The pool is still there, located in a massive complex of ruins, relics, and natural wonders in central Turkey's Denizli region.

I drove the seven hours from Istanbul, arriving at dusk. From a distance, I could see a hulking white mineral deposit rising several hundred feet above the valley of pastoral vineyards and olive groves. This was Pamukkale, or the "cotton palace." A town of the same name sits at the calcite formation's base. The enormous white travertine terraces are filled with calcite-rich water, which eddies and runs in rivulets down the geographical anomaly. Visitors like me remove their shoes and walk up and down a cordoned area of travertine, dipping their feet or swimming in pools of warm blue water. The minerals felt chalky; sometimes smooth and polished, other times rough and sedimentary.

The ruins of an ancient city, called Hierapolis, sit atop the white formation. They contain the remnants of Cleopatra's Pool and artifacts of a busy historical past. Hierapolis

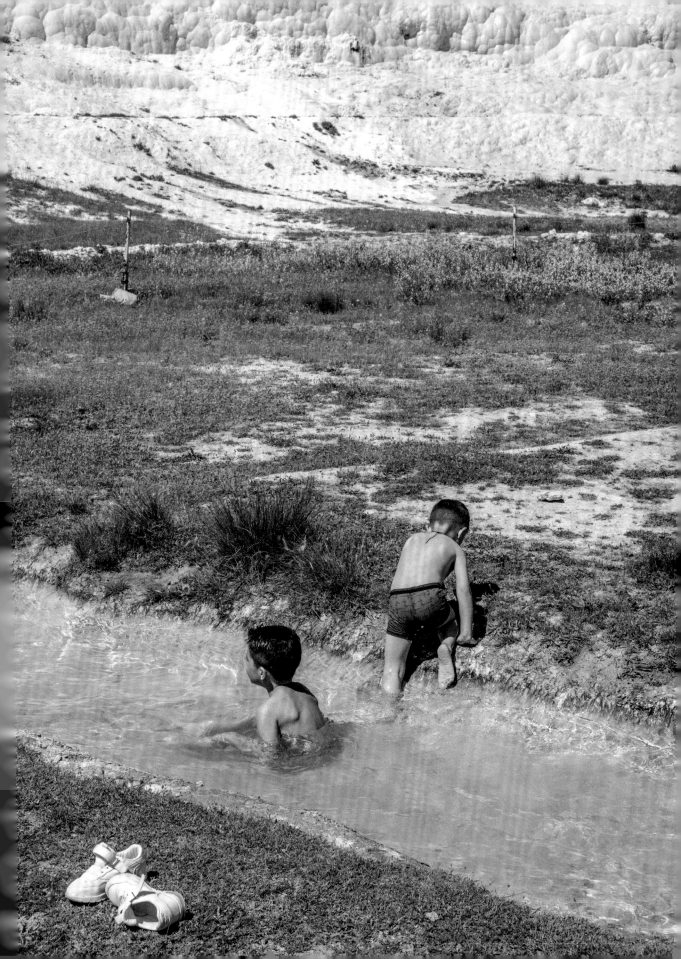

is believed to have been founded in the second century BCE, swelling to a population of around one hundred thousand. Word of the water created a city, and the geothermal activity attracted spiritual seekers. Garnering fear and awe, a steaming natural cave was used for ritual animal sacrifices, then was transformed into a devotional structure for Pluto, the ruler of the underworld. Castrated priests crawled into the noxious chamber to prove the miracle of their survival, emerging with powers and protection. Pilgrims and visitors could pay a fee to ask divine questions of the Oracle of Pluto. It became a place for ritual and therapeutic care, administered both by medicine workers and religious figures.

The evidence of those ancient lives remains. There is a necropolis with the tombs of patrons and patients who arrived to find healing and stayed for the rest of their lives, devoted to the water. There are the remnants of entire streets, promenades, latrines, and an enormous amphitheater. It is now a UNESCO World Heritage Site, a modern tourist destination built on the site of an ancient one. I wandered through the museum, now housed in the reconstructed former bath complex, filled with sculptures

of health officials, priestesses, and nymphs. There are sarcophagi festooned with carvings of garlands and faces, and a relief of a gladiator fight.

Like a lot of hot springs and natural wonders, Pamukkale has been in danger of being loved to death. In old photos, the blue pools brim with water that spills abundantly down each level. Now, only a fraction of its pools are still filled—the rest are protected after decades of weather changes and overuse. There are several gift shops with magnets and books and postcards. Cafés sell corn, fresh-squeezed orange juice, ice cream, and sandwiches. Tour groups spill out of massive white buses and gather at the edge of the cotton palace, they walk over its rippled surface and soak their feet and bodies in the lukewarm water. Some pay the extra fee to bathe in the Ancient Pool, to swim where Cleopatra may have once soaked.

I imagined her in the pool, with the columns still holding up a stone ceiling. Light must have filtered in, dappling the water in beams. Did she bathe with the lover who gave it to her? With friends? Alone? Was she ever there at all?

It was a strange feeling to walk on the same floor tiles as stately citizens from an ancient city. Everything I did suddenly felt unreasonable and uncouth, like the squeaking sounds of my sandals and the silly song I had stuck in my head. I thought of them; their search for healing and pleasure was the same as mine. They sought relief, excitement, love, clarity. We'd arrived at the same place.

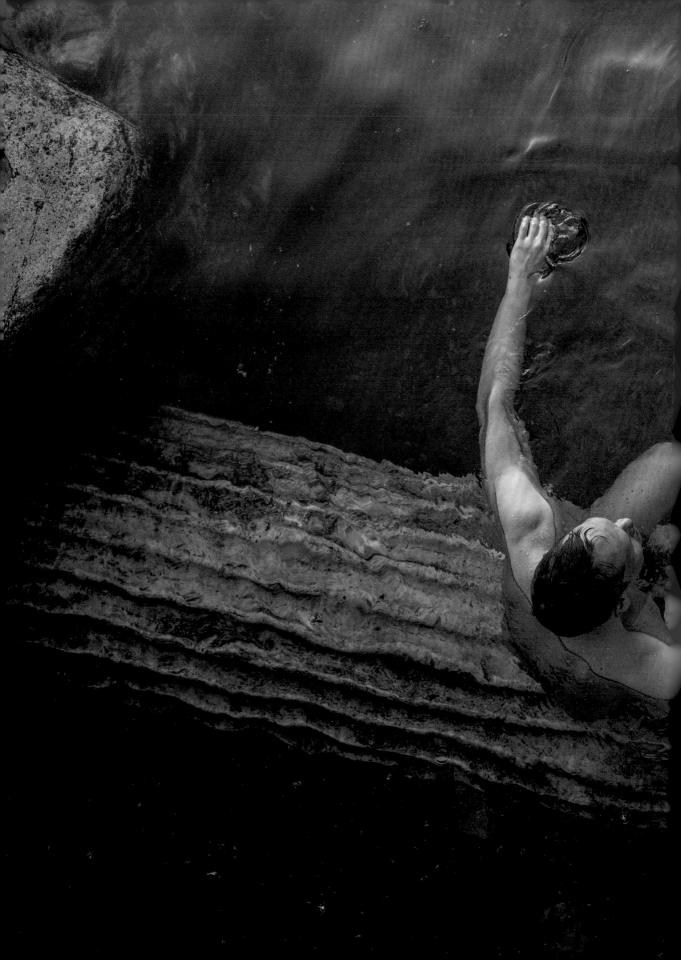

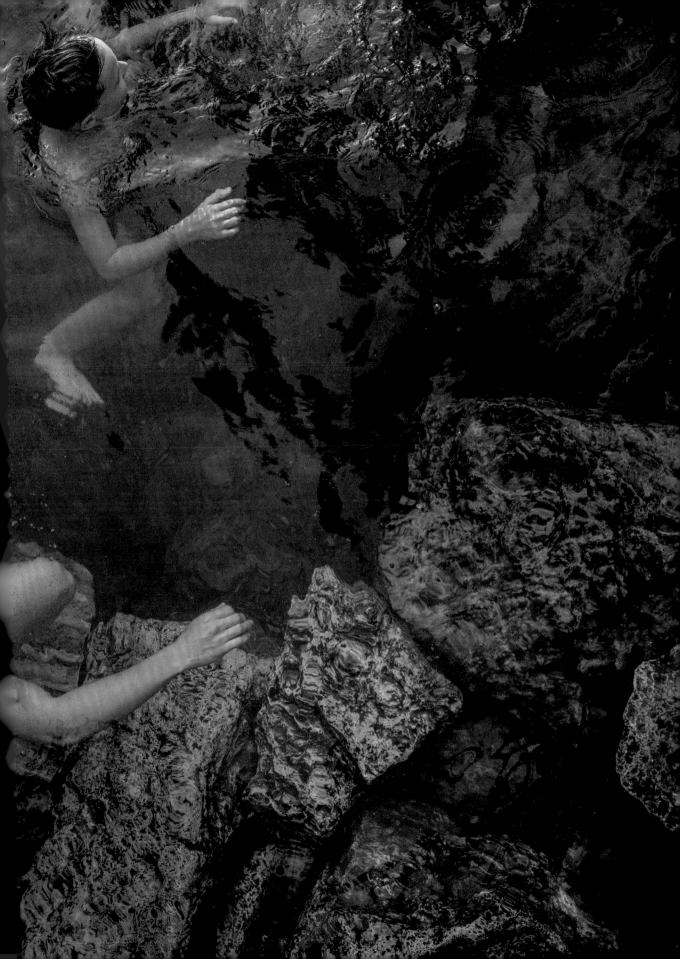

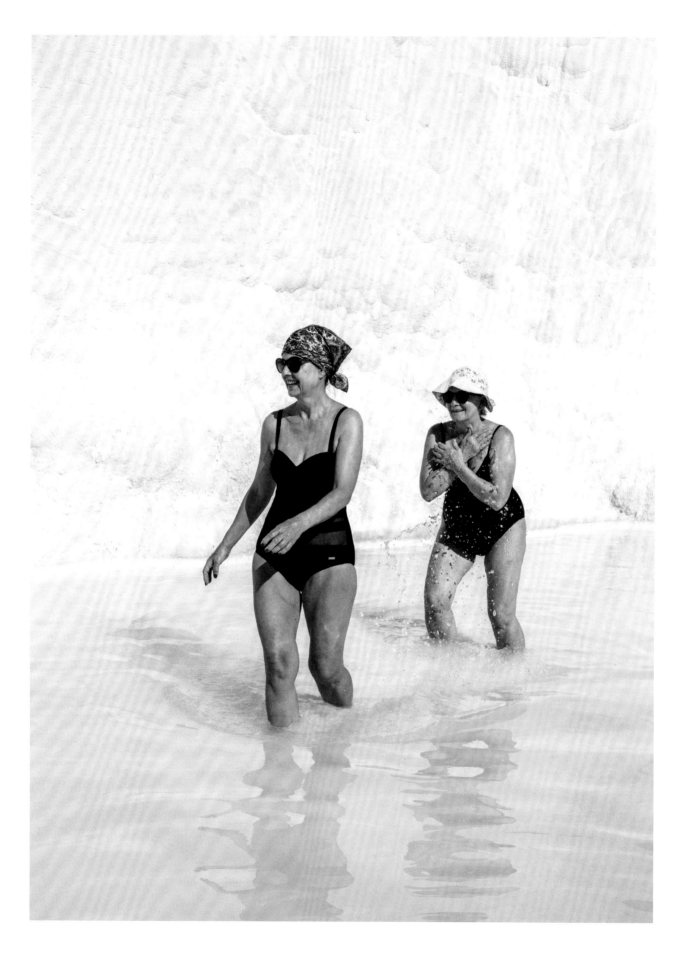

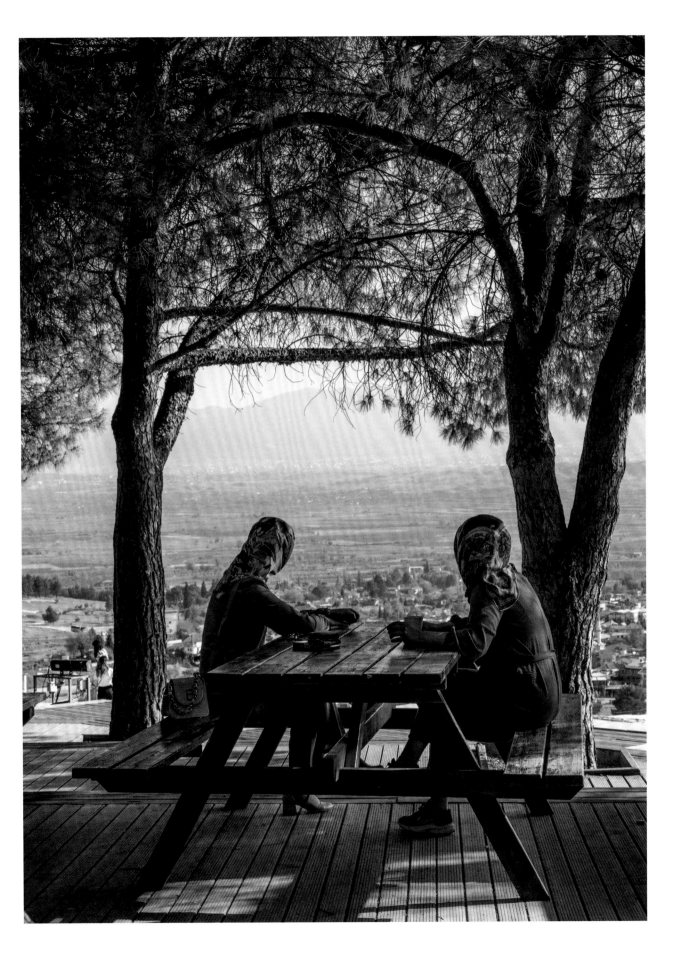

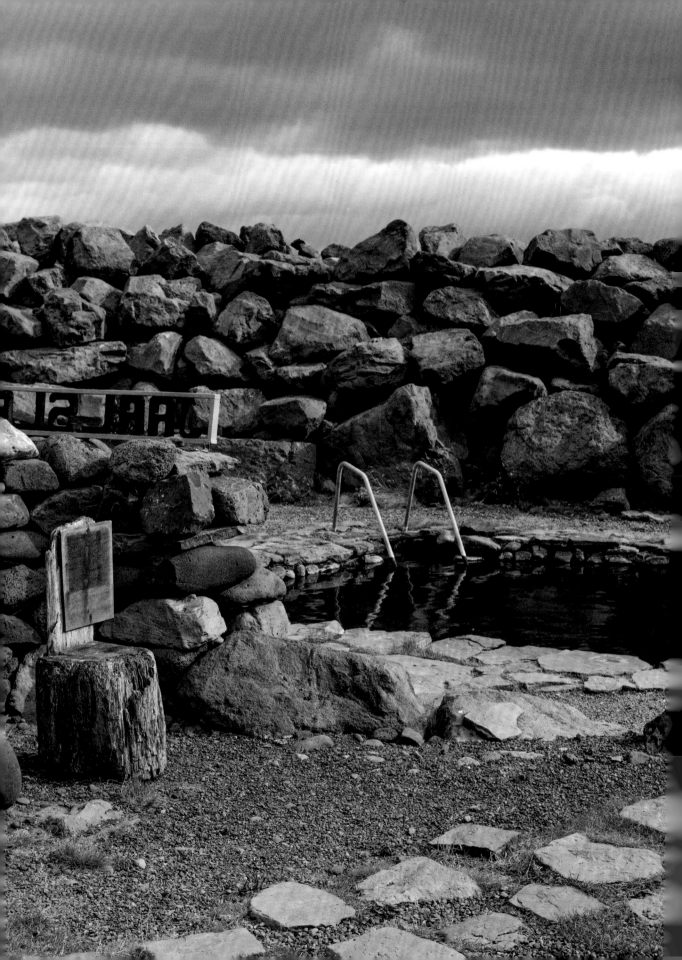

Grettislaug Geothermal Pools

ICELAND

A thousand years ago, an outlaw named Grettir was banished to Drangey, an island in a remote Icelandic fjord. There was no wood for a fire, and no way to keep warm, so he swam the four miles through the sea back to the mainland. Cold and tired from his journey, he rested in a thermal pool by the ocean's edge. His body warmed and restored, he returned to the island with embers for a fire. Grettir lived twenty years as an outlaw on the island, surviving harsh winters and evading punishment. His story was memorialized in Iceland's great sagas, an unlikely protagonist whose name appears across Iceland's landscape.

"[Grettir] hurt people and stole things, but somehow he got people's sympathy because he never gave up," said Icelandic anthropologist and professor Helga Ögmundardóttir. "He just continued to try to preserve his freedom. He never became a tame man under society and there's something about him that makes him very admired."

Grettir's impact on Iceland is still felt today. "When we tell stories about Grettir, we don't really know if he was a physical guy or if he's just mythological, a historical character in a very exciting saga," continued Ögmundardóttir. "It's so much more powerful to tell the story of someone like him by pointing to the world. This is where he went, this is where he lived. We have names that connect natural phenomena to Grettir in many, many places in Iceland. Grettislaug is one of those places."

For many years, Grettir's warm little pools were used by women in the town to wash their clothes. They would ride on horseback with bundles of linens and wash their laundry by hand. In 1934, a strong storm washed the established pools away. Jón Eiriksson, nicknamed the Earl (or Jarl) of Drangey, worked with locals to reconstruct the pools as soaking places in the 1990s, building seawalls to protect them from high waves and tides. He

wanted to preserve the story of Grettir, to allow people to experience the old sagas and the natural landscape. The hot baths are named Grettislaug, for the outlaw, and Jarlslaug, for Jón, the earl.

"My father, he built up this place," said Jón Eiriksson's son Brynjólfur Þór Jónsson, who now manages the hot springs with his siblings. He is also a professional horse riding instructor and cleans the local shrimp processing factory in town. He has three children, who, like he once did with family, play and hike in the surrounding fields and hillsides.

"You get kind of timeless here," he said. "You don't check what time it is, you just live. Relax and live. When I am here, working, I never know what time it is and I'm always late for something else. It has a good sense of calm, this place."

It's a long, dirt road into Grettislaug along the Reykjaströnd coastline, with horses grazing on either side, their long manes whipping in the wind that whirls off the cliff face. The road ends in a parking lot at the harbor's edge. There is a small café and a camping area with a turf-topped kitchen house and washroom. And there are the two pools.

The hot springs are clean and very hot, sourced from the ground's thermal waters and cold water from the mountains. The surface is cooled by the wind and warmed by the sun. When the water is too hot, some people ease their bodies out of the water and plunge into the cold sea where Grettir once swam ashore a thousand years ago, next to the dock where the earl kept his tour boat until his death in his nineties.

"My father made this not for tourism but because of the history," said Brynjólfur. "I always say to people, choose carefully who you want to tell [about Grettislaug]. We want good, kind people to come here."

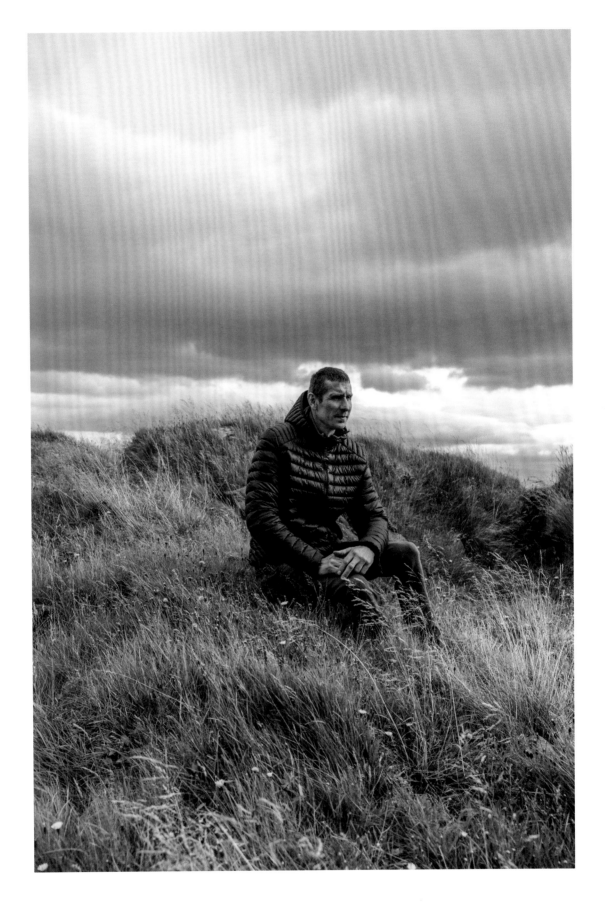

125

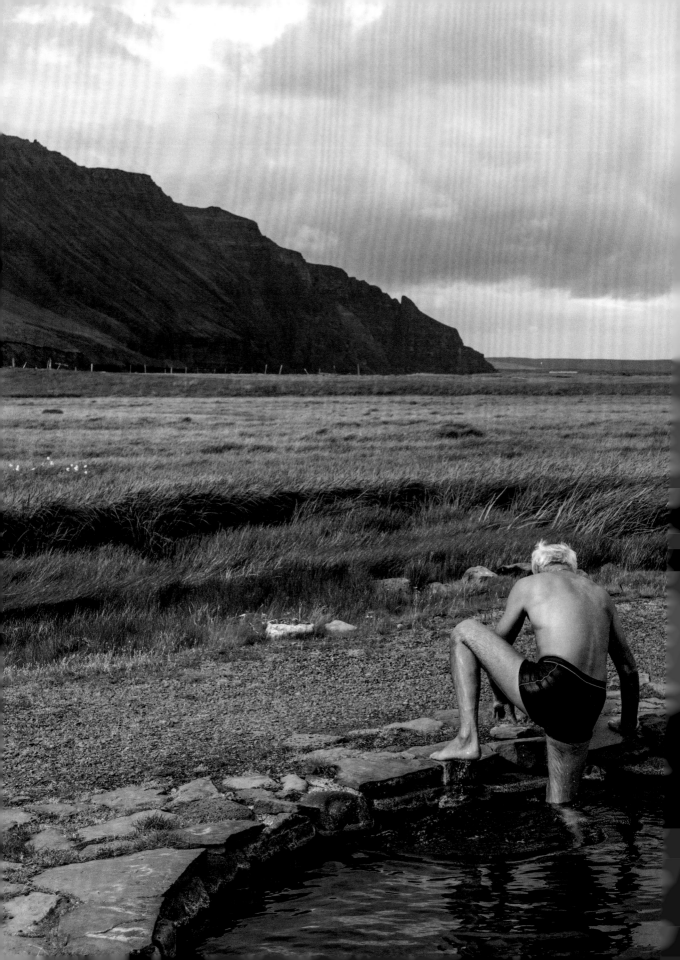

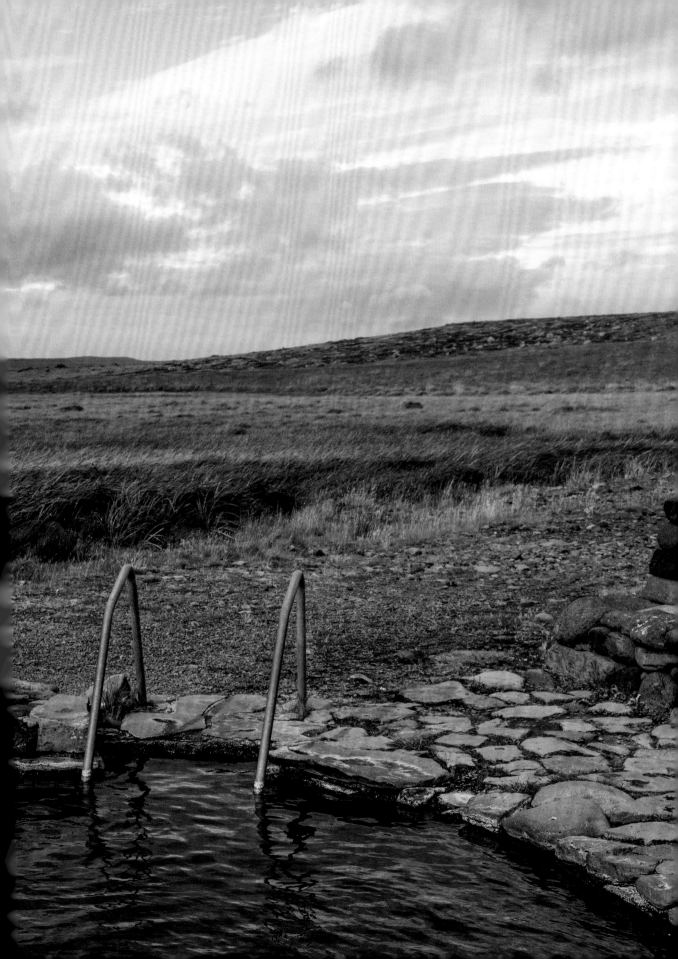

São Miguel's Inland Hot Springs

AZORES, PORTUGAL

In the pilot episode of the 1986 Brazilian telenovela *Dona Beija*, the beautiful Beija—whose character was based on a legendary but real person—bathes naked in a waterfall and slathers mud on her skin. She is absorbed in the pleasure of the water, far from the confines of colonial society and the plot points that made her life worthy of its own soap opera. The real Dona Beija, whose full name was Ana Jacinta de São José, lived from 1800 to 1873. She was kidnapped and abandoned by a lover, and she opened a brothel as a means to find self-sufficiency. Beija's story is a Brazilian legend, the account of a woman ostracized.

The telenovela version of her life gathered the attention of viewers outside Brazil, and it was distributed throughout South America and in Portugal, including the islands of the Azores. TV arrived late to the Azores, in the 1970s. "There were a lot of Brazilian telenovelas, movies, and stories," recalled Professor Isabel Soares de Albergaria, who researches the history of landscapes. "Everyone followed those shows on television, and used the names of the characters for their children or restaurants and places, everything."

The bathing scene of Dona Beija, played by Maitê Proença, was so memorable that it became the namesake of one of São Miguel island's most beautiful thermal baths. Poça da Dona Beija fits its eponym; its beautiful pools sit like starlets on either side of a river. The pools are of varying temperatures, with cascades and infinity edges and wide ribbons of water. Orange sediment settles alongside the floors and walls of the pools, transferring smears of color to skin. People rub it on their faces and bodies to absorb the minerals.

The island of São Miguel is a jumble of mountains, calderas, lakes, pastoral hillsides, tropical forests, beaches, cliffs, and rugged coastlines. Bisected by several faults and home to six volcanic zones, the island is alive and active. In its interior are several hubs of geothermal water, steaming and ready for soaking. In Furnas, on the eastern side of the island, the town centers around the water.

Professor Soares de Albergaria explains that as the epicenter of geothermal activity

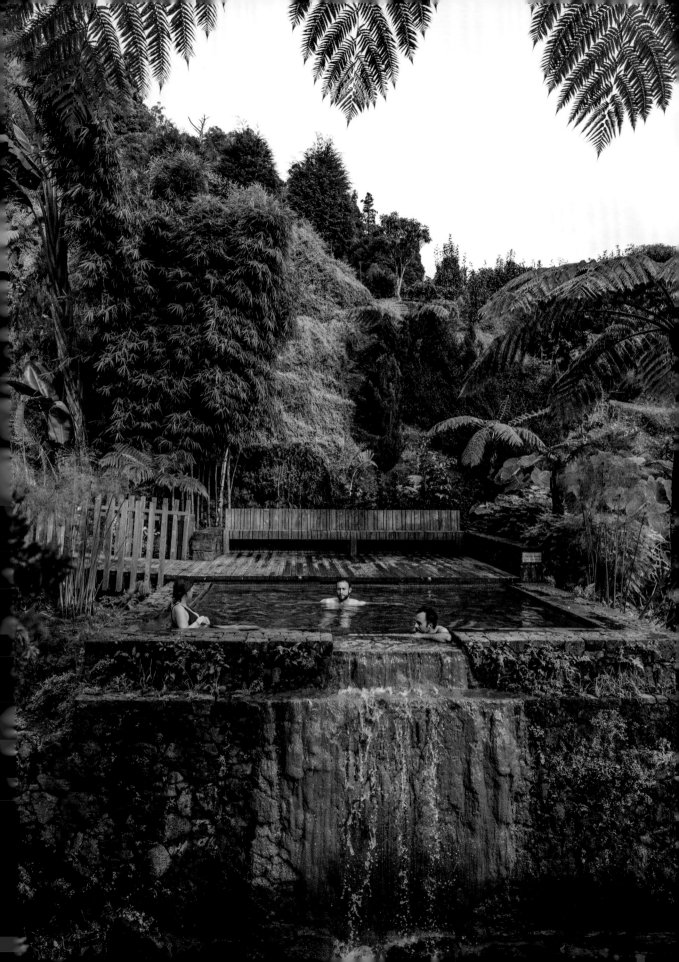

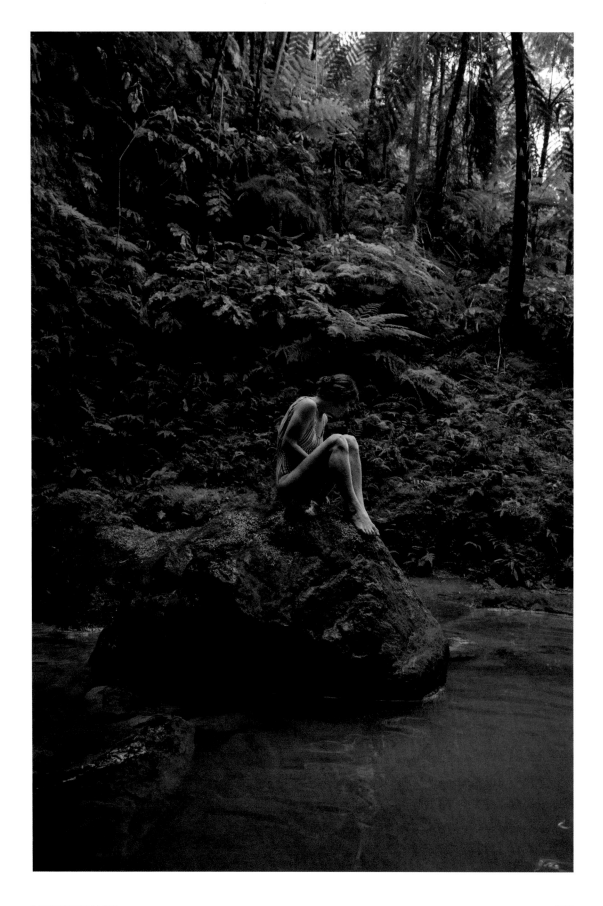

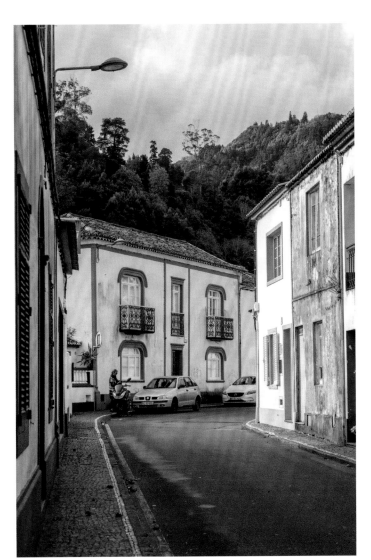

on the island, Furnas was historically both alluring and intimidating, a study in contrasts. "People were terrified," she said. "They saw columns of fog and steam, rising like smoke. There are chronicles from the sixteenth and seventeenth centuries that spoke of Furnas like it was a hell, the innards of the earth coming outward like the devil. One part of the area was named for hell and the other for heaven, because it has many medicinal waters."

It was during the eighteenth century that Furnas became a place for spas. A Bostonian merchant named Thomas Hickling arrived in 1770 at age eighteen and lived there until his death at ninety-four. He built the first country house in Furnas, with a grove of trees and a big freshwater pool that is now the hot spring. Nobility and peasants alike enjoyed his estate and would row in small boats, go fishing, and recreate at the pool. He was known to welcome all people freely.

In town, the art deco–era Terra Nostra Garden Hotel continues Hickling's spirit of hospitality at the location of his home. A massive apricot-colored thermal pool, now used for soaking and wading, gleams at the property's center. The pool is chest deep and as large as a sports pitch opaque with minerals.

The heat from the region's springs has long been used by local people to cook, loosen feathers from chickens, boil corn, or soften wood for furniture making. At lunchtime in Furnas, workers from local restaurants drive to local thermal parks to hoist silver pots of stew from ovens dug into the sandy soil between the bubbling mud pots and steaming fumaroles. The stew, called cozido das furnas, is made of meat and blood sausage with potatoes and vegetables. The volcano cooks it for hours, until it's tender and flavorful.

In the center of the island, on one side of the Água de Pau Massif stratovolcano, is Caldeira Velha. The interpretive center explains on a placard: "Geothermal energy comes from the internal heat of the Earth, associated with the structure and physical processes that occur within the planet . . . thermal springs are the surface manifestations of this deep

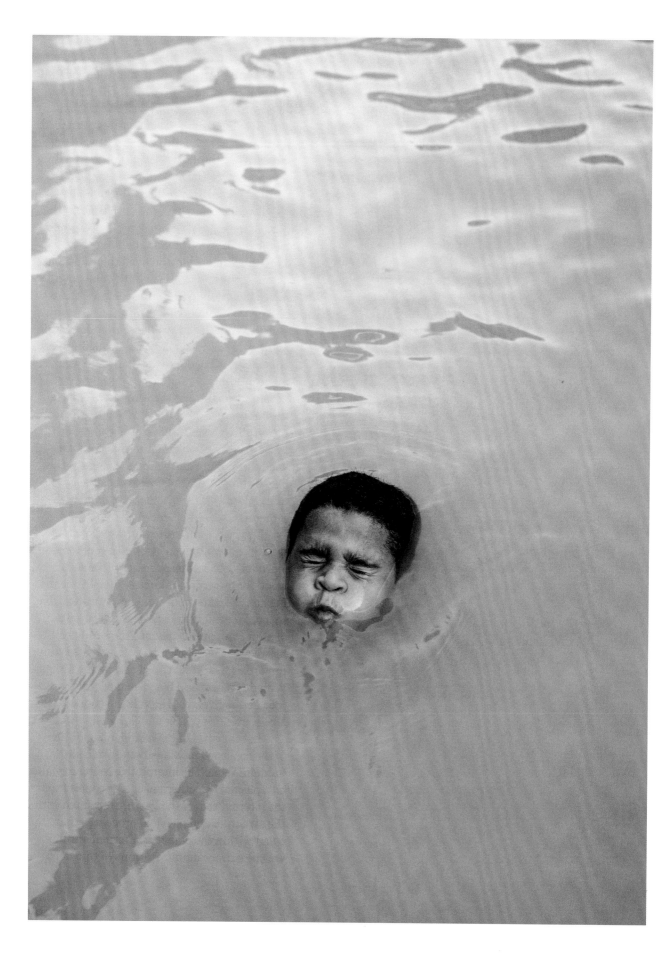

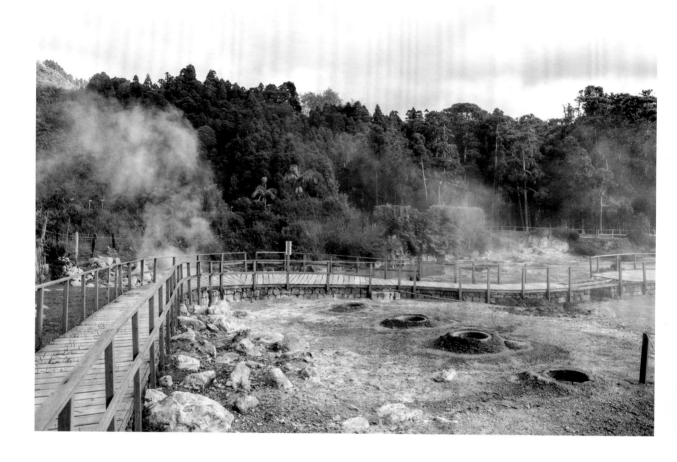

energy source." Here, the thermal springs are an emerald green, the biosphere somehow even greener than elsewhere on the island, thick and verdant.

The Azores have been shaped by a wild history of geologic activity and a more recent human history. New research suggests that the Norse arrived on the islands with livestock in the 700s and 800s, followed by the arrival in the fifteenth century of the Portuguese, who got to work shaping the landscape of the islands for human use. "Travelers always write about the nature, the nature, the nature. But it has been transformed. It is a landscape made by people, by culture," said Professor Soares de Albergaria. "But the Azoreans, in general, have a very intimate experience with nature. Nature here is very, very present: the storms, the winds, the waters, the geology. The volcanoes, the craters, the hot springs. It's a very telluric experience."

The hot springs people use are managed, prepared, contained, and structured. Thermal water, in its wildest form, is scalding and menacing. It must be tempered with cool water. It takes reciprocity to enjoy the springs; we care for them and they will return the care. They can give us a space to connect us to each other and to the planet, literally introducing us to the hidden core of the place we call home.

Pilgrim Hot Springs

ALASKA, UNITED STATES

The Seward Peninsula sits just below the Bering Strait extending westward toward Russia. During the winter, there are twenty-one hours of darkness per day. In midsummer, twenty-one hours of daylight. The climate here is extreme, with below-zero temperatures that freeze the seas, shutting off shipping and transportation. The town of Nome sits on the southern side of the peninsula, and there are no highways that connect it to other regions of Alaska, just three main roads extending outward until they end in the tundra or at a settlement. One of those roads leads to Pilgrim Hot Springs.

Ayyu, a local taxi driver, agreed to drive me to Pilgrim Hot Springs, sixty miles north of Nome. She had a full car: me, her niece, her nephew, and her mother, Darlene. Darlene told dirty jokes, and Ayyu shared the juiciest stories from town. All of them involved danger: being run off the road, a bush plane crashing in bad weather, a man getting trapped in his cabin by a hungry bear. When we pulled off onto the road that led to Pilgrim, the ruts were large enough to swallow a wheel. As they dropped me off, Darlene handed me a ziplock bag of salmon and pilot bread. She had caught and smoked the salmon herself.

Folks here rely on subsistence from fishing and hunting and gathering, and use the pricey village store for the rest. The tundra provides habitat for caribou, bear, and moose. The sea provides walrus, seal, sea lion, crab, and fish. The rivers provide salmon, char, pike, and trout. The land provides plants and berries for medicines and foods. For thousands of years, the Iñupiaq people have fished and hunted with the cycles of the seasons, animals, and plants. They used the hot springs area for bathing, collecting firewood, and gathering plants for food and medicine. While sitting in the hot springs, a woman nodded toward the mountains and the sea beyond and told me, "Our creation story is there, over that mountain range. We know the exact place we came from."

Two centuries ago, life on the tundra changed with the arrival of colonizers and extractors. Slowly, then quickly they came: sea captains, merchants, surveyors, missionaries, whale hunters, traders. In 1867, the United States purchased the Alaskan territory,

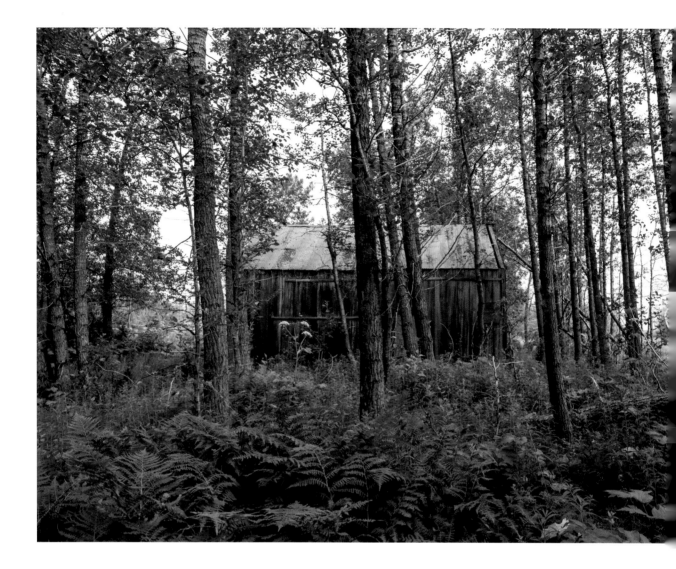

and with it came subjugation of Indigenous sovereignty, written directly into the language of the treaty. A gold rush arrived thirty years later, bringing debauchery and lawlessness to Nome. Father Bellarmine Lafortune arrived and, in 1918, founded a school and orphanage on the site of the hot springs. He selected the site for its distance from the indecency of the gold rush town and the microclimate's potential to produce vegetables in the extended warm seasons.

That fall, the last supply ship arrived in Nome, and with it, influenza. Entire families were decimated; the loss was staggering. In less than a month, 176 out of 300 Native people in Nome had perished. One survivor recalled watching chimney smoke disappear from each home, one by one, as households succumbed to illness.

In most families, the children were spared. Many of them went to live in the new school and orphanage at the hot springs, subject to the regimes of the mission. First, they lost their families, and then they lost their lifeways. "All of a sudden, they had all this structure instead of just living by the seasons and the rhythms of the daylight," said Amanda Toerdal, the hot springs' general manager.

"The influenza epidemic in itself was a result of colonization, bringing in disease and killing families," Nome local Danielle Slingsby explained while in the hot springs with her son. "And then, there was the religious aspect of missionary schools, which stripped

communities of their culture. . . . There is a traumatic history here and within the region."

Lafortune was known to speak fluent Iñupiaq and expressed disdain for schools that emphasized assimilation. However, the children were not encouraged to speak Iñupiaq and many of them soon forgot their language. The primary account of life at the mission was written entirely by the Jesuits and omitted the narratives of the children. The house diary detailed weather events, garden yields, chore cycles, and health events until the mission closed in 1941. In 2010, the Fairbanks Catholic diocese was forced to sell property, including Pilgrim, after abuse scandals and resulting lawsuits. The land and its resources are now

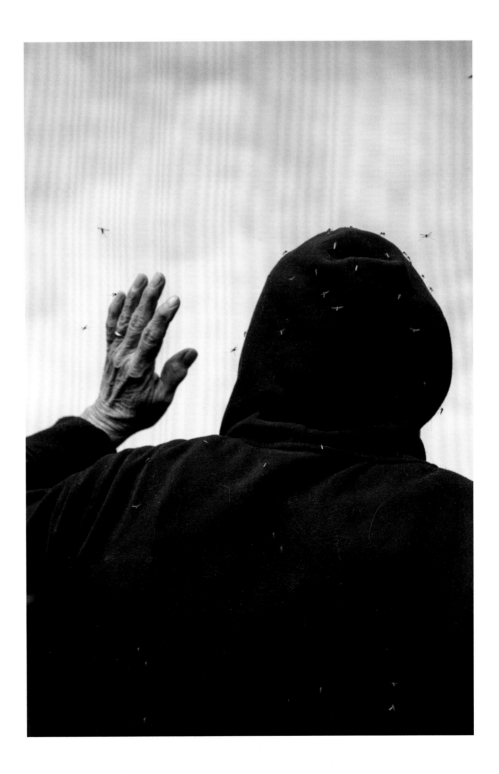

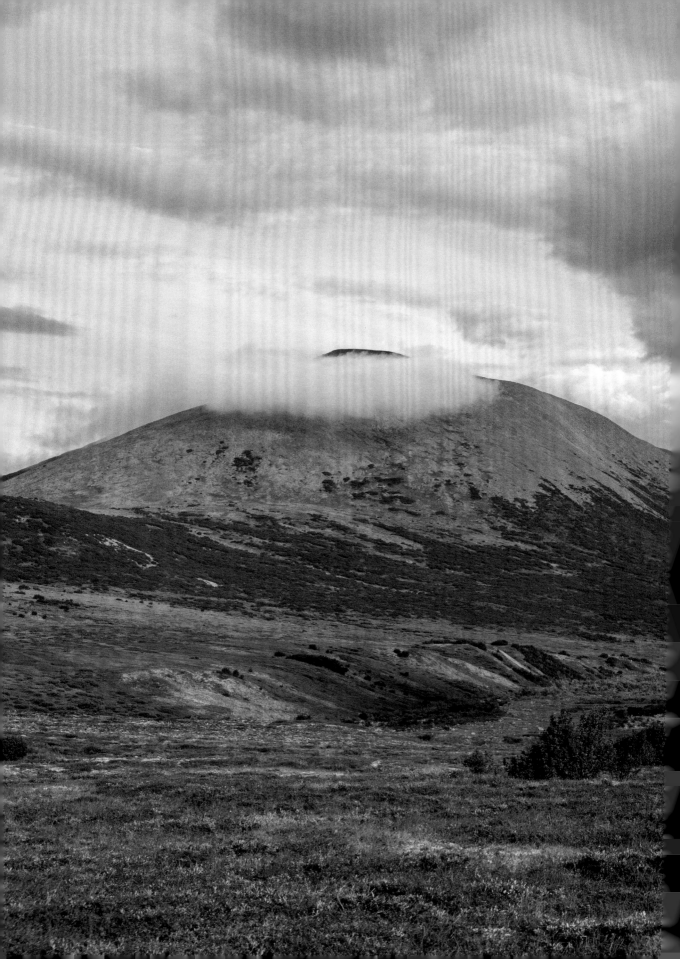

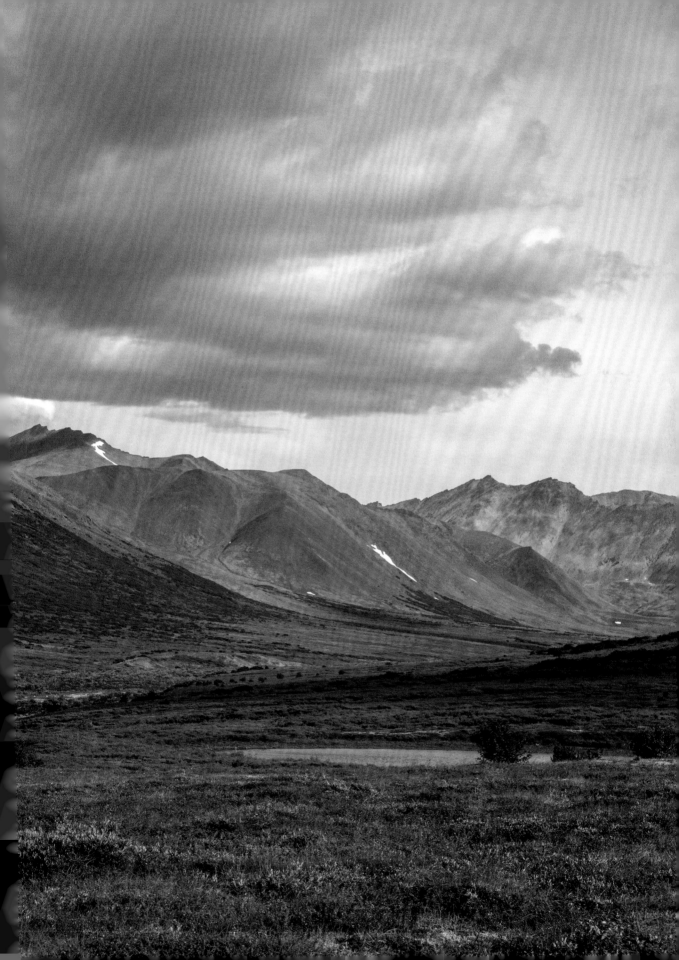

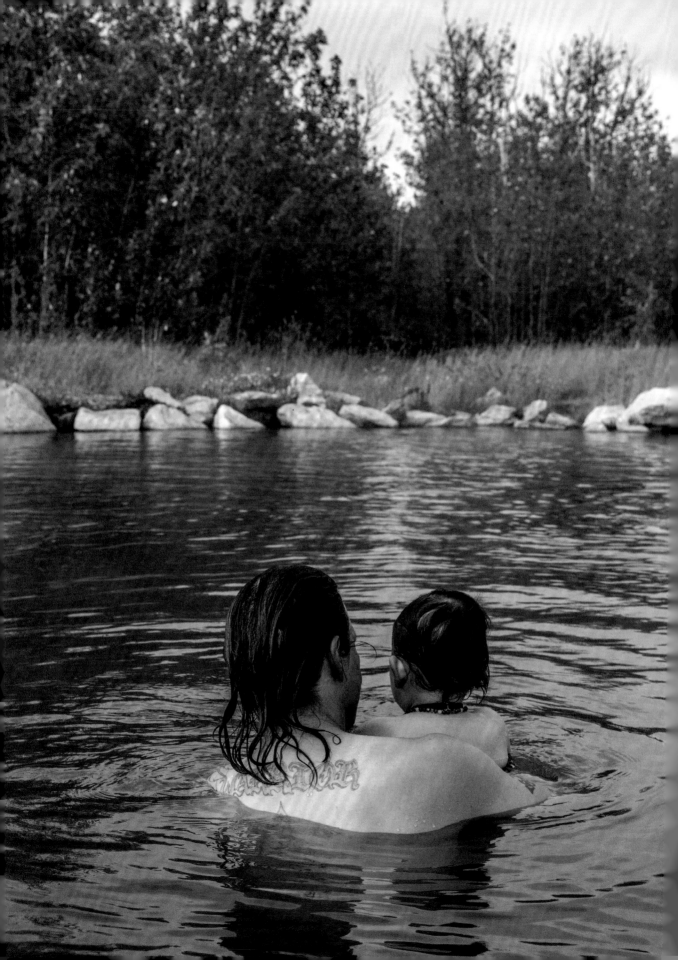

managed by a collective of seven stakeholders, including five Native-led organizations. They've built a new soaking pool, three sleeping cabins, and tent camping sites, all overseen by two seasonal caretakers. The community sees possibility in Pilgrim: they are exploring ways to honor the complicated history, produce geothermal energy, and provide fresh food to the region. "The villages don't get fresh produce as it is, and access has been worsening. So, if we could grow produce locally, it would be incredible. In the 1920s and '30s, Pilgrim grew all kinds of produce and flew it into the villages with bush planes," said Amanda.

Yaayuk Alvanna-Stimpfle was at the site visiting with her family, a large group of several generations. They brought a picnic, and the children played and swam. Each day, folks from Nome come up to soak, share a meal, or camp a night or two. A man who visited with his two children told me his job is to use special machinery to walk on the ocean floor to dredge for gold. A father and son from the lower forty-eight came to camp but were so cold they spent most of their time in the hot springs. There was a young family teaching their daughter to swim. Most people I met called the springs "Pilgrim," but some used the Iñupiaq Qawiaraq name,

"Unaatuq," meaning "warm waters." There is an effort to reclaim its traditional name.

The pool is warm and silty bottomed. Next to it is a small pool for toddlers and little ones, just a few inches deep. Marisa Neil, who spent a summer caretaking at Pilgrim, told me that her favorite thing about the job was seeing the children, the new generations that come here. She could hear families laughing from her little cabin's front porch. It's now a place for people to be with each other, to find solitude, to be with the land and the water, and to simply have fun. And that in itself is a type of restoration or healing.

"'Nuna' means 'land.' And 'nuna ga vak tunga' means 'I'm having fun.' The first part of 'having fun' is 'nuna,' 'land.' Because you have the most fun when you're berry picking or fishing or hunting. And it's true!" said Kiminaq Alvanna-Stimpfle, Yaayuk's daughter who teaches Iñupiaq language immersion to kindergarteners in Nome. "For me, when I have the most fun, I'm on the land. Like right now, where am I? I'm on the land, enjoying the hot springs! I've always been told that our language comes from that; to know our language is to know the land."

Healing

Budapest Spas

HUNGARY

The first person I met in Budapest was a taxi driver named Norbert Borbás, who drove me from the airport to my little rental apartment in the city center. When he heard I was in the city to visit the thermal baths, he brightened. He told me to visit Széchenyi and Gellért, the two most famous hot baths, called "fürdő" in Hungarian. Thermal baths are a way of life for Hungarians, he told me, an important part of local history. It is said that shamans and witch doctors were the first to persuade nomadic people to settle along the sources of hot water twelve thousand years ago, marking the beginning of a bathing tradition in the area that was later shaped by the Romans and Turks, but is now distinctly Hungarian.

My first morning in Budapest, I took a creaky yellow metro car toward Széchenyi Fürdő. In the lobby at Széchenyi, I watched people pass through with gym bags, locals looking to beat the afternoon's tourist crowds. In the water, elders playfully fluttered their feet like children. Groups of men played chess on the edges of the pool on waterproof boards; sometimes the pieces slid around in drips of water. I met a man named László who told me that he is among many Lászlós who come each day: "It is Hungary's most common name; shout the name 'László' at the pool, and ten heads will turn," he said. Women pressed their backs against massage jets to soothe sore muscles. People with scars and crutches wandered around with a towel and a laminated list of physical therapy instructions. Tourists and travelers took photos with their cell phones, posing for the camera.

Built in 1913, Széchenyi served the local people, creating a place to cleanse their bodies in the days before indoor plumbing. It is like a palace, the Disneyland of hot baths. There are eighteen pools, three outside and fifteen inside. Wide steps are built around each side of the pool, meant for lounging. The outdoor pools swirl with jets and fountains and special features like whirling currents, many of them made in the spirit of fun. On Saturday nights,

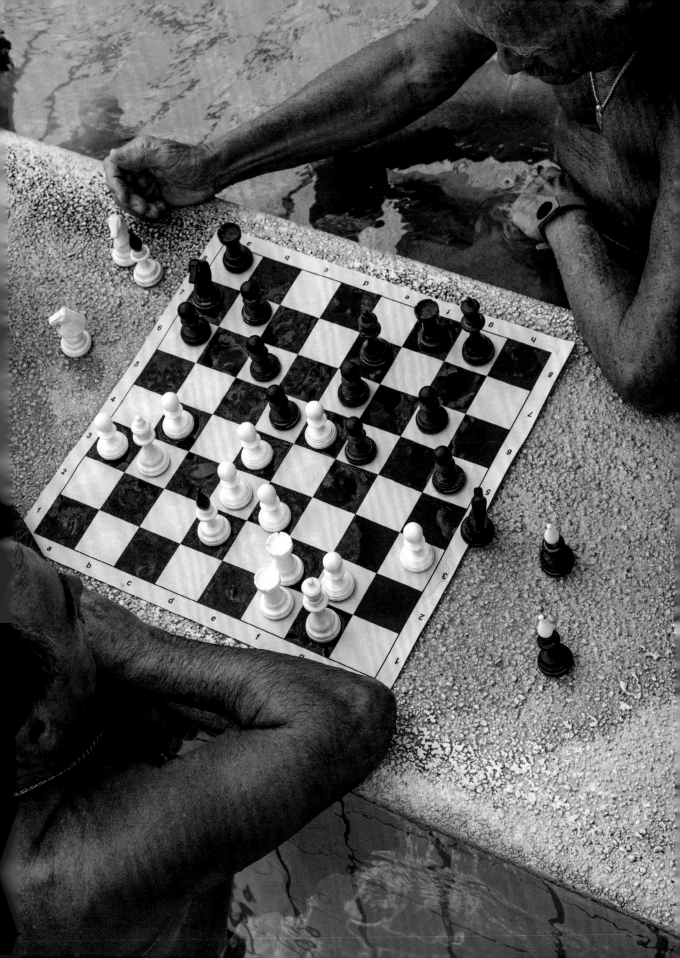

after dark, the pools become a disco. Live DJs play EDM while young tourists dance in the water. This is Széchenyi's famous "Sparty."

Budapest spas seem to clarify two distinct yet simultaneous uses of thermal water: medical and leisure use. If you are working and paying taxes in Hungary, you are entitled to use the spas for medical treatments. Doctors can prescribe a thermal treatment, referring the patient to specialists at the spa who determine the treatment's regularity, temperature, duration, and locations on the body. There are special pools for stretching and others for training with braces and weights, carbonated pools, daily water aerobics, and little fabric cubicles for massages, magnetic therapies, and electric treatments. In Széchenyi, practitioners apply heated or cooled muds to the body, swaddling muddy patients in warm blankets. A man named Augustin told me that he was there to treat a spinal hernia; the mud prevented him from having to rely on painkillers for relief. In a little tiled room in Széchenyi, a woman poured me a glass mug of warm water. It tasted the way hot springs smell and feel: metallic, heavy, rich in minerals, the water soft and comforting.

Across the Danube River and on the other side of the city is Gellért Spa. It's so beautiful, I nearly cry when I step into it. Its ornate ceilings curve upward with detailed mosaics, soft light filters through a grid of skylights. The design is symmetrical, with tandem wings that once served men on one side and women on the other, but was integrated in 2013. In the middle, an ornate art nouveau pool, now used for lap swim, was the former common area for both genders. During World War II, the women's side was bombed, its

pinkish mosaics demolished, repaired but never restored to their original complexity. Even so, the baths opened to the public the next day. Gellért has closed only three times: once because of a technical problem, once when Eddie Murphy was filming on-site, and most recently because of the coronavirus pandemic.

On my last day, I emailed Norbert and asked him for a ride to the airport. When I stepped into his taxi, he was bursting with questions about my time at the spas and stories of his own. "We love thermal and we know how to use it and enjoy it," he said. "When I'm in the thermal baths, I always think of the history. I think it's amazing that people hundreds of years ago were sitting between those same rocks and stones, sitting where I am sitting. When I go to the baths, I am time traveling."

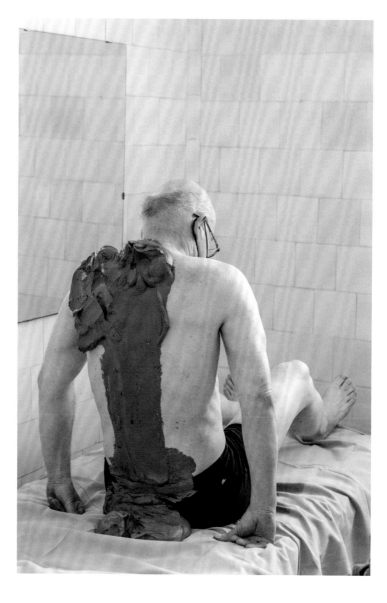

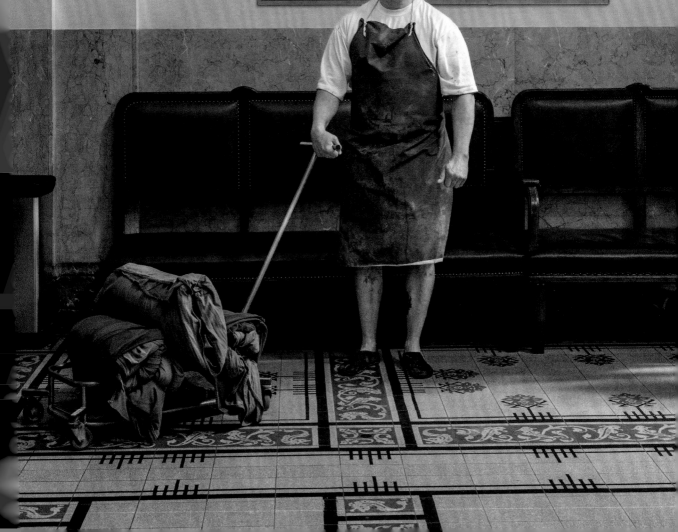

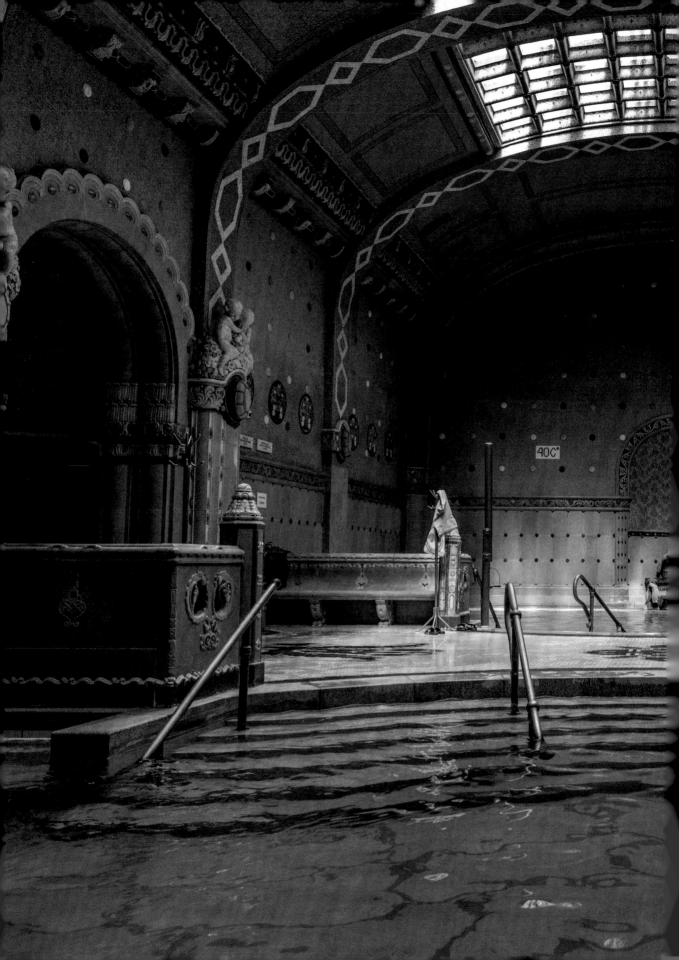

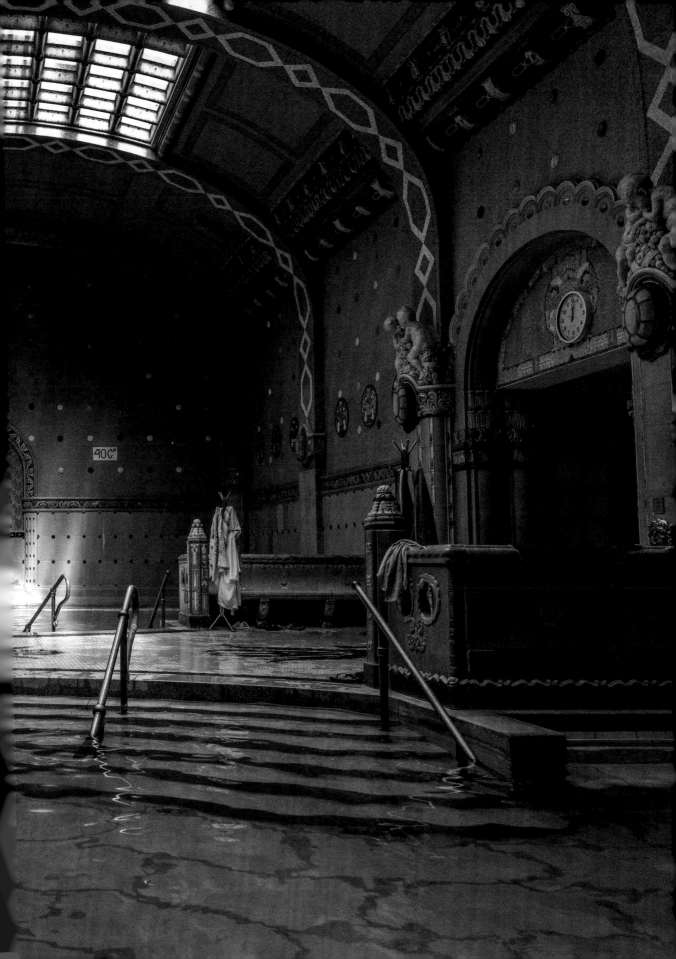

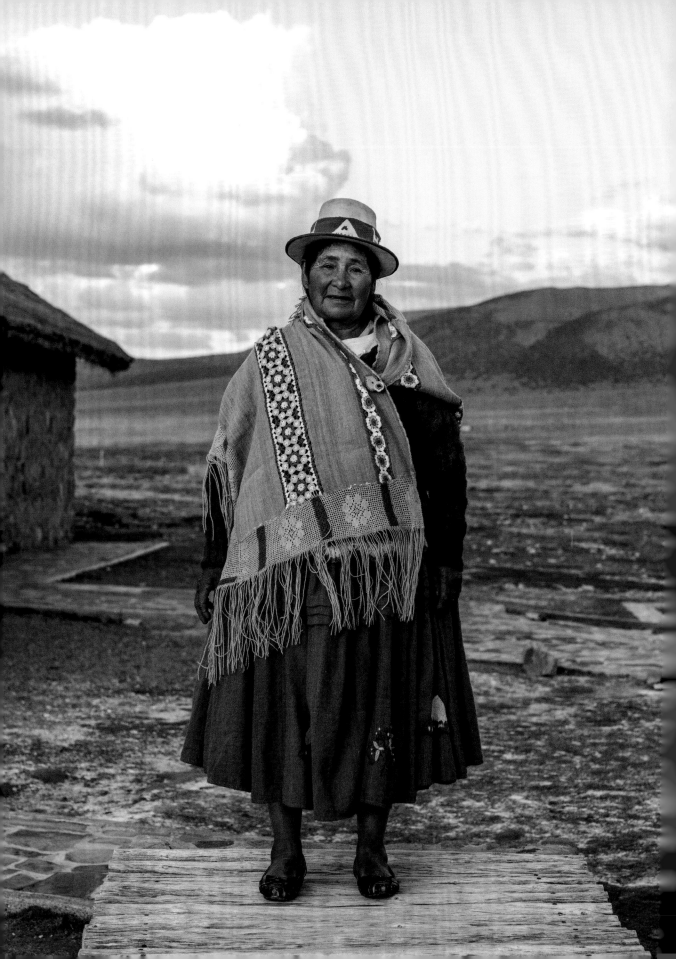

Mount Sajama Thermal Pools

BOLIVIA

From Inés Alvarez Pacaje's hot spring, we could see the storm clouds rolling in: big, fluffy cumulonimbus clouds that threatened lightning. It was evening, and the clouds and dusk conspired toward darkness. Mount Sajama, Bolivia's tallest mountain at over twenty-one thousand feet, rose from the valley floor in front of us.

Earlier that day we'd left La Paz, where we'd spent a few days letting our lungs adjust to the elevation. Stairs felt like a sprint. Our guide, Bruno Henry Choque Peñafiel, and our driver, Marcelo Nina Osnayo, picked us up and we drove up and out of the city and across the high plains. From a far distance, we could see the enormous mountain rising from the plains. We stopped at a public market for hats to protect us from the relentless sun. We maneuvered through herds of llamas, their ears decorated with colorful pom-poms. We passed homemade scarecrows that protected llamas from pumas. Once, Marcelo stopped the car to chase a dog that was chasing a chicken.

Marcelo grew up in Sajama, the eldest of eleven children. They had no running water and no electricity. He used lanterns fueled with llama fat to illuminate his homework. When his family relocated to Chile to find work, he stayed behind to tend to the herds, a responsibility so consuming he left school. As a child, he rode his bike to the hot springs on Sundays, monitoring the passage of time by setting a stone on its end and watching the movement of the shadows. Inés, who operates one of the valley's hot springs, is one of Marcelo's relatives. The day we visited, Marcelo swung open the gate to her land and was in the water before any of us had changed into our suits. We saw Inés walking industriously toward us, her hands clasped behind her as she returned from checking on her llamas.

When she was six, Inés became an orphan, raised by an uncle she described as "a very bad, broken man." The land was her father's, so she established the hot spring in honor of him.

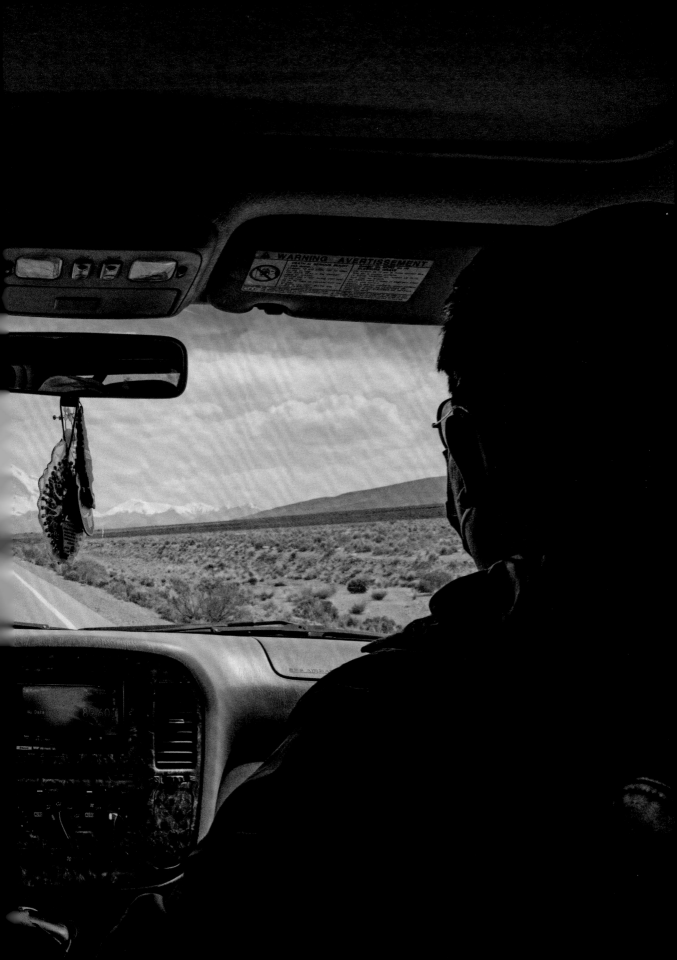

"My father had the idea of making a beautiful thermal pool for us to swim in; that's what he would tell me," she said. "This river, this fountain, was connected to the water; they were together. I initially made it a very tiny private thermal pool, just for my family. But as people have been getting to know this place, they have supported me and told me, 'Look, Doña Inés, you can expand it.'"

Word spread about the hot spring, in part because of Marcelo. At twenty-four, he climbed Sajama for the first time; he became a porter, then a cook, then a certified guide. He brought his clients to the hot spring to rest

their muscles and celebrate the effort of their climb to the summit. Sometimes when people come for holidays and celebrations, they bring a small band and a grill to cook big meals for their family and friends.

Before Inés left us to return to her home, I asked her for a portrait. She directed me where to stand to take the photo so that the mountain would be directly behind her. "I always ask for a picture with Mount Sajama," she said.

"Mount Sajama is a doctor," said Marcelo. "We have a strong ancestral culture: we say that it is 'The Doctor' that cures you. The mountain is covered with the coat of the white

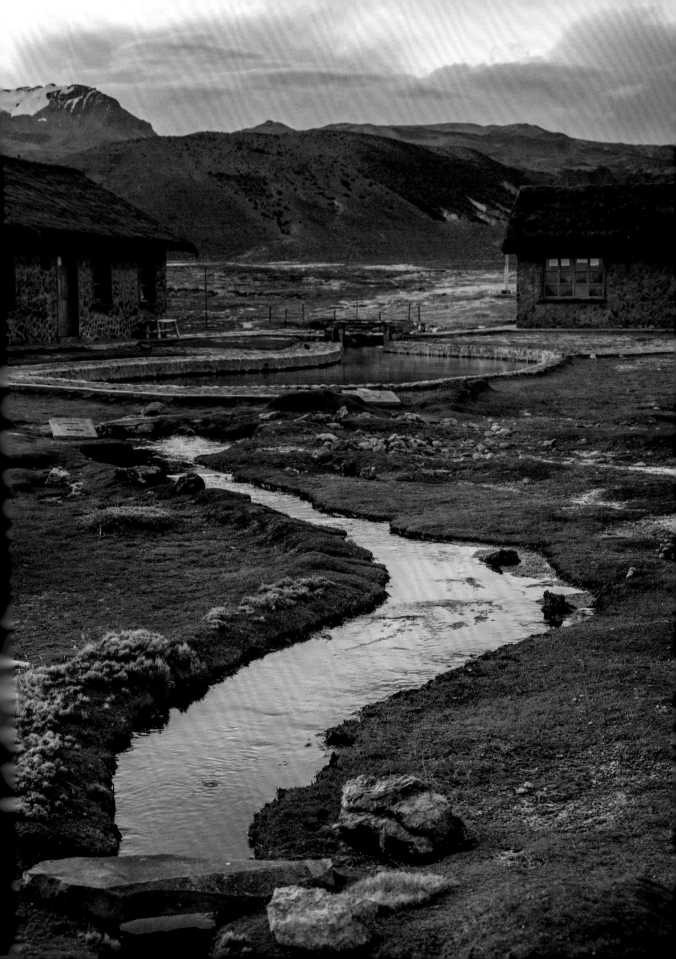

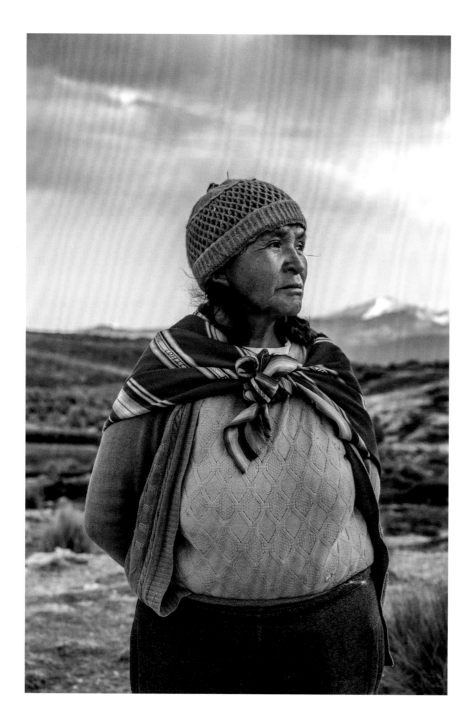

snow like a doctor, and the water that emerges from the mountain are his tears that give us what we need for stockbreeding. He is like a father who takes care of us."

The hot springs, too, are considered to be medicine, a balm for the hardworking people of the area. The weather is harsh, and the daily work is relentless, especially for women whose workloads include labor in and outside the household. "My wife, for example, worked here for seventeen years in a kitchen with only cold water, and she developed arthritis," Marcelo said. "When we used to go to the water springs, it moved in her bones. They contain many minerals, like sulfur, arsenic, potassium, and salt. It is a mixture of medicines."

Not far from Inés's hot spring, a woman named Micaela Billcap runs another hot spring with several other families who manage the water and its facilities together. Micaela owns the parcel of land with the thermal springs, but it is collectively managed and operated by the community, including sharing the profits. When I met her, she was hopping off a four-wheeler wearing a dress over sweatpants, an apron, and plastic boots. She took our payment for use of the warm pool and promised to come visit us later. We soaked and admired the vantage point of Sajama. She returned in a grand, traditional dress with an intricately woven shawl and a matching hat. The outfit was the color of soil. She held my hand while she told me that each piece was woven from her herd of llamas.

Before leaving the valley, Marcelo drove us to an area in the surrounding hills full of geothermal activity, where geysers steam and bubble. While we explored, he boiled several eggs in the roiling water and we ate them with fruit. He took us to Sajama village, where his success as a guide has allowed him to open a hostel and restaurant and find ways to give back to the community. "You must give back to the town's society," Marcelo said. "Then, you feel at peace. Then, there's freedom." In town, we climbed an ancient bell tower at a church. From there, we could see roving llama herds, the road that led to the hot spring, and the small grid of the village. In the square below, a small group gathered to organize a community cleanup, and above them, above everything, stood the mountain in its white coat.

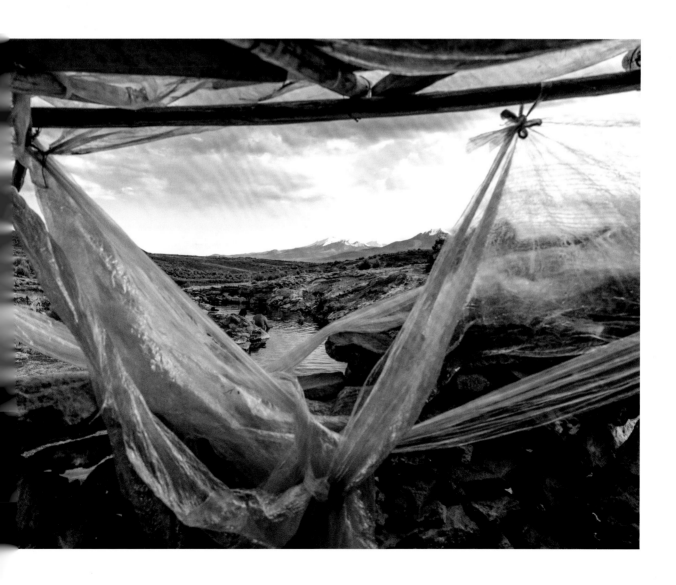

Mývatn Nature Baths

ICELAND

Iceland often smells of geothermal water and steam; heavy, sulfuric, and metallic. I could smell it outside the airport, running in the municipal faucets, and in wafts along the roadside as I drove northward along the ring road. Over 85 percent of homes in Iceland are heated by geothermal energy, using turbines to capture the pressurized steam that results from precipitation trickling down to hot bedrock. Among the earliest of the island's six power plants is the Bjarnarflag Geothermal Station, built in the late 1960s between the shores of Lake Mývatn and Námafjall Mountain. It generates 18 gigawatt hours (GWh) of electricity annually, creating a bright-blue alkaline runoff that pools at the power plant base, then is harnessed by the Mývatn Nature Baths for soaking and swimming.

Considered to be smaller and less touristy than the Blue Lagoon in the south, the nature baths still see their share of tourists coming to soak their bodies after hikes in the steaming, surreal mountains. The pool is large and deep, with chest-high water and a silty bottom. There is a swim-up bar, a steam room, a café, and changing rooms. There is a calm sense of order, a set of rules and procedures for doing things. Everyone obediently follows the guidelines about cleanliness and showering: strangers scrub their bodies beside each other before venturing outside to the big, blue basin. There are special areas for outdoor shoes. Once an hour, a worker circles around with a trash bag to pick up rubbish. But rules and fun are not mutually exclusive. I saw a large group of friends from Italy laughing on one side of the pool, while a couple from Spain meditated on the other. A group of retirees from the Netherlands took turns floating on their backs, and two sweethearts from France kissed each other on the cheeks and face. Everyone seemed content.

"In hot springs, you see all kinds of bodies and you see the bodies of strangers," said Icelandic anthropologist Helga Ögmundardóttir. "Now that tourism has increased, you may see people from all around the world in an Icelandic hot spring. I mean, to see the half-naked bodies of others! That should be normal. Your body is irrelevant. Your body is your shelter

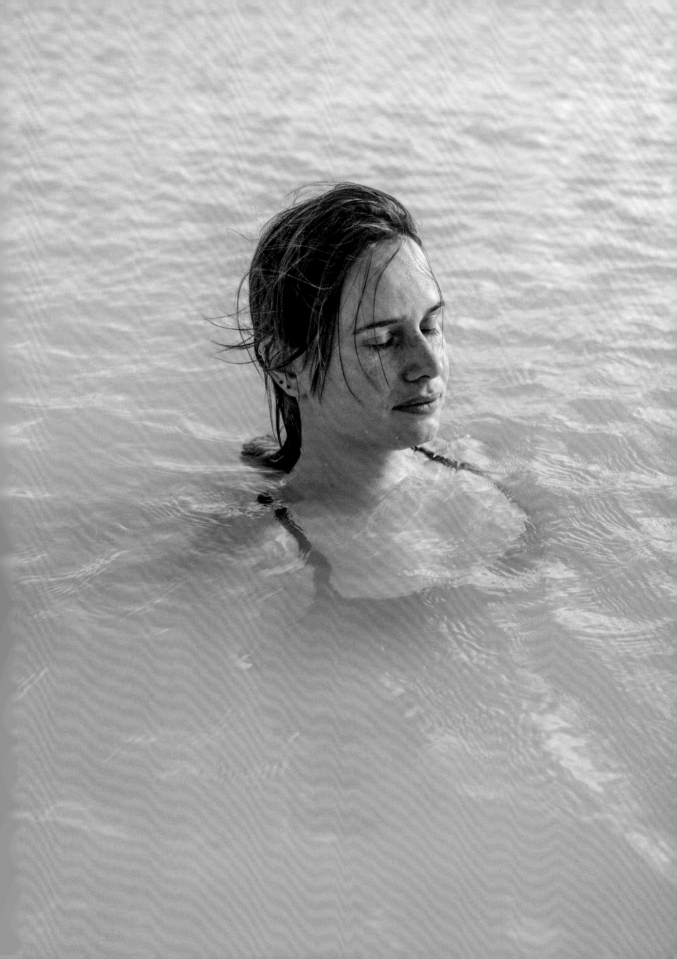

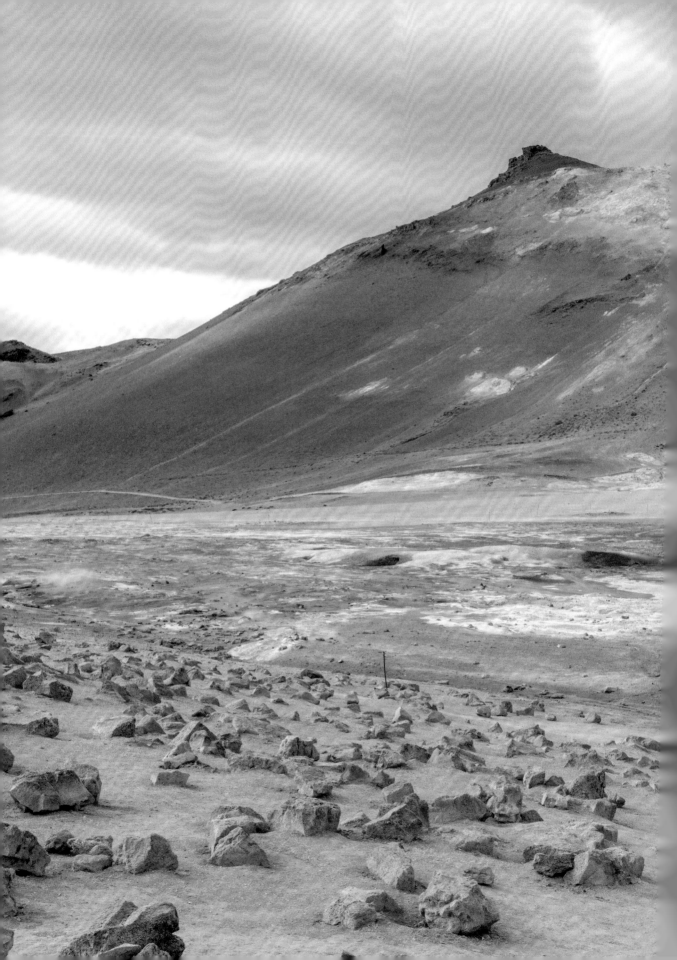

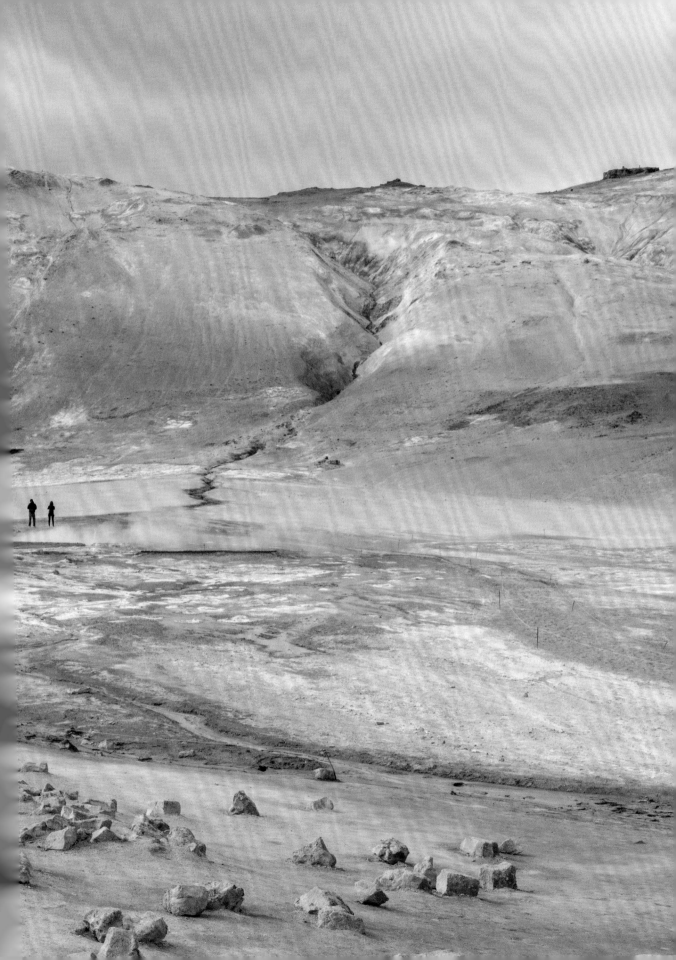

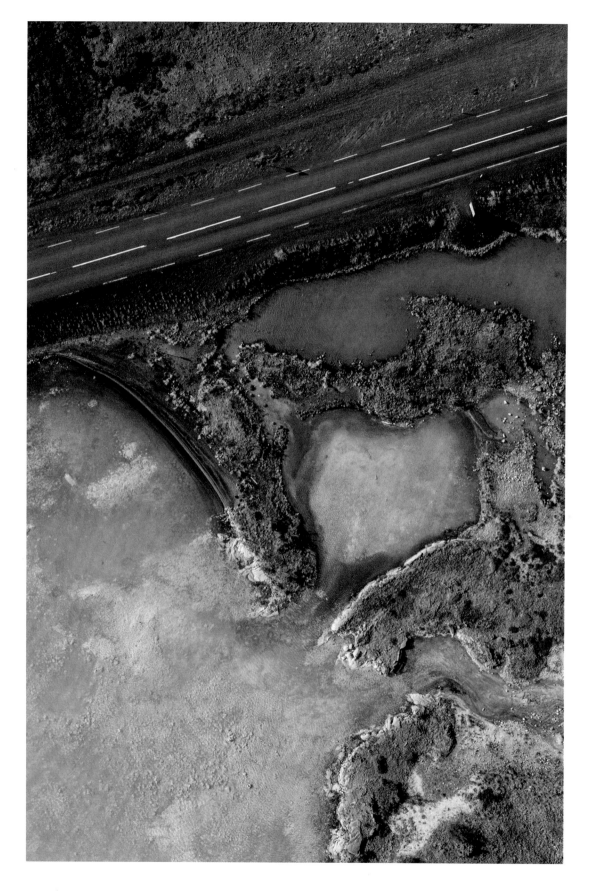

for this life." The hot spring is a place with a warm perspective of our bodies.

Jón "Nonni" Friðriksson runs a popular nearby café named Kaffi Borgir with his father. Each morning, he visits a nondescript patch of land between the power plant and the hot spring and pulls the cover off a hidden hole in the ground. It is an oven. Steam billows out, and he reaches gloved hands into the warmth, pulling out loaves of rye bread. His bread is cooked the old way, using his grandmother's recipe and the heat of the volcanic earth. Some days, a busload of tourists will stop by to see Nonni pull Geysir bread from the ground, and Nonni gives each of them a slice of warm, sweet bread with salted butter. He explained how this is a remnant from the old days when there was no electricity and no firewood from the treeless landscape. They used the heat of the ground and cooked with affordable ingredients like rye flour and sugar syrup. The bread is cooked for an entire day, making it soft and sticky like cake. "There is nothing else like it," Nonni said. "If I make the same bread in an oven it is okay, but not nearly as good as straight from the ground."

From the ovens, I could see the power plant and its billowing pipes and little geodesic domes. Up the hill, the Mývatn Nature Baths had yet to open for the day. The parking lot was empty. When the wind dropped, you could smell the minerals.

"The local hot springs are a very special part of our culture," Nonni explained. "We have a secret pool that the locals bathe in. The local way is to go nude there and I feel like that also gives us a very healthy way to be confident and just accept the way you are and how everyone is different."

Nonni gave me a little plastic container with a loaf of Geysir bread, which I rationed throughout the rest of my trip, slicing off chunks of it during long days in my rental car or for a midnight snack in my hotel room. It can be a little bit lonely to be on the road by yourself, but the rye bread from Nonni felt like a remedy. I saved the final slice for my last morning, and when I got home, I tried recreating it in my oven. He was right. It's just not the same.

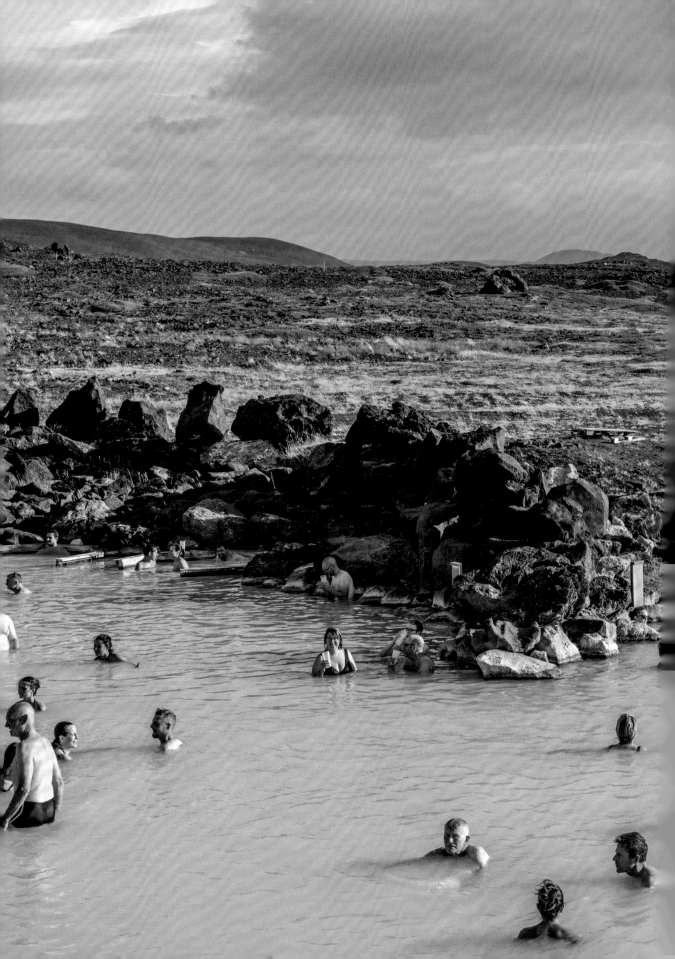

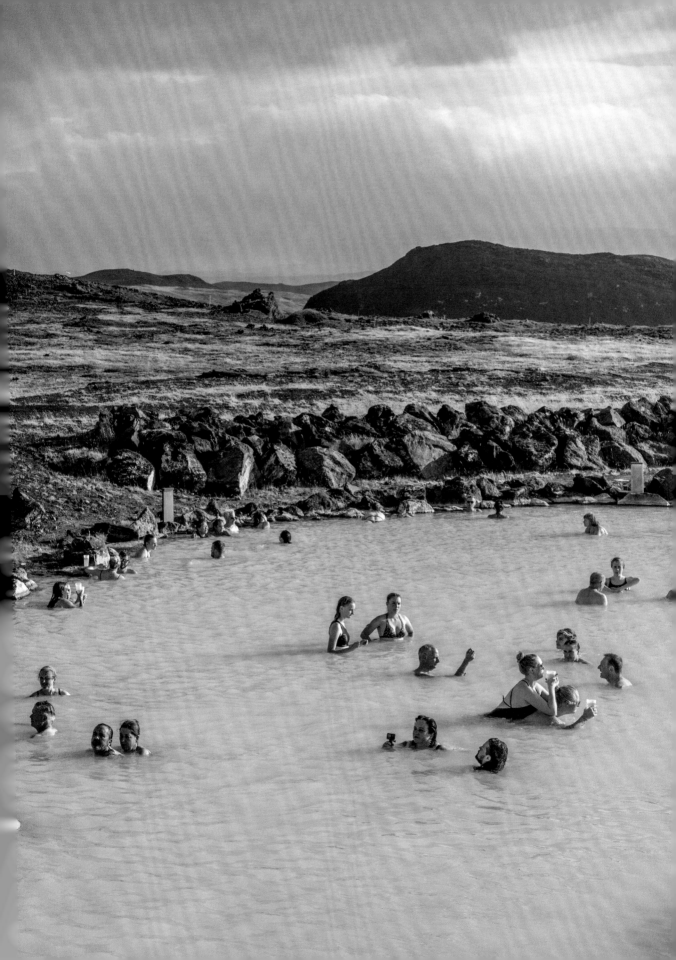

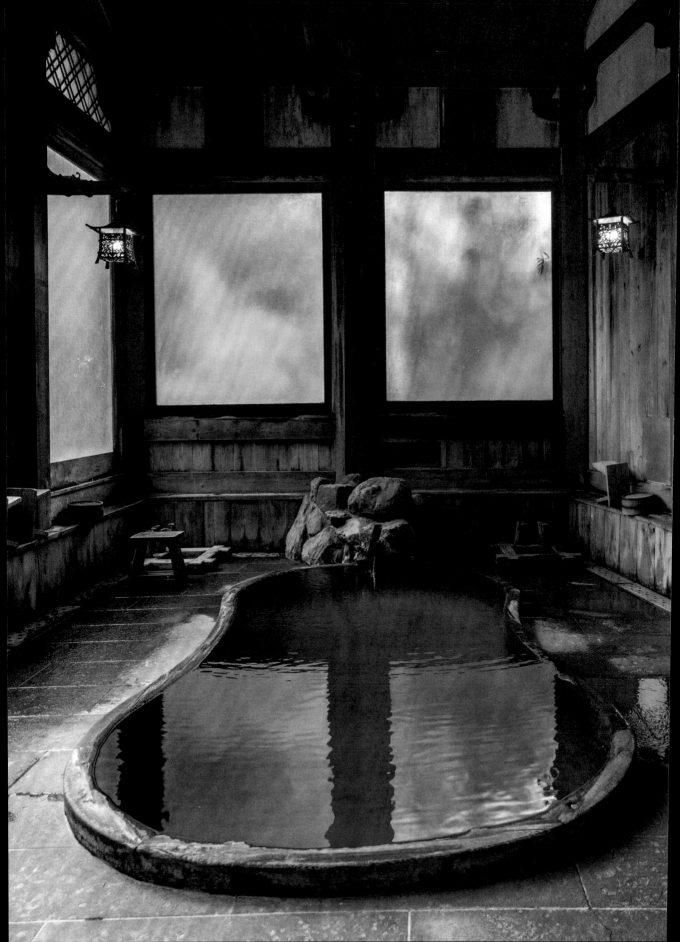

Nagano Prefecture Onsens

JAPAN

There is a term in Japanese, "Hadaka no tsukiai," or "skinship," which is written in katakana characters as "sukinshippu." It refers to casual, platonic time together naked. It allows for friends, neighbors, and colleagues to find connection and healing through time spent without the armor or societal markers of clothing. Mostly this happens in the baths. Sometimes, especially in places with small or private baths, it's possible to find a version of this togetherness simply with yourself, to enjoy the comforting experience of being present with your own body.

Nagano prefecture is in second place for Japan's most hot baths with 231 soaking places (Hokkaido has 254). Several of its towns are famous for their public baths and traditional onsen inns, popular with those seeking the experience of skinship beyond their daily routines.

The hot springs town of Shibu Onsen is said to be thirteen hundred years old, built along the route of a pilgrimage to Zenkoji Temple in Nagano City. Hot baths and inns sprang up to support pilgrims on their journeys. In addition to the onsen inns, the town offers nine small baths that are open to the public. Locals have their own keys for access, and visitors receive a key when checking into a nearby hotel. Each public bath is marked with a single symbol in hiragana: "yu," which simply means "hot water." And each onsen promises specific healing properties from the unique cocktail of minerals in the water. A town brochure lists the baths' medicinal specialties: Hatsu yu can address gastrointestinal issues; Take no yu is best for gout; visit Matsu no yu for nerve pain and spinal issues; soak in Shinmeidaki no yu for women's health and gynecological diseases, and so on. Tourists explore the town with oversize keys for the public baths, wearing cotton yukata robes and wooden geta sandals that sound

like horse hooves. There is so much hot water, sometimes it feels like the whole town is boiling. It burbles under the roads and steams from vents.

One of Shibu Onsen's iconic ryokans, the historic inn Kanaguya is over two hundred years old and has eight baths total: two communal baths that switch gender access at midnight, one outdoor bath, and five private baths. The mazelike hotel feels like the setting of a mystery novel: the hallways and tatami rooms almost echo with the dramas of the past. In the evenings, guests wander the inn with their towels and shampoo, searching for a private bath with an unlocked door, so that they may lock themselves inside for their own quiet experience. Bathers can enjoy it as long as they like, and couples and small groups can have the rare experience of bathing together in a less public setting.

Up the valley from Shibu Onsen is the famed Jigokudani Monkey Park, where a society of Japanese macaque monkeys take up residence in a mountainside hot spring during the cold months. They snuggle, wrestle, eat bugs from one another's bodies, nurse their babies, and get into little spats. The monkeys seem calmest in the water. In the warmer months, they sustain themselves with a rotation of wild mountain foods: acorns, wild grapes, butterbur.

In the 1950s, large development projects destroyed the monkeys' habitat and they turned to farmers' crops for sustenance, wreaking havoc on vegetable harvests. A local innkeeper began feeding them. She scattered peanuts in the forests, which were quickly eaten by the birds. Then, to the monkeys' delight, she fed them apples. As the legend goes, one day she threw an apple into the thermal pool, and a

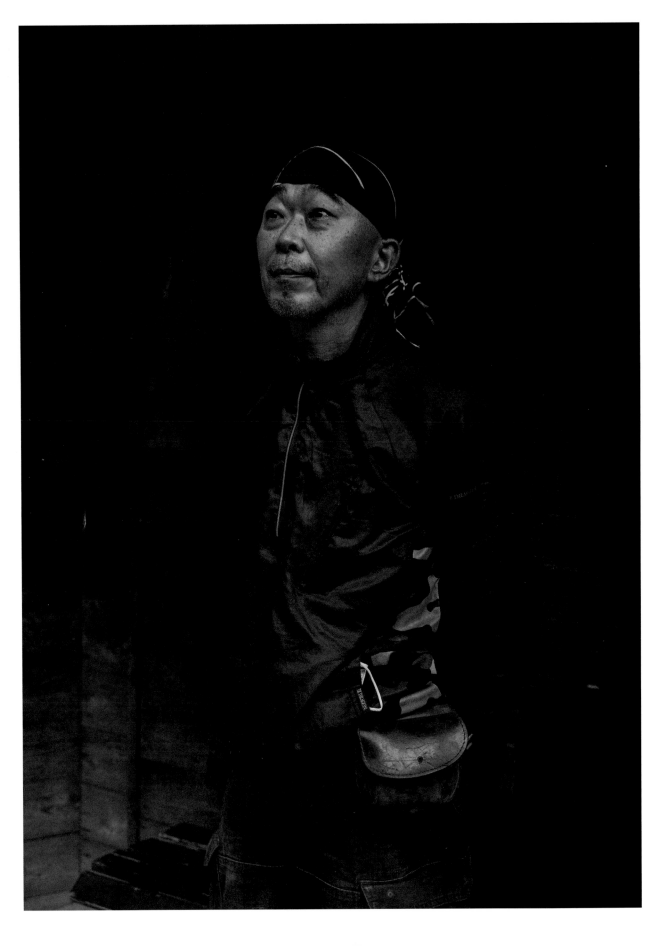

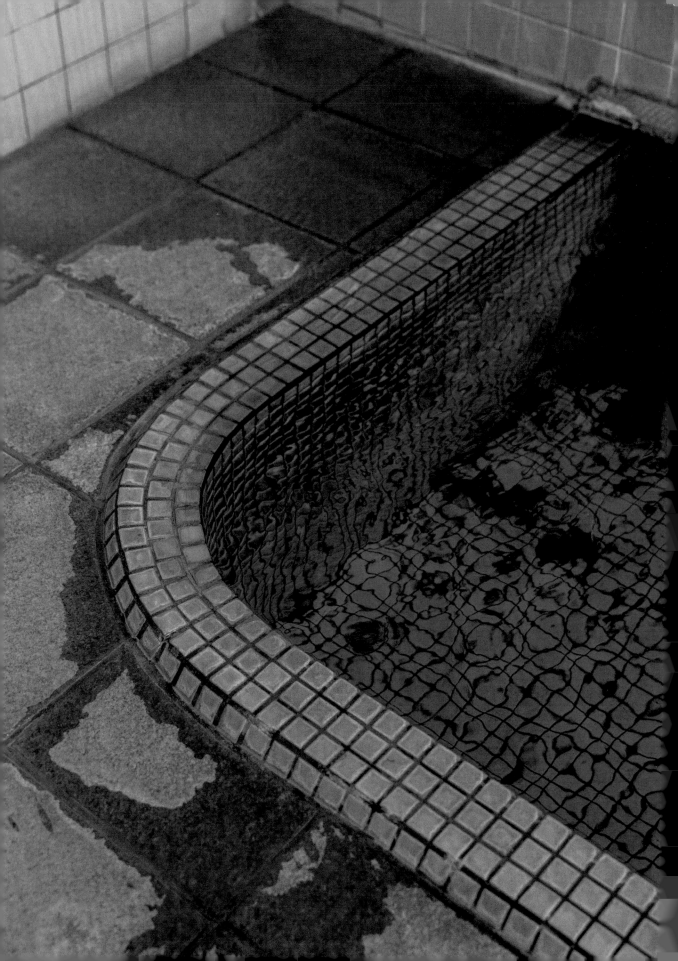

monkey followed. Soon, other monkeys learned they could be warmed by the water. "This was the moment when the snow monkeys became onsen monkeys" reads an informational sign at the nearest inn, Jigokudani Hot Spring Korakukan. It's now managed by Katsuyoshi Takefushi, who welcomed me and quickly instructed me not to look the monkeys in the eye and to always close the windows and doors of the hotel or the monkeys will find their way in to run around. If you hear strange noises at night, he said, it's just the monkeys. And sure enough, monkeys stretched and napped on the rooftop just outside the window of my room, chattering throughout the night.

In late fall, the farmers burned piles of leaves and low clouds clung to the mountains, threatening snow but never materializing. Steam billowed from hot spots. It was hard to know which plumes were smoke, steam, or fog. The town of Nozawa Onsen is a popular ski town with a year-round population of three thousand people. Eighteen of them are Olympians. In 1998, Nagano hosted the Olympics, which helped boost Japan's winter tourism scene.

Naoko Tsukagoshi moved to Nagano with her two sons so they could have a life in the mountains and learn snow sports. She said her sons go with their friends to bathe together every day before dinner. Naoko is part of a small organization of people who care for their neighborhood bath together. They pay a small maintenance fee and take turns cleaning the onsen. At the center of town is the ogama, a public geothermal kitchen accessible only for townspeople for culinary use. Most people cook greens from their gardens, the onsen water is said to temper bitterness. They also use the thermal kitchens to boil eggs and collect spring water from taps for drinking at home.

On my last night in Nagano, I found an open izakaya restaurant. I was there in the offseason, and most of Nozawa Onsen's restaurants were closed. As I ate my udon, a group of men arrived for beers and a hot meal. They carried little containers of shampoo and soap and had towels slung around their necks. Their hair was still wet from their time together in the onsen.

Riemvasmaak Hot Springs

SOUTH AFRICA

"The elders believe that this is a sacred place, a holy place," said Henry Basson, who manages Riemvasmaak Hot Springs. "They come here to get rid of demons and evil spirits and even come down here to pray to connect with God. They believe the water has a lot of power." That was the first thing he told me about this place. The second thing was about the day they were forced to leave.

"The day we were removed, it felt like the saddest thing that had ever happened in history," he said. "They forcibly, *forcibly* removed us. Back then, we had quiver-tree houses, traditional houses made from plants. They took us out of our homes and set them alight, they would shout, 'Everything out!' They said we must grab our things, but we were so near the fire, we couldn't get everything out. Everybody was crying, especially the older people."

The forced eviction took place in 1973 and 1974, when the people of the Riemvasmaak were torn from their homes and driven to different parts of the region. Henry's family was relocated to northern Namibia, sent there because of the language they spoke, Nama. For decades the land was occupied by the military, the landscape used primarily to train infantry to shoot and to practice unleashing bombs upon the land. The hot springs were cordoned off to be used only by members of the military; any visitors were escorted and monitored.

In the 1990s, Namibia gained independence and Nelson Mandela was elected president of South Africa, and negotiations to return the land began. Riemvasmaak became South Africa's first repatriated land when it was returned to the original owners in 1995. At the time of writing this book, despite some initial efforts of land redistribution by the government,

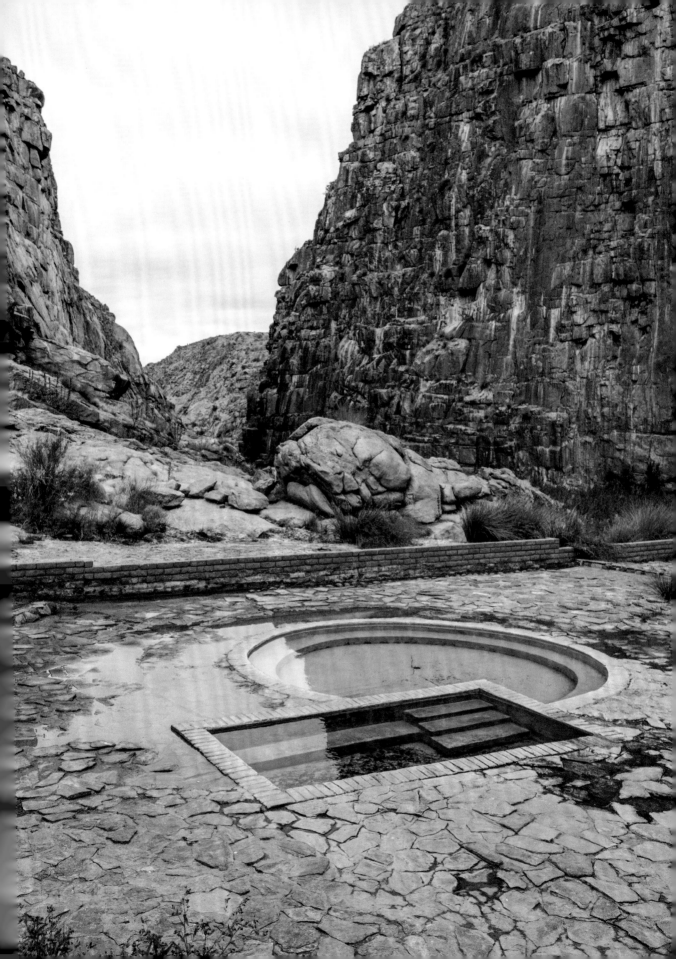

Black South African people own less than 4 percent of the nation's private land, while making up 67 percent of the population. White South Africans own 72 percent of land, but they make up only 21 percent of the population.

"It was a very emotional experience to return," said Henry. "When the land was given back, the people started coming back. But not all of us. It had been twenty-one years; people had set routines or gotten married and had jobs, so some people stayed in the relocation places. My grandmother and father died before the land was returned. But most of us came back because of that sense of belonging."

Immediately, the community got to work rebuilding. In 1997, they expanded the hot spring pool, adding a second cement pool next to the existing one—a circle that hugs a sharp rectangle. Below the main pools, they added stairs and reinforced the bottom of a natural stone pool in an enormous boulder. They built several chalets on the hillsides, naming each

after wild birds. They still operate the hot springs collectively. "Decisions are made by the Riemvasmaak Community Development Trust; members are elected by the community," said Clarissa Damara, who staffs the tourism office, constructed where the old town was before it was burned during the forced eviction. "Any funds go straight into the bank and the trustees manage it. It's used to pay the salaries of the workers and pay maintenance fees, then after that it is distributed to the community, if someone from the community needs assistance or the school needs funds."

Riemvasmaak is a popular place for youth clubs, church groups, and school field trips. Campers stay at the sites near the springs, grilling meats in the famous South African way, called "braai." In the evenings, you can smell food cooking from the hot pools, carried in the wind. It smells rich and hearty.

I met two preteens who loudly played a game they'd invented called "Beast." The

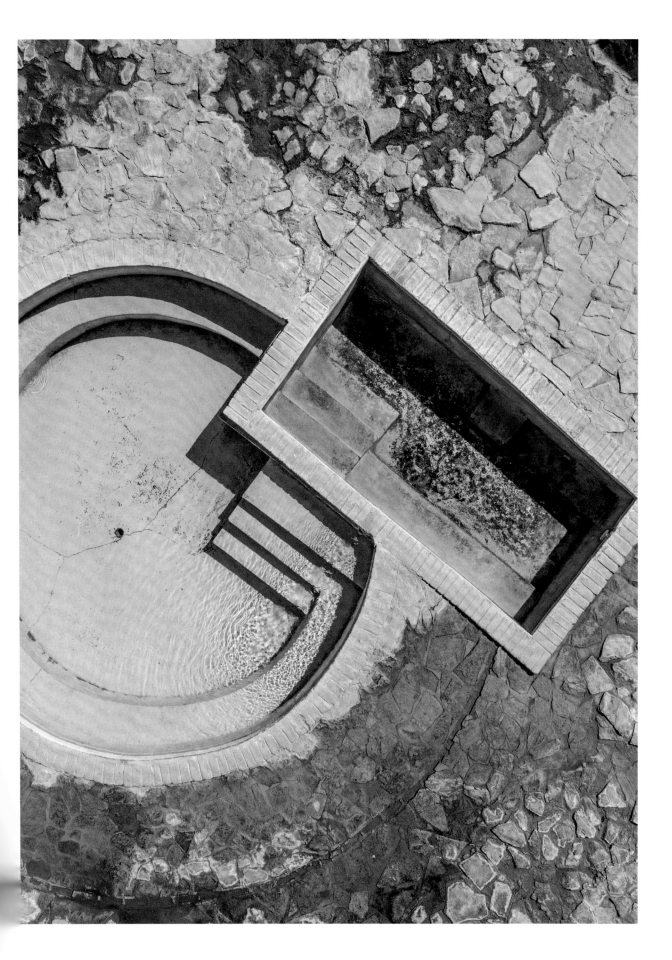

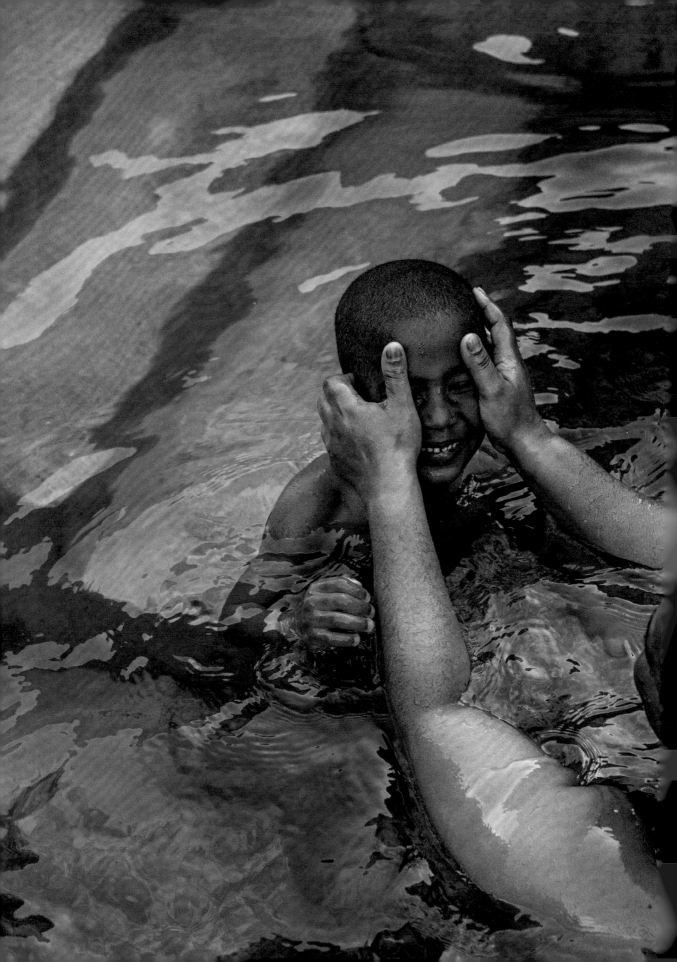

boys were visiting with their family to collect rocks. This area is popular with rock hounds, who gather gems and stones in the nearby hillsides. The rocks are the same colors as the hot springs and their landscape: rusty orange, russet brown, aqua blue, soft green. One evening, in the hot water, I chatted with a woman named Beverly who works in customer service in a town a few hours away. Beverly told me that at home she uses an electric kettle to heat just enough water to clean herself. Like much of the world, the average South African person doesn't have municipal hot water. At Riemvasmaak, the experience of submersion and soaking in hot water is novel, a true luxury. She cradled her young son in the water so he could float. He stared up at the canyon walls and dusky sky.

Henry and his colleague Patrick always take a soak whenever it's time to clean the hot springs. "We give ourselves a chance to be in the water and feel it, feel that sensation and relax," he said. This is his true home, the place that receives his care and attention, and where he continues his ancestors' story. But he tells me that this kind of connection to the land is available to anyone. "When you are visiting a hot spring, or any place, don't just come for a jolly thing: try to make that connection," he said. "In a hot spring, you get yourself disconnected from the things that rush you, and connect again to nature itself."

Spirit

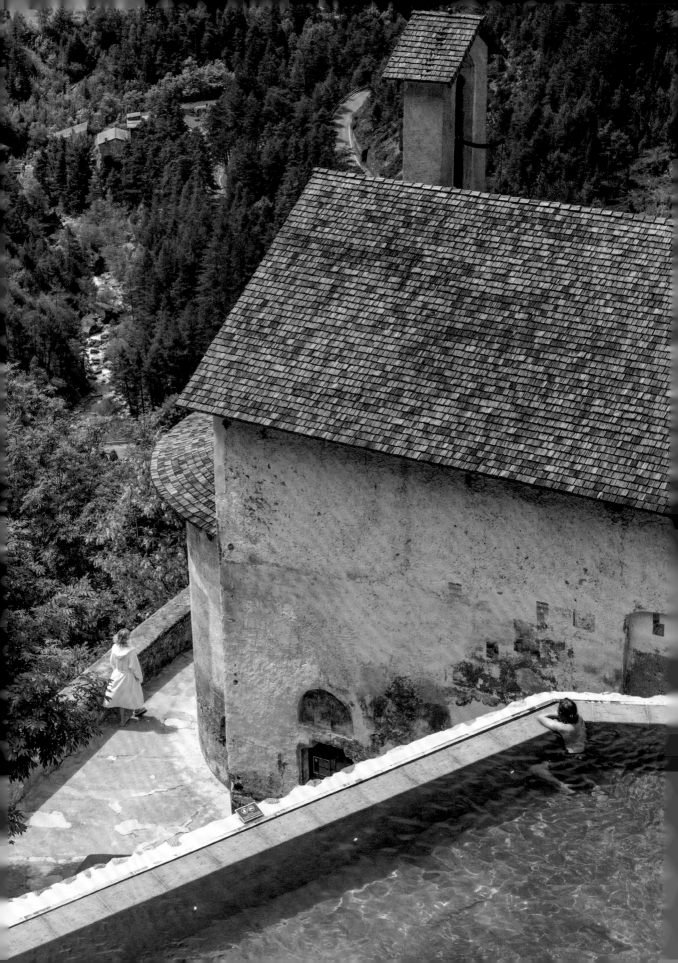

Bormio Thermal Baths

ITALY

Thousands of years ago, many Europeans followed a cult of water. The continent is dotted with the relics of sanctuaries and offerings to the aquatic gods of the holy pantheon. Borvo, a Celtic god of healing waters, has names that translate to "to boil," "to be intensely hot, agitated, and wild." Often associated with Apollo, he was thought to make water bubble and seethe with heat. Revered during the Roman period, his legacy is found in antiquities across Europe: in France, the Netherlands, Germany, and Italy. Some of these countries have places still named for Borvo (also called Bormo, Bormus, Bromine, or Bormanus), like the town of Bormio in the Italian Alps.

The Grand Hotel Bagni Nuovi overlooks the valley of Bormio like a pink layer cake. Inside, the stately dining room is frescoed with flowers and adorned with six glittering chandeliers. Guests roam the hotel in workout gear and spandex, ready for a day of bicycling in the Alps. Or, they wander the grounds in white bathrobes, like relaxed and comfortable ghosts, dutifully wearing the plastic flip-flops provided by the hotel. The spa area is a winding series of steam rooms, saunas, and indoor and outdoor pools. There is a tea room and a solarium. There are tubs made of wood or marble, one shaped like a pentagon, another lined with little pebbles. Some are still and calm, some are effervescent like Alka-Seltzer.

Bagni Vecchi, the town's other iconic hot springs hotel, is situated higher in the valley and tucked into the mountain, where the sun hits last in the morning and the shade arrives first each evening. It's smaller and cozier than the grand hotel below and feels absolutely ancient, because it is. There are preserved Roman grottoes and steaming caves. An infinity pool is wedged tightly between an eleventh-century church and the hotel. When I visited, the hotel was sheathed in a skeleton of scaffolding for restoration; I imagined the restoration as perpetual, as things this old crumble and rust, a constant battle against the entropy of ruin and rubble.

Just beyond Vecchi's gleaming pool, a faint path recedes into the forest: the remains of the main road that connected Rome to the rest of Europe through the rise and fall of empires. For thousands of years, people stopped in Bormio along their journey. In the first century, Roman naturalist and philosopher Pliny the Elder traveled that path, writing about the area in his encyclopedic *Natural History*. He described hot springs in his section called "Of Clefts of the Earth" as part of the

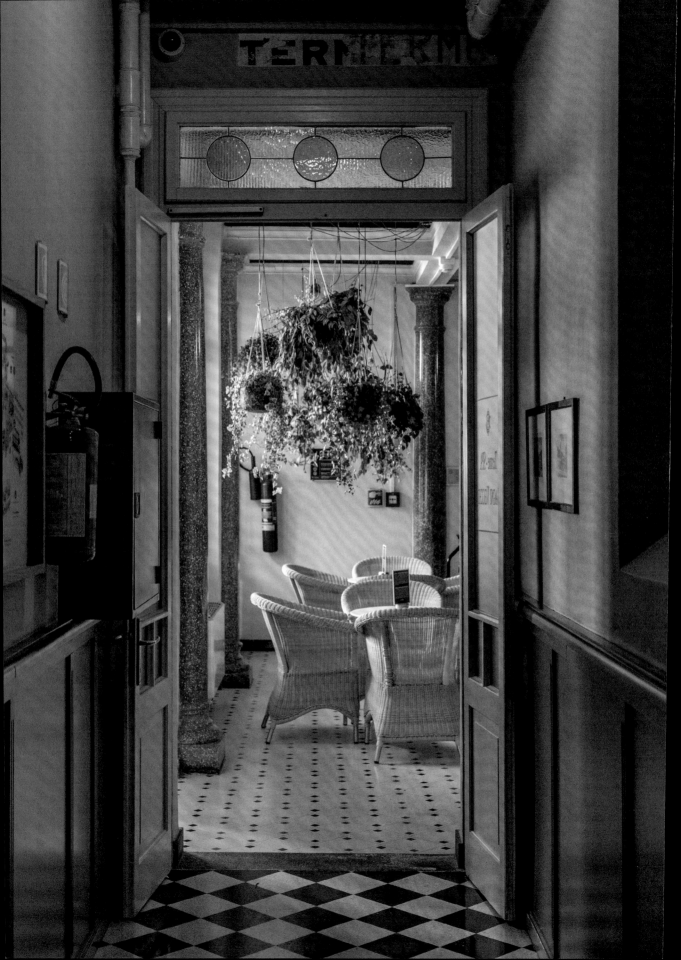

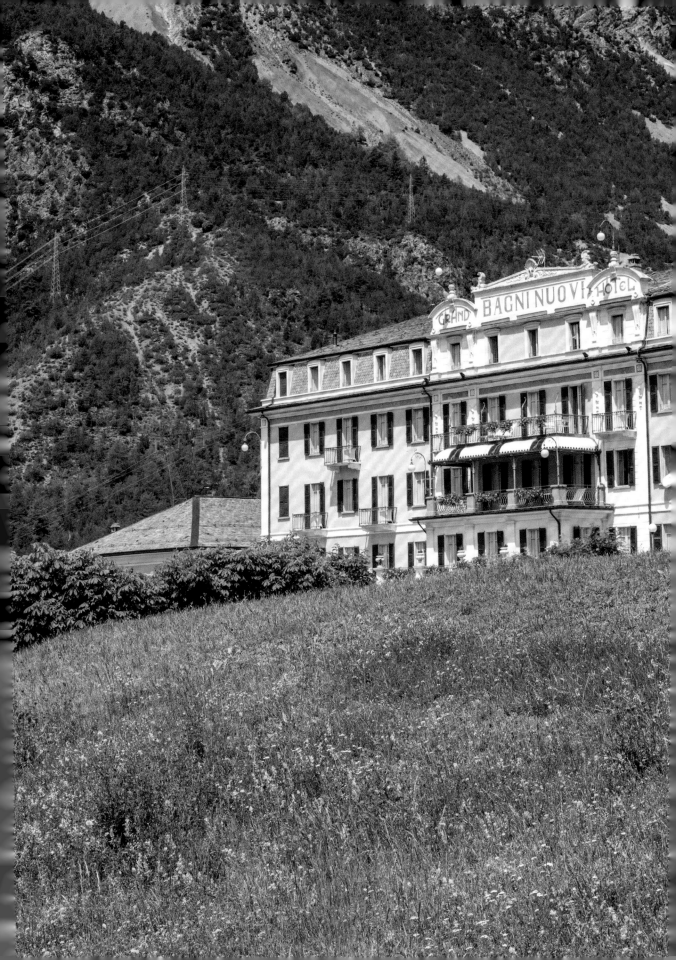

dynamic natural phenomena of the planet. "Sometimes great masses of earth are heaped up, and rivers forced out, sometimes even flame and hot springs," he wrote. Archduchess Anna Caterina Gonzaga visited the baths in the 1590s to care for herself as she struggled with infertility, returning home and later delivering healthy babies. Leonardo da Vinci visited Bormio in the late 1400s, leaving a perfunctory note about the baths in his journal.

Down the hill from the two luxury hotels, now managed by a wellness destination company, is a free public hot spring managed by no one and everyone. From a nondescript parking area, a short trail through the forest leads to riverside pools and dripping water features. I met a few women in the bath; strangely, they were fully clothed, their dresses billowing in the water and their mascara smudged. I didn't speak enough Italian to get the backstory. A gray-haired gentleman hung up his clothes on a tree branch as he stripped down, a cigarette between his first and middle fingers. A man in his boxers told me about Pliny the Elder and Leonardo da Vinci, about the artifacts found there with Celtic symbols from those who worshipped Borvo. Warm water sloshed as he gestured toward various points on the landscape.

Up at the resorts, each room and bathing area is marked with a name and a placard: Neptune's Pathway, Daphne's Garden, Vapors of Morpheus, Hercules Bath, Vulcan's Footbaths, Zeus' Bath, the Diamonds of the Gods. The names are pithy and romantic, and I imagined a team from the company putting their heads together as part of a branding effort. The resorts remain connected to history

and character, but with a corporate sense of control. But the spaces for bathing remain just that—a place to be in warm water or lie in the sun. There was no snack bar, no souvenir shop, no additional commerce or hustle and bustle. You can feel the layers of history: flourishes and signatures of bygone eras. While it looks different than it did thousands of years ago, it's still a place for people to show their reverence for water and tend to the rushed and weary parts of themselves.

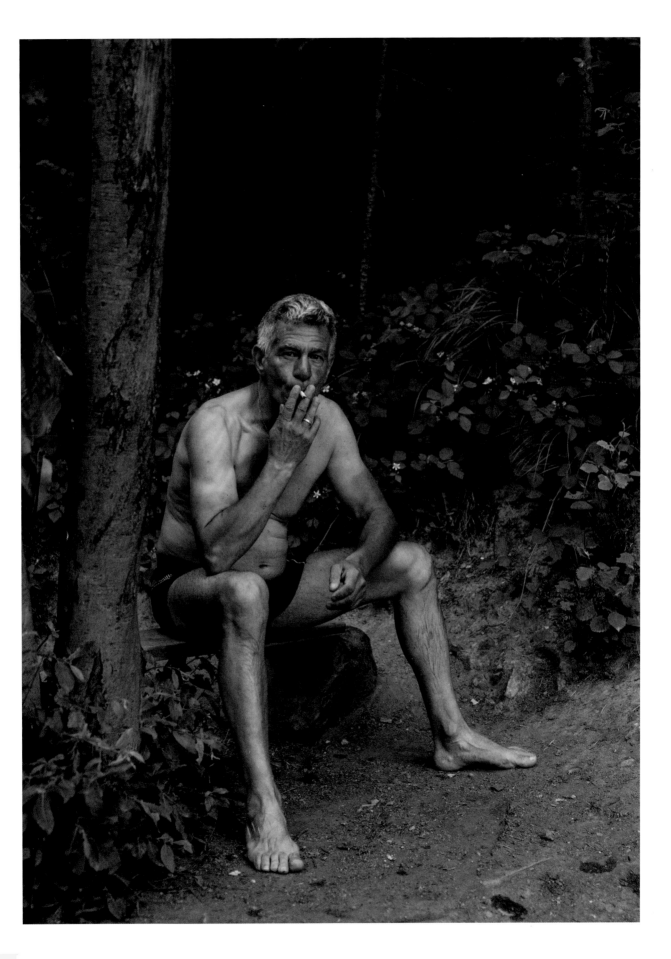

Mystic Hot Springs

UTAH, UNITED STATES

In 1995, Mike Ginsburg was traveling through the Utah desert in his double-decker bus, a 1971 school bus with a Volkswagen van welded to the top. He was returning home to Colorado from what would fatefully become the last time the Grateful Dead played Vegas, just months before Jerry Garcia's death. Suddenly, the old bus had troubles, and they sputtered into hot springs situated on a hilly rise above the small, conservative town of Monroe, Utah. Mike, who designed and sold stickers at the Dead shows and worked in concert production, recognized this place as home. Soon after, he bought it. He's now known as Mystic Mike.

"It was a metaphysical journey," Mike said of the trip that led him to the springs. "For a while, it looked like I wasn't going to be able to make that trip. As a last resort, I decided to take my bus: we'd have a place to stay, and a way to get there, despite a long drive. I had a smudge stick with some sage in a bundle and I went around the bus three times to bless the journey. The philosophy was 'No matter where we go, that's where we're going.'"

Mike's double-decker bus is still at Mystic. It and a row of other vans, buses, and an old sheepherder's wagon are lined up between a shaded campground and a row of crumbling trailers. They've become the on-site lodging, each unit is named for a Grateful Dead song. One is adorned with a bumper sticker reading "If you get confused, listen to the music play," another with an Al Di Meola album tucked above a defunct sink, and some are decked out with beaded curtains and intricate wood interiors. Each is adorned with notes and messages scrawled into ceilings and walls by past guests:

Gweeto was here

Shine your light

Hippie vibes

Spirit in me, spirit in you

Meeshroom

Play didgeridoo

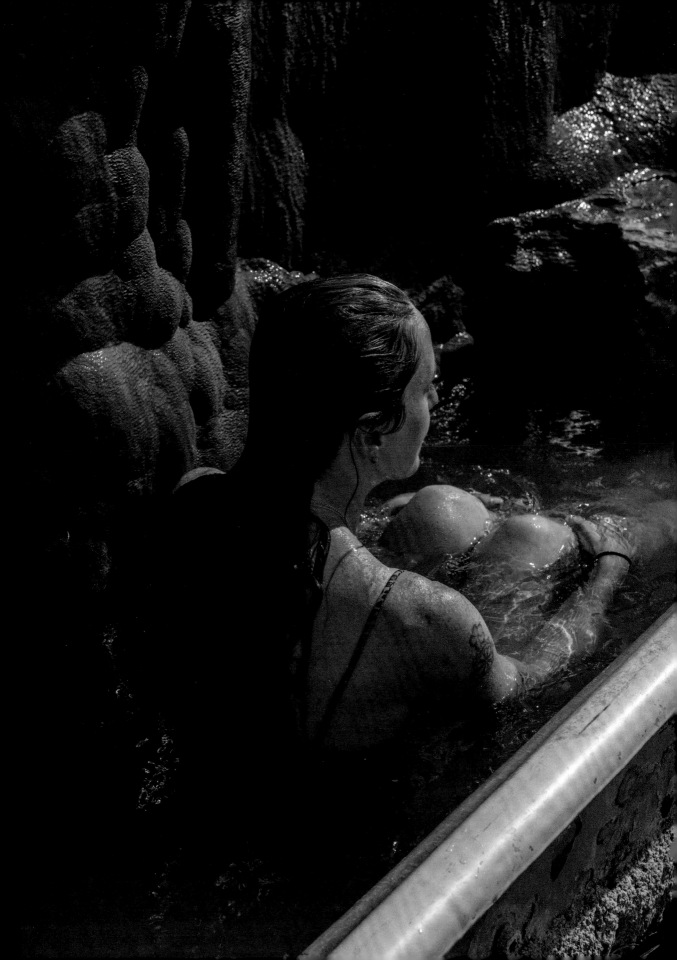

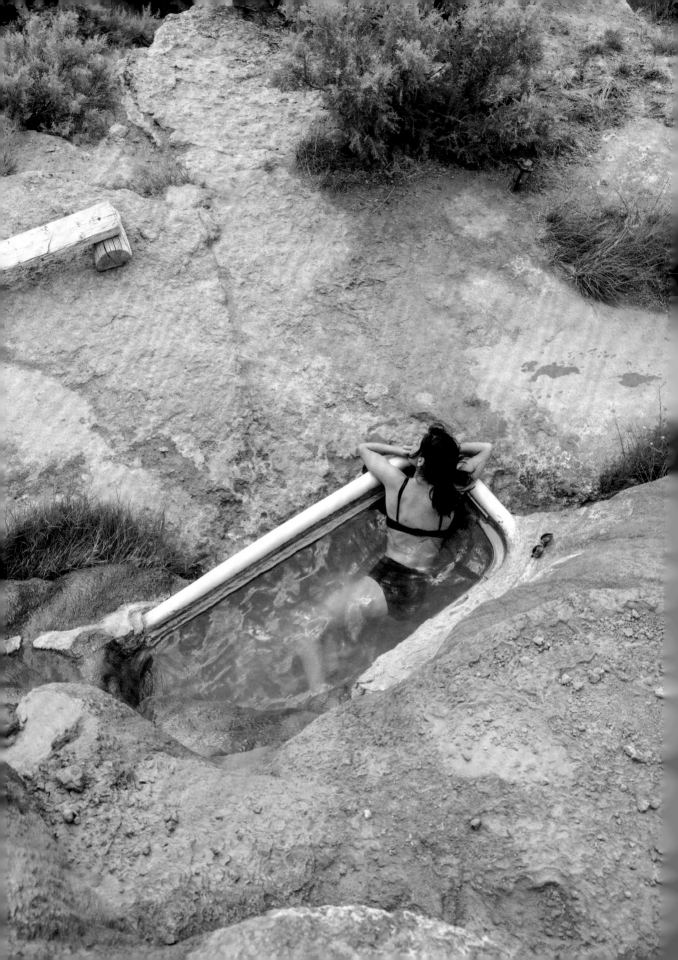

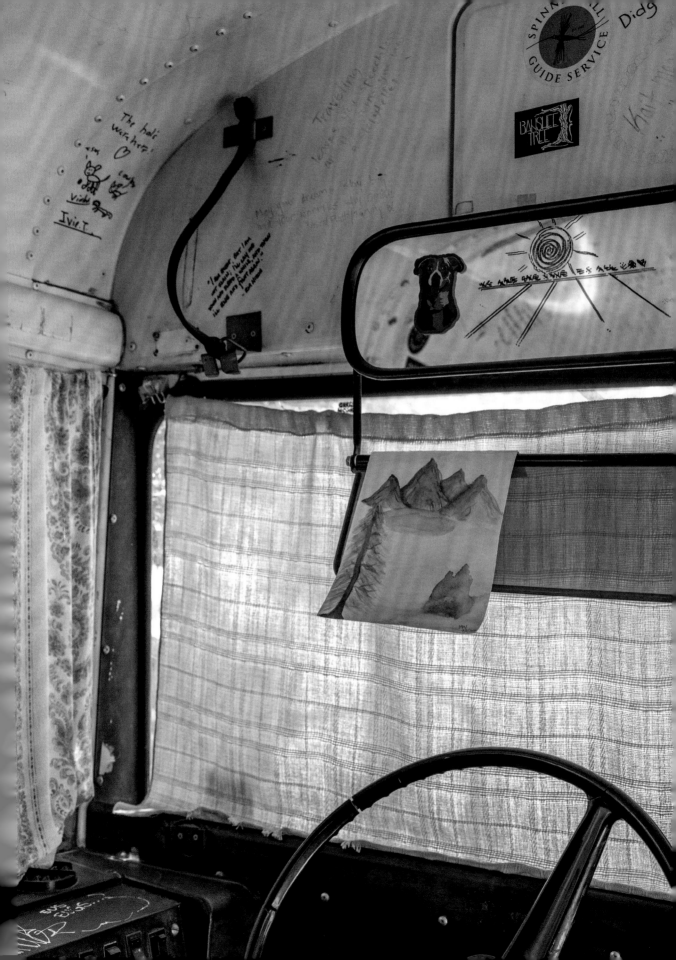

"A lot of people come here and they're confronted by the piles of stuff and the falling-apart-ness," said Aubrey Ixchel, who also lives at the hot springs. "For some, it doesn't compute, especially for the kind of person that's expecting Holiday Inn or McDonald's. And then there are people who are ready to get something different, and that can reveal something really precious and unusual. I think Mystic is a reflection of who you are, what you're up to, and what you're ready to see and confront about yourself."

Music has always been at the heart of Mystic, beyond the Grateful Dead show that brought Mike here. In the 1930s, a bandleader named Farnsworth bought the property so he'd always have a place for his band to play, giving the springs the slogan "the home of mirth and merriment." Mike built a stage on-site and has held thousands of concerts. The springs themselves have their own music; they burble and chime with a constant, melodious stream of water.

"I love being in the shower pool by myself, when nobody's out there and no one can hear me, and I can be with the water," said Aubrey. "I've had quite a few songs just come to me when I've been soaking. And the water itself is super rhythmic and melodic. It's always got a song going on."

Mike's ideals and personality—his mission is "mindfulness, permaculture, and conservation"—are wholly reflected in Mystic itself. Mystic is his home: the check-in office is in his living room, adjacent to a stage covered in instruments and tapestries. The main desk sits under a framed portrait of Jerry Garcia. The entire property is filled with the *heeeyoooo* calls of roaming peacocks. In the mornings, he tends to his gardens, built over a filled-in swimming pool. The six cast-iron bath tubs that Mike installed in the hillside have become consumed by minerals the colors of a psychedelic sunset.

"It's just unbelievable that I could be the caretaker of something so amazing," said Mystic Mike. "Yeah, when you want to talk about mysticism, and what that actually means, I have no idea. But what I do know is when I start to contemplate things like why I'm here, or those unanswerable questions, I see this hill, and as I watch the water running over in its infinite detail, I see these little teeny molecules that are forming in different ways based on the temperature and the speed, and all these external forces. It's really amazing to contemplate."

Therme Vals

SWITZERLAND

Therme Vals is an austere, brutalist shrine to hot water. It is built from sixty thousand slabs of granite from local quarries. The granite is warm to the touch, and it absorbs sounds so that everything is muffled, reverent, church-like. There are the sounds of lowered voices, moving water, and a deep thunk of water from the source place.

Cell phones aren't allowed here, an intentional decision to create a meditative, inward, and connected atmosphere. Time is marked by the movement of light. If you seek them out, there are tiny clocks mounted on brass pillars. Otherwise you can stay suspended in a sense of timelessness.

The space is designed for intentional, immersive sensory experiences, with a central internal chamber of water and a larger, steaming pool outside. There is a cold plunge room with a glowing blue floor; the water feels like ice. Adjacent to it is its opposite, my favorite room: a narrow pool with a glowing red floor, its water extremely hot. It's almost hellish, hot enough it made the blood thump in my body, the heat stored up like firewood for the winter. I carried it with me for another hour.

There is a room for drinking water, and another for resting. There is a room to experience sound: the music is a trancelike mix of mountain sounds and the bells of herd animals. The sound of the music doesn't carry beyond the small room.

The granite changes color when wet, rained on, or when a dripping body walks or reclines on it. Eventually, as time passes, the granite returns to a neutral gray, the splatters like a temporary experimental art piece. I sat beside a stranger, both of us on daybeds. We had no need to chat, no need for small talk. Just a shared silence. I noticed that everyone had fallen silent, even little groups of friends

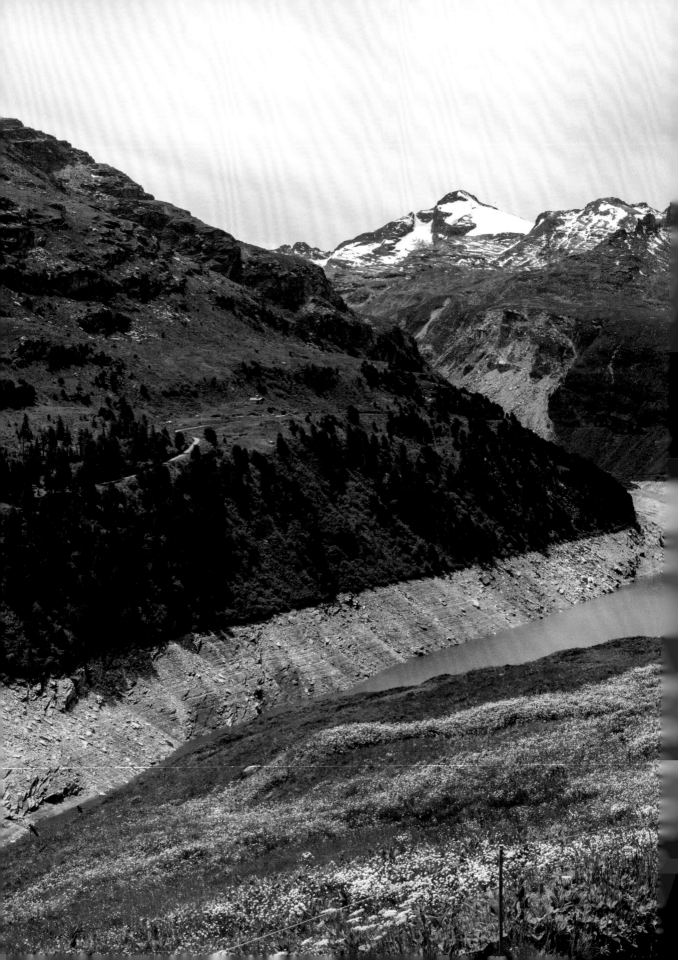

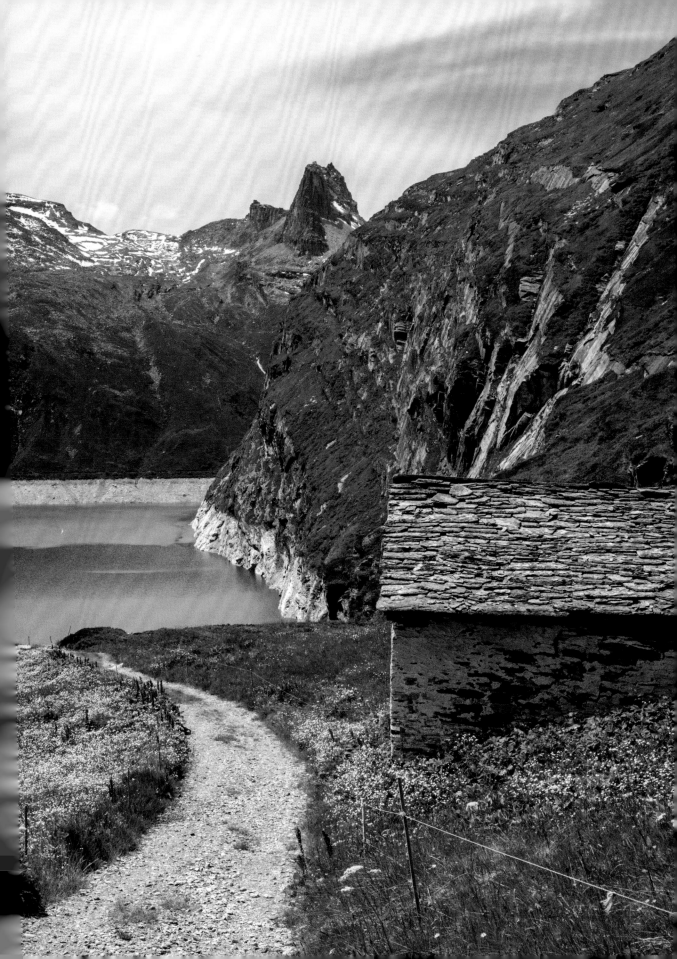

or couples. We'd entered into an agreement together.

When I started this book, I thought I would be instructed in the ways of intricate bathing rituals. Instead, there is no intricacy, just simplicity. While in Vals, it occurred to me that in most places, bathing itself is the ritual. There is no need for ceremony around soaking, when soaking is enough. The repetition occurs in the ways we submerge and emerge, submerge and emerge.

From the baths, I watched the mist over the mountains and in the trees, conjoined and indistinguishable from the steam. Odd sunbeams illuminated the chalets and barns on the mountainside like little spotlights. The community of Vals was in the distance, home to just over a thousand people. The town rings with the sound of running water and bells. There is the high *ting-ting* of the sheep's bells and the lower *thonk-thonk-thonk* of the cowbells. Every hour, the church bells in the town center chime, too. Later, while eating barley soup at the café in the town center (the businesses have names like Alpenrose Hotel and Gardens and Restaurant Edelweiss), I saw three people leading sheep from a milking barn out to pasture on the hillside. This is the kind of town where people carry wicker baskets to the single grocery store and haul buckets to the town fountain to fetch water for their gardens. They stop on their bikes to wish each other "gut morgen."

Doris Berni, who works at one of the cafés, told me, "We live all from the therme: the farmer brings milk to the therme and the hotel, and the people who visit the therme come to the shops and the bakeries."

For many years, the thermal bath was a simple pool outside a classic Swiss chalet-style hotel. In the 1960s, a new hotel was built with the more modern, streamlined architecture of the time. Hotel rooms with individual balconies looked out onto the warm pool. But over time, the hotel and therme struggled, and the town did, too. The town concluded it was time for a change, and they decided to invest in architecture. They hired renowned Swiss architect Peter Zumthor to create something new. He built what is now considered

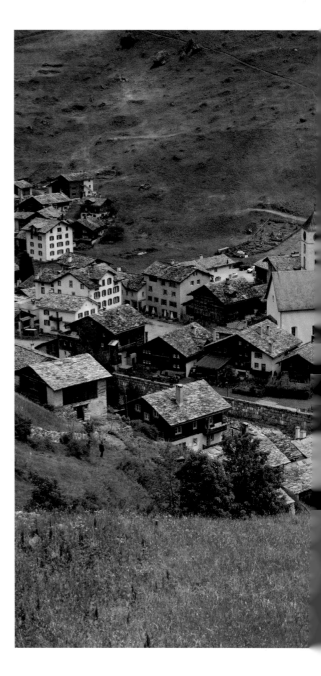

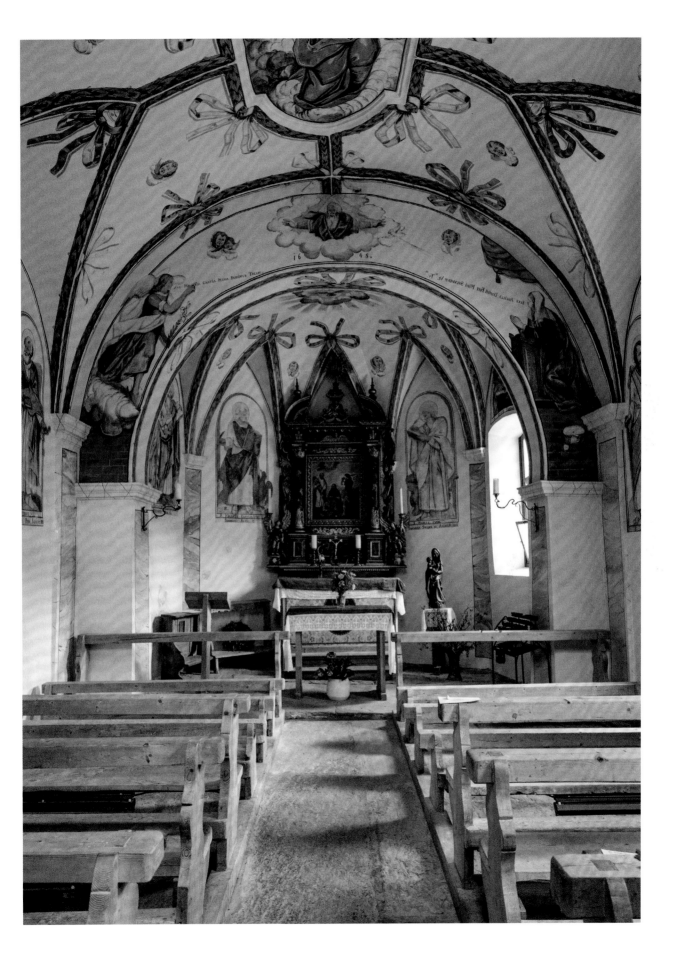

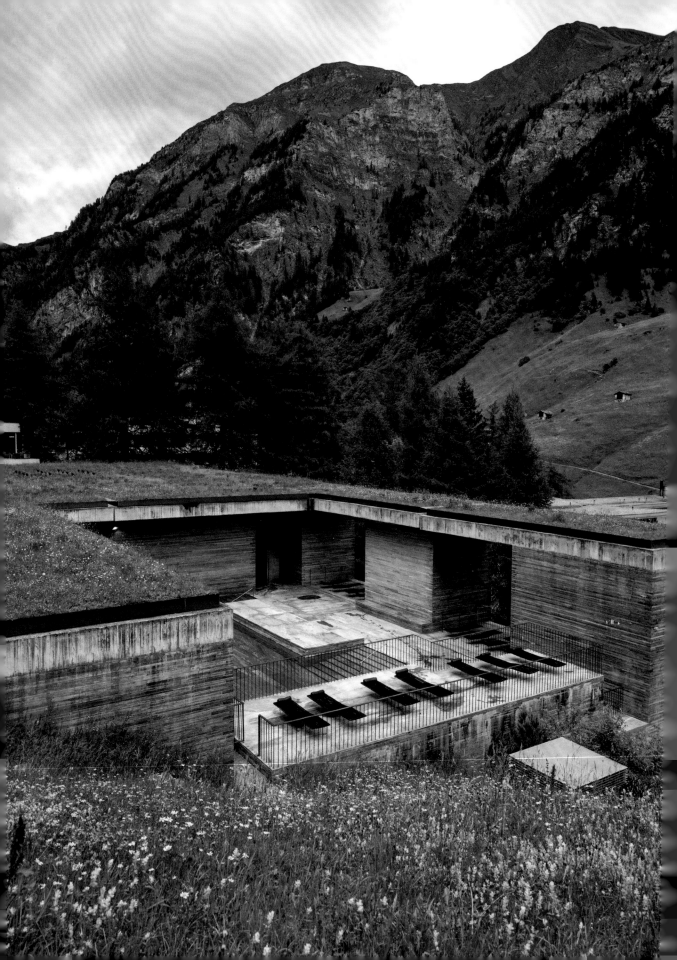

an architectural masterpiece, the granite sanctuary of Therme Vals. But it opened up questions and controversies: Whom does the masterpiece belong to? Its maker? The community? The property owner? Who is responsible for its maintenance, funding, and direction? The answer is likely different depending on whom you ask. Very recently, a new foundation was formed that consolidates the perspectives and interests of everyone: the townspeople, the hotelier, and the architect. Everyone I talked to seemed hopeful and curious about this new system, focused on the well-being of the baths.

Because there are no cell phones or cameras allowed in the bath, I got special permission from the staff to photograph when the therme was being cleaned. The cleaners are specialists in caring for the granite and the water and the metal detailing. They use special cloths and sprays for each surface, and they explained their careful techniques, how it took trial and error to figure it out. I thought about how our sacred, special places require work and maintenance, the ongoing negotiation of local politics. It requires figuring it out together, navigating each other, and tedious, quiet labor. That's the ritual, too.

Himachal Pradesh's Hot Water Temples

INDIA

Each day at seven in the morning and seven in the evening, a priest named Mahant Shiv Giri performs puja, a set of religious rites in a small temple at the hot springs near the River Gaj. First, he bathes himself in the hot springs, washing his body and face in thermal water. "The significance of bathing is to purify yourself," he said. "It is a way to mark your attendance in the house of God." He gathers a bucket of warm water and carries it to the temple to perform Panchagavya, a Hindu practice of pouring the five cow derivatives (dung, urine, milk, curd, and ghee) over the shivling, a statue that represents the fertile and creative powers of the god Shiva. He carefully arranges an apple, incense, marigolds, and hibiscus before reading sacred text.

Shiv Giri is a mahant, a religious figure and inherited role that stretches back one thousand years to his ancestors who sat in meditation in the forests. His duty is to tend to the physical and spiritual practices of the baths. When the time comes, one of his sons will ascend to the role.

After puja, he welcomed our little group to the small concession stand where his wife served us hot, milky chai. My friend Maggie and I had traveled from Maine to India, meeting my friend Surbhi in Delhi and traveling north to the Himalayan state of Himachal Pradesh. Our driver, a mustachioed Himachali man named Rakesh, sipped chai with us. He was fond of telling us about the "very dangerous road" and pointing out the locations of devastating landslides, always while smiling from behind the wheel of his Toyota.

Another day, we met Pujari Mailer Ram, who performed the puja at a remote hot springs and temple outside the town of Bir. It takes an uphill trek to find the thermal baths, some of them wild and too hot for bathing, others just the right temperature. "We believe in the hot water," said Mailer Ram. "We pray and bathe in it. When you come here, you must bathe. When you bathe in the water, you know its power." He was the first to tell me the origin story of the area's hot springs, one I heard in various versions throughout Himachal Pradesh: Once, Shiva and his wife, the benevolent Parvati, spent over a millennium meditating in the green hills, enchanted by the mountains. Parvati lost her mani, a beautiful and sacred jewel, in a stream. Shiva commanded his attendants to retrieve the stone, and when they failed to find it, he

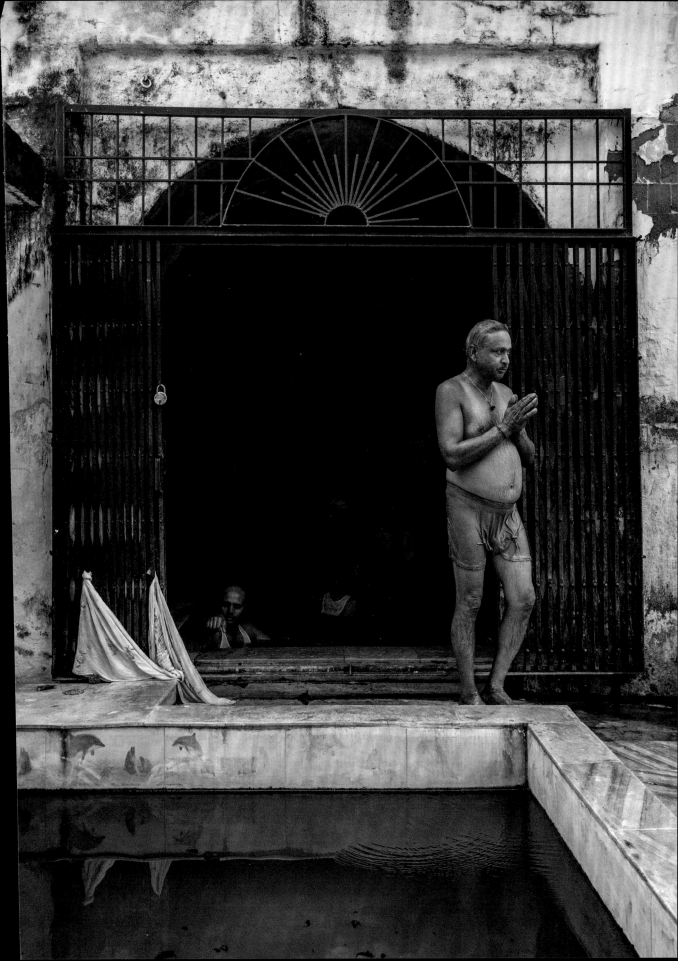

became enraged. In his fit of anger, he opened his third eye, disturbing the harmony of the universe. To pacify Shiva, Sheshnag, the serpent god, emitted a hiss that led to the creation of hot, jewel-like springs.

Manikaran, named for the goddess's gem, shares this origin story. Situated on the Parvati River in the Parvati Valley, Manikaran is home to Sikh and Hindu temples, which both sit snugly against the riverside, sharing the same geothermal sources and potent spiritual energy.

The bridge to the temple complex leads to the gurdwara, a place of shared worship and community building for Sikh people. The complex is staffed entirely by volunteers committed to sevā, a commitment to service without personal reward. They organize the shoes of visiting worshippers, clean and maintain lodging for visitors, prepare hot meals in a community kitchen, and recite holy songs and text. No payment is collected. The baths are open to the public. The back entrance of the gurdwara opens to the tight corridors of a public market selling religious icons, jerry cans to collect thermal water, and colorful puffed rice for puja offerings.

At the Hindu temples of Manikaran, men performed a ceremony in the streets. On their shoulders, they carried gold idols that tipped and swerved, pulling the men to and fro. The gilded, fabric-swathed idols represented local gods, and when they are unable to stay still or upright upon the men's shoulders, it meant something was out of balance. "Gods were talking as they swayed," explained a passerby.

These local deities are called devtas: they provide guidance on land use, development projects, and governmental policies. They extend blessings over health, crops, and community affairs. They may be consulted before cutting down a tree or scheduling a wedding. It is during ceremonies like this that the gods deliver messages through a priest's interpretation. Consultations with the devtas through ritual is central to small towns and communities across the region, taking place during seasonal transitions, annual festivals, or whenever guidance is sought.

Below the mountainside hot springs of Kheerganga, the people of the village Tulga conducted a similar ceremony in which the gods delivered a decisive set of instructions: close the hot pool and drain the water.

"This is the order of the goddess: close it forever," said Pujari Devi Ram, the priest of Kheerganga. "Too much dirtiness, drinking, talking too much. It became a party in a holy place. All the gods of Parvati Valley said to close it." Kheerganga is another site of Parvati and Shiva's mythical meditation, this time with their sons, Kartikeya and Ganesha. There are no roads to Kheerganga; it takes an adventurous one-way seven-and-a-half-mile trek to reach the mountainside location. Increasingly large crowds seeking a party flocked to Kheerganga, where a disorganized town of tents and makeshift cafés offering instant noodles sprang up below the springs. Garbage collected in piles on the hillside.

The gods had given warnings before, said Devi Ram. "But no one listens. She has said it multiple times. People don't understand." He explained that the disregard of gods and nature resulted in landslides, strong storms, and other consequences. As soon as they received the directive to close the hot springs, the community drained the large pool on the hillside above the tent village. The hot springs are a massive tourist draw to the valley, so I asked Devi Ram about the potential economic impacts. He shrugged. It was clear to him that money was of little value when seeking the restoration of harmony. His job was to tend to a precarious balance; the message was clear and unwavering.

One day, I visited a hot springs pool at the edge of the Parvati River, where men came to bathe each morning. They washed their bodies and used toothbrushes to clean their teeth and the back of their throats until they retched. A middle-aged man in a red sweatshirt stopped to visit the holy men who tend a temple and garden just above the baths. "There is value in tradition and also in modernity, but too much of either makes an imbalance," said the man in the sweatshirt, who grew up nearby. "Too much tradition is rigidity. Too much modernity

makes one lose ethics. And one must have ethics. It falls from person to person to make sure they have balance, ethics, and connection beyond themselves and with nature." We talked about Red Sweatshirt Guy and what he said for the rest of the trip, kicking ourselves for never exchanging names.

We moved deeper in the mountains to Manali, guided by a woman named Samhita Tanti, who left a corporate job to live in the mountains. Manali's hot spring temple, Vashisht, has two bathing places: one for men and one for women. The men's side is encircled with intricate carvings explaining alignment with the universe and the pursuit of spiritual attunement. The women's side is smaller; the pool spills out through pipes into a recessed shower area where women shower together, bringing soaps from home. The water was so hot, it almost felt dangerous, but the proximity to pain felt like a purification. My skin felt new; my insides, altered. Samhita drank from the hot spigot one, two, three times. "The water is talking to you from down in the magma," she said. The baths were busy and hot, and a woman began to faint from the heat. Before her body reached the ground, women were catching her, holding her with their own bodies, delivering cool water to her mouth with their palms.

Samhita introduced me to Pujari Vidya Prakash, who sits on a small cushion at the Vashisht Temple entrance, blessing visitors with a prayer, holy water, and the tilak: a thumbprint of red powder at the third eye. "There is nothing in our world that does not belong to God," said Pujari Vidya Prakash. "Especially the trees and environment. Our life comes from water. So we clean the water and we worship the trees and keep the environment good."

In addition to his holy rites, Vidya Prakash fought in the courts to protect the local

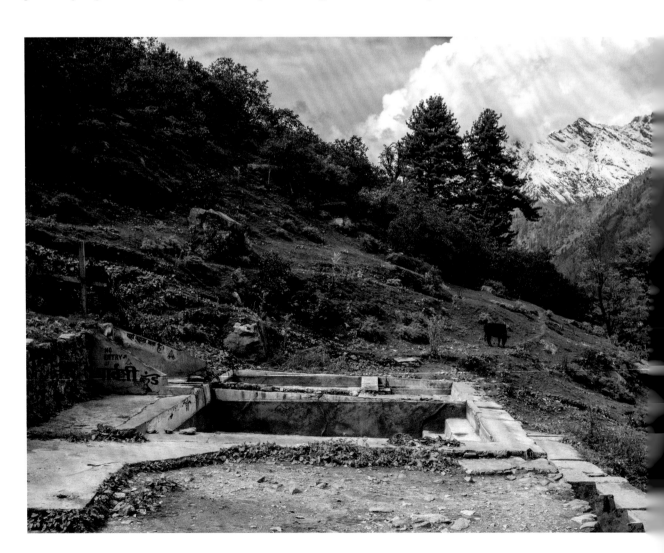

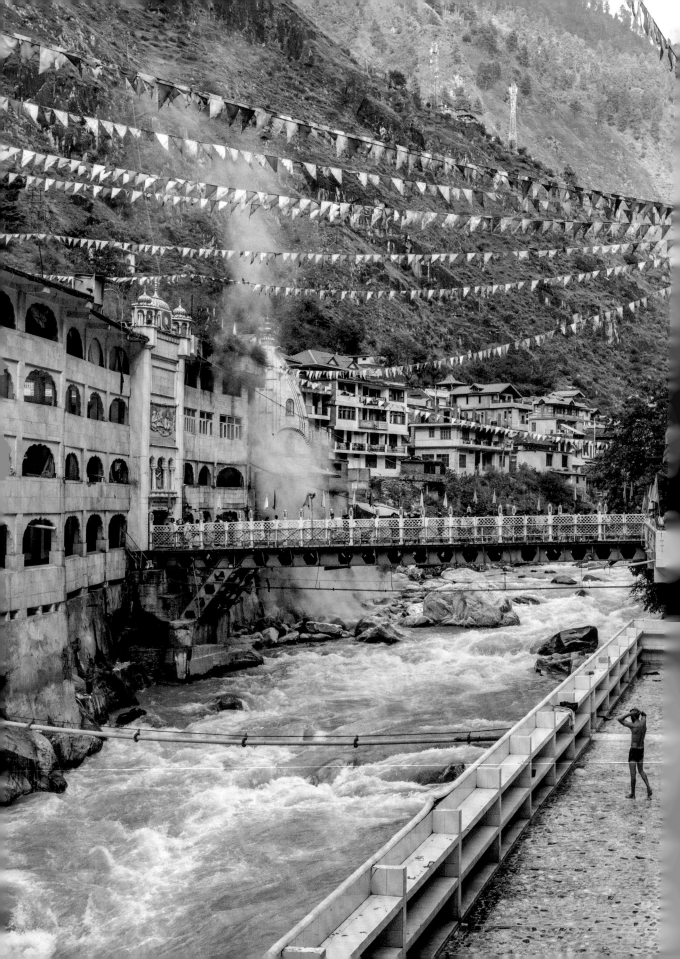

ecosystems against development projects he knew would be harmful. He explained to me that in the ancient scripts, the rishis, or ancient scientists of Hinduism, created the hot water to save the environment. The water gave people access to heat without needing to set fire or use trees as kindling.

That day, Pujari Vidya Prakash performed a puja for me and my duty to care for the stories in this book. First, he applied the tilak to my forehead. "Before we start anything, we try to absolve things through the third eye," he said. Then, he tied the mauli, wrapping a red string around my wrist and instructing me to wear it until it falls off. "It is symbolic of tying you into the duty." He offered me water, in three sips. "Drinking the water, the energy goes from negative to positive." He gave me a handful of rice to toss in the four directions. "So that all the unwanted energies can leave from all sides." We bowed and touched the floor. "We worship the earth." After that, he gave me an intention for this very book: "We pray to Guru Vashisht so that well-being passes through you to the world."

The people and priests I met in India reminded me of the role of duty. How easy it is to eschew our responsibility to the world and to each other in an effort to find personal liberation. The concept is often tied to restriction, propaganda, power, pressure. But what about duty in service of connection and contentedness? Hot springs, and the people I met while working on this book, reminded me of a gentler kind of responsibility. Inés in Bolivia tending a pool to honor her ancestors. Practitioners in Hungary using minerals from deep in the earth to care for ailing bodies. All of Greenland sharing their land. A mother and daughter in an onsen in Japan finding comfort together. Strangers who picked up litter along the trail in Nevada. Pujari Vidya Prakash tying a red string to my wrist to remind me of my responsibility to make this book with care.

Sometimes I think about how perfect the conditions had to be to create life on this earth, to make someone like me and you. The right amount of oxygen, hydrogen, carbon. The perfect distance from the sun, one of so many stars in the universe. The way our bodies evolved to allow us to eat, digest, sleep, give birth. And also, to think, make art, and love each other. We have plants we can eat or wear or use as medicines. We can gaze at the stars and lie in sunbeams like kittens. We have dreams and tell each other stories. We have mountains to climb and oceans to swim in and sail on. And on top of all of that: the soil, the sky, the flowing water, the billions of variations of living creatures; the earth makes hot water for us from its deepest places. What a miracle a hot spring is: an earthly riot, a terrestrial bonus, an unexpected geologic twist!

I spent a lot of time in hot water making this book, dozens of kinds of hot water. I soaked in hot pools in the middle of cities, on remote islands, in the desert, in thick forests. Sometimes the hot water was green, orange, yellow, turquoise. Sometimes it was milky white, crystal clear, or silty with sediment. Sometimes it was barely lukewarm; other times it was so hot it hurt. Always someone had tended to it, protected it, mixed just enough cool into the hot to make it safe and comfortable. Sitting there in water, those many kinds of water, I had the time to think about the silly luck of life and what it means to be alive in a place that provides so much. When given such an enormous gift, how can we even begin to give back? Maybe we start simply: by taking stock of it all, soaking it all up, and finding our own unique way to protect and contribute to the fine, beautiful balance.

THANK YOU

Thank you to my family, my partner, and my little dog. Thank you to my friends, especially those who joined me at the hot springs or edited these pages. Thank you to my editors and agent. Thank you to the local translators, drivers, and guides who showed me the way.

Thank you to the people who let me photograph them in their swimsuits, or in nothing at all. Thank you to hot springs workers, cleaners, managers, and maintenance staff. Thank you to people who hold on to stories and share them with visitors like me. Thank you to those who tend to hot springs, and anyone who cares for a little patch of this planet.

ABOUT THE AUTHOR

Greta Rybus is a full-time freelance photojournalist. She specializes in stories about human connections to the natural world for magazines and newspapers.

Born in Boise, Idaho, Greta studied photojournalism and cultural anthropology at the University of Montana. She is based in Maine, where she lives with her partner and their dog, Murray.

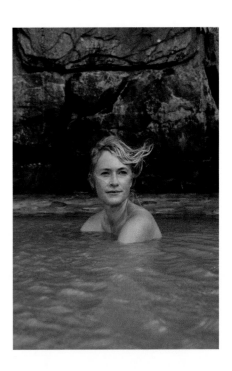

Published in the United States by Ten Speed
Press, an imprint of the Crown Publishing Group, a
division of Penguin Random House LLC, New York.
TenSpeed.com

Ten Speed Press and the Ten Speed Press
colophon are registered trademarks of
Penguin Random House LLC.

Map on pgs. 8–9 adapted from map by
stringerphoto-stock.adobe.com

Typefaces: Bretagne's Self Modern and
Suisse Typefaces' Suisse Int'l

Library of Congress Cataloging-in-Publication
Data is on file with the publisher.

Hardcover ISBN: 978-1-9848-5937-2
eBook ISBN: 978-1-9848-5938-9

Printed in China

Editor: Kelly Snowden
Production editor: Serena Wang
Editorial assistant: Gabriela Ureña Matos

Designer: Lizzie Allen
Art director: Kelly Booth
Production designer: Faith Hague

Production manager: Jane Chinn
Prepress color manager: Nick Patton

Photo retoucher: Tammy White

Copy editor: Heather Rodino
Proofreader: Su-Yee Lin

Publicist: Kristin Casemore
Marketer: Andrea Portanova

10 9 8 7 6 5 4 3 2 1

First Edition

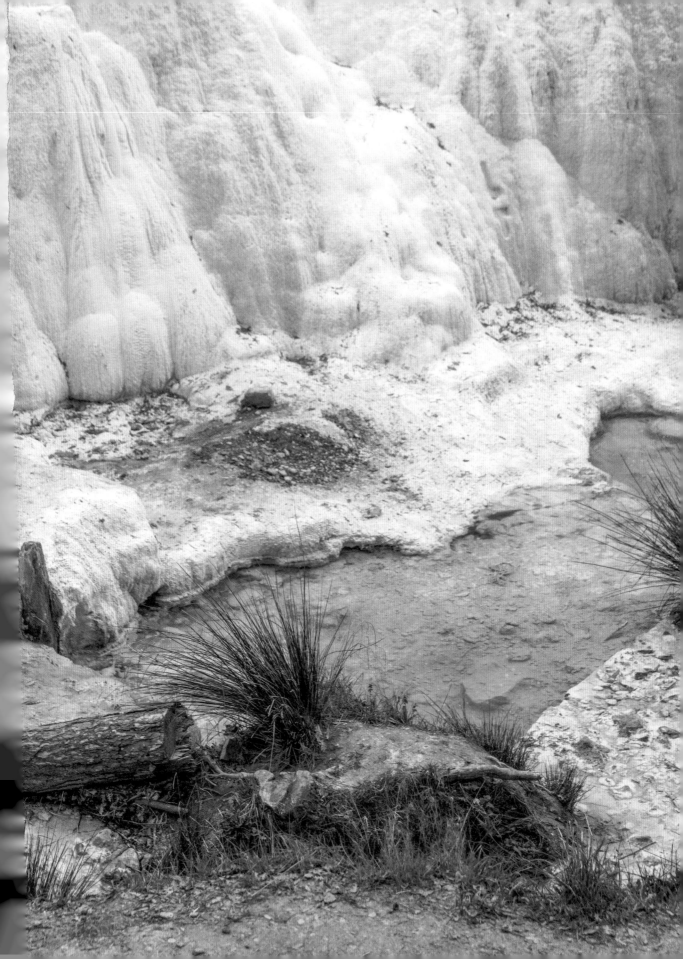

CAFÉ AT PAMUKKALE

JARLSLAUG

YARROW

ICELANDIC HORSE

FORAGED BERRIES

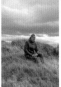
BRYNJÓLFUR ÞÓR JÓNSSON

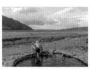
GRETTISLAUG

POÇA DA DONA BEIJA

HISTORIC SCHOOL BUILDING

MOSQUITOES

ALASKA TUNDRA

KIMINAQ ALVANNA-STIMPFLE

DARLENE'S SALMON

FAMILY FROM NOME

MÝVATN NATURE BATHS

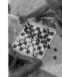
CHESS AT SZÉCHENYI

MARCELO NINA OSNAYO

WOMAN AT PUBLIC MARKET

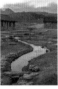
MICAELA BILLCAP'S HOT SPRING

COPAL IN LA PAZ

INDIGNEOUS NEO-ANDEAN DESIGN

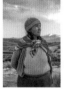
INÉS ALVAREZ PACAJE

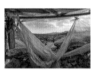
CHANGING HUT

MÝVATN NATURE BATHS

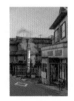
SHIBU ONSEN

KATSUYOSHI TAKEFUSHI

NAGANO ONSEN

RIEMVASMAAK

RIEMVASMAAK'S SOURCE

LOWER POOL

HENRY BASSON

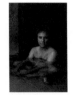
BAGNI NUOVI

VECCHI CHAPEL

BAGNI NUOVI

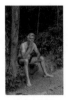
BORMIO PUBLIC BATH

LISTENING TO WATER

CAST IRON TUBS

"NATURE BUS"

MYSTIC HOT SPRINGS

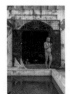
MAHANT SHIV GIRI

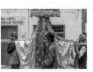
DEVTA CEREMONY

MANIKARAN PUBLIC BATH

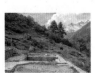
KHEERGANGA

COOKING RICE IN THERMAL WATER

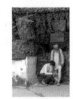
HOLY FIGURES AT GURUDWARA

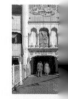
GURUDWARA MANIKARAN